The *Austin* FOOD BLOGGER ALLIANCE Cookbook

AMERICAN PALATE

Published by American Palate

A Division of The History Press

Charleston, SC 29403

www.historypress.net

Cover images: *Front*: Savory Peach Gorgonzola Galette photo by Amy Kritzer. *Back*: Granola photo by Kristin Schell; Black Bean Burger photo by Melissa Skorpil; Roasted Brussels Sprouts with Sriracha Lemon Caramel Vinaigrette photo by William Burdette; and Habanero and Apricot Vinegar with Thyme photo by Melissa Skorpil.

First published 2013

Manufactured in the United States

ISBN 978.1.60949.967.9

Library of Congress CIP data applied for.

Notice: The information in this book is true and complete to the best of our knowledge. It is offered without guarantee on the part of the author or The History Press. The author and The History Press disclaim all liability in connection with the use of this book.

Contents

Foreword

Long before the Austin Food Blogger Alliance was just kernel of an idea bandied about around a table at a local beer co-op, Austin's bloggers were connecting with their readers and with one another to share a love of more than just food—or even of food in Austin. We have a deep passion for connecting and communing around food, both online and off. We'll just as happily share a photo of a favorite dish on our blog, Facebook, Twitter or Instagram (or all of them) as get together around a potluck table to share the dish itself. We come for the food and stay for the connections the food inspires.

If you think about the things that make Austin Austin, it's not surprising that we would have such a strong food blogging community. Before Austin was established as a food destination, it was known to the world for two things: music and technology. Nowadays, we celebrate all of the aspects of an evolving food culture—from farmers, chefs, brewers and cheese mongers to food trucks, pop-up suppers, mobile food apps and food-centered social networking. Our perspective on food is shaped by so much more than great tastes and experiences. At the heart of our food culture is a love of community and an unrelenting commitment to supporting it. It is from this heart that the Austin food blogging culture was born, and it's these roots that keep us grounded.

Looking back on our journey this far—and I'm entirely convinced that we are really just beginning that journey—producing a group cookbook was the next right step. Food communities are reinventing themselves, forming new connections thanks to the kinds of relationships made possible in our socially networked world. It makes sense that community cookbooks should do the same. From our blogs, which together form a constantly evolving and living online cookbook, we've brought together a tasting of what we have to offer. Think of this cookbook as a starting point for your explorations of the Austin food blogging community. From each recipe in this book, you can visit a local food blog brimming with more recipes and a sheer love of food. We look forward to joining you on the many wonderful journeys you'll take as you move from the book to our blogs and back again.

Yours in food, online and off,
Natanya Anderson
Founding President, Austin Food Blogger Alliance

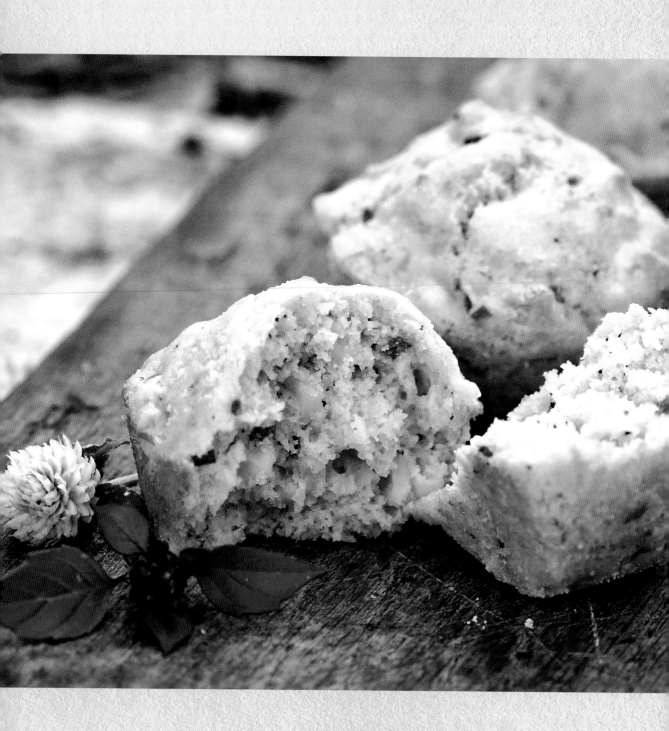

Acknowledgements

No two community cookbooks are alike, and they would not exist without a community effort to put them together.

This book is an entirely volunteer project, with Austin Food Blogger Alliance (AFBA) members contributing every recipe, photo and essay that fill up the pages. Without members' participation, we wouldn't have much of a group, much less our very own cookbook. Thanks to each of you who contributed something for the book, even if just a word of encouragement along the way.

Special thanks to David Ansel for planting the seed and the rest of the advisory council—Cathy Cochran-Lewis, Susan Leibrock, Dave Shaw, Adam Holzband, Elizabeth Englehardt, Lisa Goddard, Mando Rayo, Jam Sanitchat, Marshall Wright, Vance Ely and Toni Tipton-Martin—for being such a wise guiding force as we birthed our group. Thanks also to the AFBA board members—Natanya Anderson, Jodi Bart, Jennie Chen, Michelle Cheng, Kathryn Hutchison, Rachelle King, Mike Krell, Megan Myers, Kristina Nichols-Wolter, Rebecca Otis, Mariam Parker, Kristi Willis and Michelle Webb Fandrich—who did all the pushing. Thanks go to newly elected board members Nelly Paulina Ramirez, Margaret Perkins, Heather Santos, Kristin Sheppard, Christy Horton, Brittanie Duncan, Tiffany Young and William Burdette, all of whom are helping us into toddlerhood.

We couldn't have done this without relying on the keen eyes of Megan Myers, Lee Stokes Hilton, Meredith Bethune, Suzanna Cole and Shefaly Ravula to edit the book. Photo editor Melissa Skorpil and designer Shaun Martin made the book look as beautiful as it does. Assistant Project Manager Lindsay Bailey's contributions far exceeded making sure that the recipes work. Our gratitude goes out to the Cooking Planit team, which signed on to sponsor the book when it was just an idea we were tossing around. Thanks to The History Press for putting faith in us to publish this book. Last but not least, thanks to our families for their patience during all the nights and weekends we have spent making this group the best that it can be.

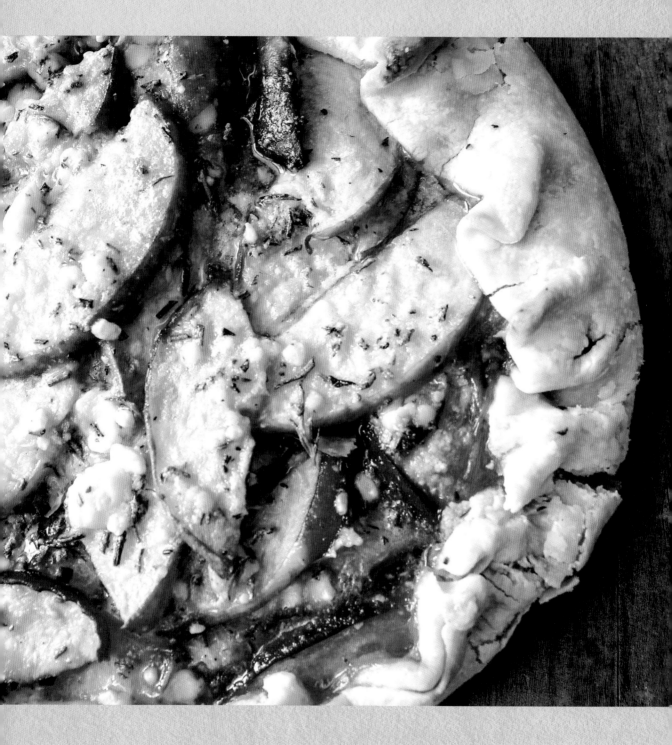

Introduction

Every time I want to make applesauce muffins, I go straight to a three-ring recipe binder in my living room, where I store a little yellow booklet of white copy paper folded in half and stapled—not so evenly—at the seams.

It's a community cookbook that my school put together when I was in junior high. When my teachers asked us to submit recipes for the book, my mom's applesauce muffins were an easy choice. It was my favorite recipe at the time, one that I loved to cook with my sister on snowy winter days and one that made the freezing cold (but not snowy) days a little more bearable.

When I make those muffins now, I flip through the pages and skim the names of former classmates and dishes with names like "Mexican Roll-Ups" and "Yogurt Pie." It's a snapshot of my life in a small school in a small town in rural Missouri. For me, it's a personal relic. For historians, community cookbooks like this are magnifying glasses into parts of ourselves that we rarely think important enough to document.

That changed with food blogging. We started telling our own stories in ways that our foremothers couldn't: what kind of casseroles we made on Monday nights after volleyball practice; what Christmas cookie we always gave to neighbors, even the mean ones; what soup we ate when the Longhorns were on the road; and what dishes we prepared to welcome babies and comfort those who'd lost loved ones.

Blogs, in many ways, are our virtual scrapbooks, and in food blogs, we simply tell our stories through what we eat and/or like to feed others: photos of our kids eating spaghetti, what we brought to our friends' baby shower and the Instagram version of last night's anniversary dinner.

Consciously or not, we are creating our own little virtual community cookbooks that we can constantly update as we cook, eat and blog our way through life.

Austin Food Blogs

There are more than 350 food blogs in and around Austin. For the past four or five years, we've been cultivating an offline community that started as a group of strangers

that met for a happy hour and led to a full-fledged nonprofit organization, the Austin Food Blogger Alliance, which is the first of its kind in the nation.

As a journalist, bloggers weren't supposed to be "my people." I graduated from a fine journalism school just as the tension between credentialed reporters and citizen journalists was really ramping up. When I was hired in 2008 to fill a position held by a much-loved and well-respected food columnist who had been in the job for more than twenty-five years, I didn't know a whole lot more about food and cooking than the average home cook. But my magazine journalism degree made me realize that telling other people's stories, especially those who didn't think they had stories to tell, is just as important as knowing how to prepare a perfect soufflé. Most importantly, I knew that social media, including blogs, was something that traditional media couldn't afford to ignore.

My first task at the newspaper was to start a food blog. We had had an infrequently updated dining blog, but we were sorely overdue in creating a first-person food blog like the ones that were popping up daily after the release of Austin native Julie Powell's *Julie & Julia*, which had been a bestseller.

All it took was a quick Google search of "Austin food blogs" to discover a handful of websites, many with tantalizing photos, personable writing and adorable names like Poco Cocoa, Boots in the Oven and The French Fork. I realized pretty quickly that I had a lot to learn.

After reaching out to them via e-mails and blog comments, we met for a happy hour at a local restaurant to meet face to face. About fifteen or so of us showed up, and some of the bloggers found out that they had been reading one another's blogs online for years but never met in person.

We started a Facebook group to share blog posts and food adventures and coordinate trips to wineries, restaurants and bowling alleys. Food photographer Penny De Los Santos opened her home for our first potluck in April 2009, and our meet-ups only grew from there.

By the end of the following year, my list of Austin blogs had grown to almost three hundred. I was getting ready to have a baby and knew that it was time to let the Austin food bloggers' group take on a life of its own. Some of the most active bloggers got together for a meeting that was the seed for starting the Austin Food Blogger Alliance, which officially launched in March 2011.

Two years in, we've raised thousands of dollars for local nonprofits including SafePlace and Bake a Wish, hosted social outings and field trips, coordinated care package swaps with food bloggers in Boston and offered educational classes on ethics, food photography and recipe development.

In early 2012, advisory council member David Ansel threw out the idea for the blogger alliance to create a community cookbook to raise money and awareness about the group. He'd had success with a similar book for his "soupies," loyal fans of his Soup Peddler

business. The original idea was to publish an informal booklet of recipes and give it out at our holiday party, but as we thought more about the talent in our group—after all, what is a food blog without photos?—the scope of the project grew.

Over the course of a few months, we hosted classes on recipe writing and testing and collected more than one hundred recipes from members. We asked them to write vignettes and submit photos that would help tell the story of the food community we get to call our own. We matched bloggers up to test each other's recipes and then hosted a potluck at Springdale Farm in East Austin so that they could share the resulting dishes. (That also gave us a chance to take additional photos of the dishes and the conviviality of our group.)

Even members of the food community outside of our group have embraced the project. At a cookbook event at Olive & June in early 2013, Chef/Owner Shawn Cirkiel prepared two recipes from the book—the Thyme and Four Cheese Corn Muffins from Rachel Daneman and the Italian Grapefruit Cocktail with a Texas Twist from Lindsay Robison—to serve to recipe contributors, AFBA members and early supporters of the cookbook.

The work has been worth it. In your hands, you hold a book that was entirely produced—from recipes and photographs to editing—by members. So why would such a technologically savvy group put so much work into a print product? Since our founding, the Austin Food Blogger Alliance has emphasized the real-life connections that our online group has brought, and a print cookbook reflects that.

And as much as we love—and thrive in—the digital world, nothing can replace the feeling of turning the pages of a real book, especially a cookbook. Seventy-five years from now, who knows what kind of device we'll be reading, writing and sharing recipes on, but we hope that one of those ways will be a printed book that you can place on your kitchen counter.

The History of Community Cookbooks

Cooks, especially women, have been leaving their mark on the world through their recipes for as long as they have been cooking. As women learned to read and write, they started to transcribe dishes that had only previously existed in their heads. Pretty soon, they were swapping those recipes and sharing parts of their families' traditions with others.

Through those recipes, which might not seem practical in this world of having every recipe printed at our fingertips, we can learn details about their lives that weren't documented otherwise: how they stretched rations in wartime, how they switched to Oleo to save money and calories, what soups they fed to comfort a sick relative and what sweet treat they felt comfortable serving to guests.

Elizabeth Englehardt, an American studies professor at the University of Texas who specializes in women's history, says that community cookbooks, like oral histories, are historical documents that reveal a lot about cultural norms, race, class and gender.

Community cookbooks have long been considered a fundraising source. Groups of women built churches, schools and other nonprofits on the plastic spiral bind of the community cookbook. These books—which were often compiled, edited, marketed and sold by the women who spearheaded them—gave the women access to a world of commerce that they wouldn't be privy to otherwise. Being able to sell a compilation of recipes from the average housewife put a monetary value on something that might have been taken for granted previously.

Food blogs today represent just how far we've come in giving value to the everyday cook's perspective on putting dinner on the table. It's becoming more common for individual bloggers to make money from their sites, even if it's just a few cents per month from an ad network. But the value of the virtual paper trail that we are leaving today is priceless. Through our "weblogs," we are sharing more about our lives—and with a bigger audience—than we ever have in the history of humankind.

Amanda Hesser, who along with Merrill Stubbs created a thriving online community of cooks through their website food52.com, argued that by cooking, we make a statement about who we are and how we want to be remembered. In 2011, Hesser and Stubbs published their own community cookbook, *The Food 52 Cookbook* (William Morrow, 2011), a collection of the winning recipes from a year of weekly cooking contests. In a manifesto in the introduction, the authors expounded on the joys of cooking together, even if it's just virtually and among friends whom you've never met in real life. But most importantly, they wrote, "If you cook, people will remember you."

A few years ago, my mom took the community cookbook idea and applied it to our own family, gathering favorite recipes from aunts, in-laws, close friends and her own collection to create an inexpensive but heartfelt Christmas gift. I can think of few presents I've received in my life that I've used more often and that have meant as much as that set of recipes and stories that remind me of just the kind of cooks whom Hesser and Stubbs had in mind.

Even though community cookbooks might not have the recognition that they once did (I polled a University of Texas food studies class recently and found that only three had participated in such a book before), they continue to inspire commercial projects.

In 2007, the smart folks at Central Market compiled the best recipes from their annual Hatch chile recipe contest for what they called "The First Ever Unedited and Untested Hatch Chile Pepper Recipe Book." Like the Soup Peddler book that inspired our project, the recipes in this book were straight from the sources: handwritten and, as the title confesses, completely unedited and untested. On the other end of the production scale is *Music in the Kitchen*, a 2009 book from the longtime makeup artist

and stylist behind the *Austin City Limits* television show, Glenda Facemire. Over the years, Facemire had connected with so many internationally known musicians over their shared love of food that she asked them all to submit a recipe for an ACL community cookbook, if you will.

Austin Food Blogger Alliance member Karen Morgan took the group cookbook idea and applied it to her gluten-free community. She asked friends and fans to submit recipes that called for flour, which she then adapted to be gluten-free. That book, *Blackbird Bakery Community Cookbook*, is slated to come out in 2013.

These are all relatively recent examples of community cookbooks, but we can't publish ours without recognizing the trailblazing efforts of two nonprofit groups in Austin, the Austin Junior League and the Austin Junior Forum, both of which have published highly successful community cookbooks in the past forty years. While the groups continue to thrive, they are phasing out the traditional print community cookbooks.

The Austin Junior Forum's *Lone Star Legacy* cookbook series has sold more than 100,000 copies, but member Jan Burnight said that they don't currently have another edition in the works. The Austin Junior League's most recent community cookbook, *Austin Entertains*, came out in 2001, and nonprofit spokeswoman Kendra Young said that the group is selling the last of the physical copies that are left and transitioning to an online-only recipe project at austinentertains.com.

Carrying on the legacy that these groups started feels like the least we can do to honor their efforts in the pre-digital era.

Where Are All Y'all From?

In the process of putting together this book, members often asked me if the recipe they submitted had to be "Texan." "Are you all from Texas?" I would respond.

The number of people who live in Central Texas has almost doubled in the past twenty years, which means that many of us who live here, including me, came from somewhere else. When each of us moved to the area, we brought personal culinary histories with us, and I wanted this book to reflect that.

From Persian stew to Czech kolaches, Greek phyllo wraps and good old Texas sheet cake, it's clear that we are geographically diverse. From handmade empanadas to a simple strawberry balsamic salad, we are of all skill levels. Melissa Joulwan's chocolate chili might introduce us to the Paleo diet, while Kristen Vrana's chocolate peanut butter postal cookies fit into both the vegan and gluten-free lifestyles that have become more widely embraced in recent years (and they ship well, hence the name). Some bloggers are adept at coming up with dishes seemingly out of nowhere, while others embrace the craft of

adapting others' recipes into their own. Other members who don't necessarily blog about cooking or recipes contributed essays, photographs or their time volunteering at events.

The ethics of adapting and sharing recipes—not to mention that of reviewing restaurants, cookbooks or products—is something we take seriously as a group and have tried to educate members on through educational classes and our ethics policy. We have indicated which recipes are adaptations of other recipes, but if a recipe does not contain a note about adaptation, it has been changed significantly enough—at least three significant ingredient or technique changes—to be claimed as the blogger's own.

The recipe that best helps tell the story of where I come from is my grandmother's coffeecake. In 1884, my grandmother's grandfather emigrated from Sweden's Gotland Island in the middle of the Baltic Sea to build wagons in Springfield, Missouri, smack dab in the middle of the United States. Ten years after he left his pregnant wife, Carolina Sophia, and their three-year-old son for a new life in a new country, he returned to Sweden to get them.

Among the items that Carolina Sophia packed into her luggage were a bread knife and a rolling pin, which my grandmother has in her kitchen to this day, less than forty miles from where her grandparents first settled. Her mother was a first-generation Swede raising a family in southwest Missouri, and when other Scandinavians would get together, my grandmother remembers helping her mom serve the guests this coffeecake on little saucer plates.

Gaga, as she is known to many, now uses her grandmother's knife to slice her mother's famous cake, and that recipe, though certainly not perfect by today's standards, is a family heirloom. Because it's not the world's best coffeecake recipe—it's a dense cake closer to a pound cake—I considered further developing the recipe to try to improve it, but I realized that if I started to change the structure of the cake, it would have become *my* coffeecake recipe, not my great-great-grandmother's. I didn't want to fiddle with the recipe for fear of fiddling with the story.

This recipe helps tell my story. When we compile a group of recipes like this, we not only get to tell the story of our group, but we can also help paint a picture of what's cooking—and who's doing the cooking—in Austin kitchens in the early twenty-first century.

We hope you enjoy the book as much as we've enjoyed putting it together. Happy cooking!

Addie Broyles,
cookbook editor

Breakfast and Breads

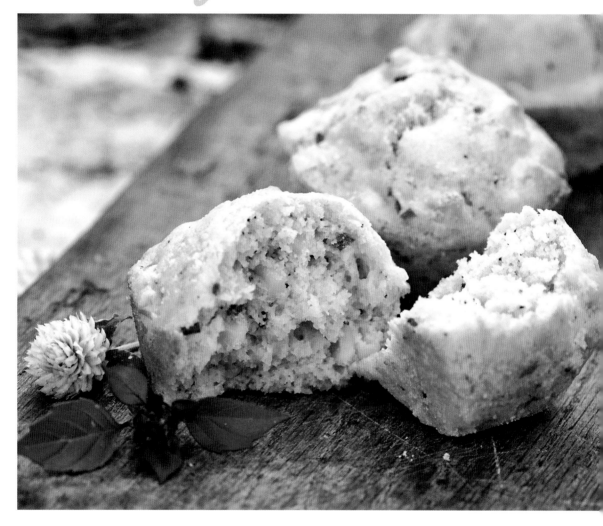

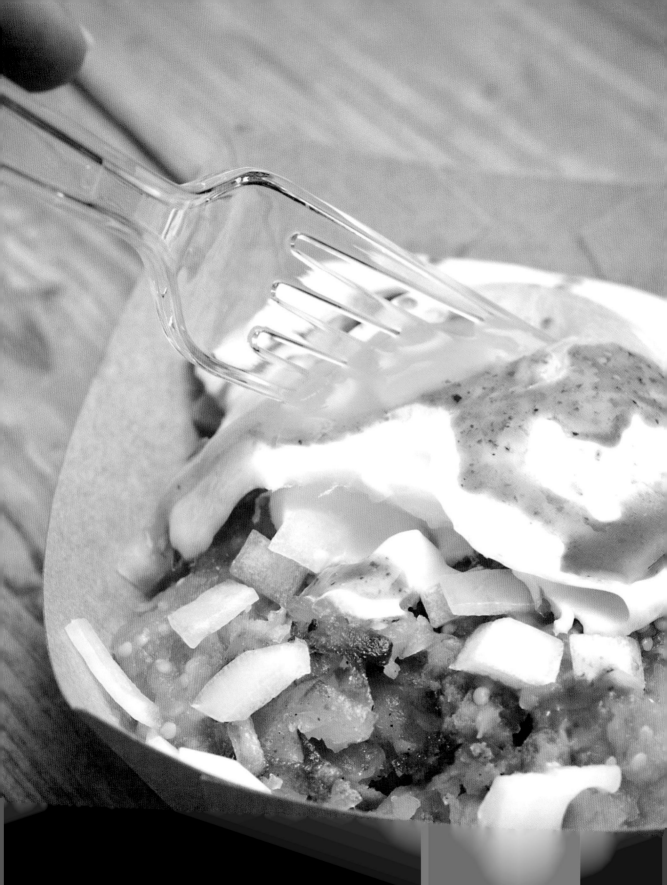

Papaquiles

Ryan Schierling and Julie Munroe, Foie Gras Hot Dog (foiegrashotdog.com)

The word "chilaquiles" comes from the Nahuatl word *chil-a-quilitl*, which means "herbs or greens in chile broth." "Papaquiles" is not actually a word. We made it up! That's all right, though, because this concoction bears only a passing resemblance to chilaquiles, one of our favorite breakfast dishes.

Since our very first introduction to this thrown-together Mexican breakfast, we've been huge fans. Fresh-fried tortilla pieces gently tossed in a red or green salsa, with sour cream or fresh crema, a little diced onion and the glorious yellow of yolks spilling from fried eggs—what's not to adore?

Our homage is ridiculously simple. Hash browns cooked to perfection with nice crispy edges, a big spoonful of salsa verde, a dollop of cool sour cream and chopped white onions for their brightness and crunch, all crowned with an over-easy egg. Finish this with a drift of your favorite hot sauce, and your day is off to a fantastically rich and savory start.

We don't play favorites between roja and verde versions of chilaquiles, but with hash browns, the regular ol' store-bought salsa verde has been our mainstay and the best fit in terms of consistency and flavor. While we're still running all over Austin exploring the plethora of amazing chilaquiles at local taquerias, for breakfast at home, "papaquiles" remains one of our very favorites.

This dish won the Today Home Chef Challenge Southwest Edition, and a version of it was served at the *Today Show*'s Munchie Mobile food truck at South by Southwest 2012.

1 30-ounce bag of frozen hash browns
¼ cup vegetable oil
6 eggs
butter for cooking eggs
1½ cups salsa verde
⅓ cup sour cream
⅓ cup diced white onion, rinsed in colander
 under cold water
hot sauce, to taste

In a large skillet, cook the hash browns in ¼ cup of vegetable oil over medium-high heat until crispy and golden brown. Turn off heat under the hash browns, and in a separate skillet or griddle, begin cooking your eggs in a little butter. Our preference is over-easy. When the eggs are almost finished, plate your hash browns in a serving bowl (5 ounces, or ⅙ of the bag, is a nice serving size). Top with ¼ cup salsa verde, a dollop of sour cream and a sprinkle of the diced onion. Place an egg on top, add a few shakes of your favorite hot sauce and dig in. Serves 6.

Papaquiles. *Ryan Schierling.*

Family Dinners, Breakfasts or Even Snacks

Lee Stokes Hilton, Spoon & Ink (spoonandink.blogspot.com)

A kitchen table, a dining room table or a picnic table—even a big square tablecloth on the floor will do, if that's where your family will gather, face to face and with the television off, for regular dinners (or other meals) together.

So many of my favorite memories of our family revolve around mealtimes. Someone sets the table, and I always insist on candles. I want the mealtime to be peaceful, and I find that most forms of chaos are at least diminished by the presence of candlelight. We talk about work, school, sports or politics. And if the conversation lags, my younger son turns to me and says, "So, Mom, what's your favorite color?" My co-conspirator.

It turns out that the emotional and social benefits of family dinners are widespread and powerful. A study by the University of Minnesota found that children who had fewer family meals were—in addition to being more likely candidates for substance abuse—more likely to have lower grade point averages and fewer symptoms of depression.

One key, of course, is conversation—face-to-face conversation about nonthreatening topics. If dinner is a time of judgment or criticism, much of the good is undone. Sociologists tell us that conversation topics that range from current events to stories of the parents as children help to broaden a child's perspective on life, improve language skills and provide a sense of family unity and stability.

Another important aspect of family dinners is the ritual, which helps us regroup if life starts to feel out of hand. Practices as simple as setting the table or using candles, special plates or even cloth napkins bring a sense of calm and order to our lives. This is part of your family's culture, and it will continue to influence each member of your family, even if they move out of the house and away from one another.

AFBA City Guide

Jodi Bart, Tasty Touring (tastytouring.com)

Food bloggers give great recommendations. We get asked for them a lot, so we all started to develop these lists in our heads (or on our blogs) of where to get the best breakfast taco, who served the strongest cocktail, which white tablecloth restaurants deserve your anniversary dollars and so on. In 2010, before the Austin Food Blogger Alliance

was even founded, a group of local bloggers started the City Guide, an annual set of recommendation posts to help both locals and out-of-town visitors navigate the ever-changing Austin food and drink scene.

We have continued to publish the City Guide under the AFBA banner in recent years, choosing to release the guide each March, just before the South by Southwest (SXSW) music, film and interactive conferences take place, and more than 100,000 people flock to our vibrant city.

The 2012 guide included posts by AFBA members in a wide range of categories, such as new establishments, ethnic eats, special diets, fine dining, drinks, day trips, mobile food and recommendations by location. The City Guide also includes a link to the "Austin Food Blogger Faves," the results of an online survey in which AFBA members voted for their overall favorites in a number of categories.

In keeping with the blogger culture, the City Guide is only available online. For the latest version, go to http://austinfoodbloggers.org/city-guide.

Gluten-Free Quiche

Rachelle King, Blinded by the Bite (blindedbythebite.wordpress.com)

I love to eat breakfast for lunch and dinner, and quiche is one of my most favorite gluten-free dishes to make. I use a gluten-free crust in the frozen section at Whole Foods Market, but you could use a gluten-free flour mix to make your own.

I like to use a variety of cheeses from a favorite cheesemonger, Antonelli's Cheese Shop. I usually go with a goat milk chèvre, a Pecorino Romano and a cheddar. I sometimes go with a sharper cheddar and/or even a bleu cheese, depending on the other ingredients I am adding. Base the cheeses you use on what you like; I tend to like my cheese on the strong side. Be careful when selecting your cheese, as some of them contain a rye starter, which contains gluten.

Gluten-Free Quiche. *Kristin Vrana.*

1 gluten-free crust (or homemade)

3 tablespoons nonfat cream cheese

¼ cup chèvre

¼ cup grated cheddar

¼ cup grated Pecorino Romano

6 eggs

¼ cup nonfat milk

1 tablespoons minced garlic

½ medium onion, finely chopped

½ tomato, diced

pinch of dried dill

lonzino (you can substitute bacon and/or
 another other meat you choose)

Slightly defrost crust (if frozen). Using a fork, poke holes in the bottom and sides of crust. Preheat oven to 325°F and bake crust until lightly golden, about 8 minutes.

Place cheeses in large bowl and, using a large whisk or a handheld or stand mixer, mix together. Add eggs and milk and whisk on low. Add in garlic, onion, tomato and dill.

Place the crust on a cookie sheet and pour mixture into crust. Bake for 45–50 minutes. Test center of quiche with a toothpick to ensure that it is cooked through completely (toothpick should come out clean). Allow to cool before refrigerating if you're not going to eat right away. Serves 4.

Making Family Dinner Work for You

Lee Stokes Hilton

1. *Set the table.* This is one way the children can help. Use plates, forks and spoons—even fast food looks better on a real plate. Consider candles or flowers—anything that will make the table more attractive.

2. *Turn off the television.* Nothing is gained from a meal in front of the TV. And the same goes for cellphones or other technology. Make the family your network for the evening.

3. *Remember your manners.* Family dinners are how children learn what behavior is acceptable at the table, but be instructive rather than destructive—no power struggles or lectures.

4. *Everybody talks, everybody listens.* Tell your children a story from your childhood. Ask him what his favorite color is and why. If she could be another person, who would it be and why? Make sure everyone participates in the discussion, but make sure you listen, too. Be serious or be silly. Be both.

5. *They're not angels—they're your children.* Don't expect too much too soon. Your children may never learn to keep their elbows off the table, but with time and patience, you'll see the ritual take root and grow.

6. *It doesn't have to be dinner.* Try breakfast, a bedtime snack, Saturday brunch or Sunday lunch. Build into the week as many of these opportunities as you can. The important ideas are intent and consistency. Make it a family ritual.

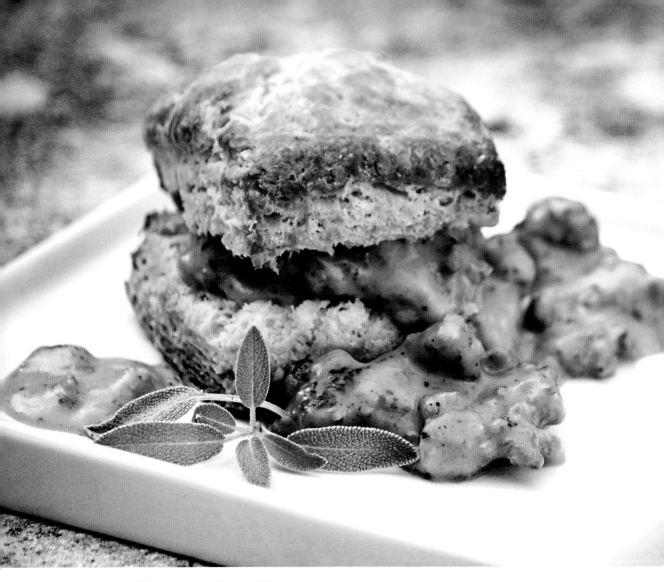

Biscuits and Sausage Gravy. *Kristina Wolter.*

Biscuits and Sausage Gravy

Suzanna Cole, South Austin Foodie (southaustinfoodie.blogspot.com)

I love to bake, particularly quick bread items such as biscuits. I've collected more than a dozen different biscuit recipes; this one combines the best qualities I've found as I've tinkered with them over the past few years. However, I know not everyone is comfortable baking, so I've tried to be as specific as possible with this recipe so you, too, can have nice warm buttery biscuits. Be patient and follow the steps listed. Whether you add the gravy (pure decadence!) is up to you.

For the biscuits:

¾ cup (1½ sticks) frozen
 unsalted butter

2 cups all-purpose flour, plus
 extra flour for shaping
 dough

1¾ teaspoons baking powder

½ teaspoon baking soda

1–1¼ teaspoons non-iodized
 table salt

1 cup milk

2 tablespoons cream or 1½
 tablespoons additional milk

For the gravy:

1 pound pork sausage,
 regular or spicy

1–2 tablespoons butter or
 bacon fat, as needed

2 tablespoons all-purpose
 flour

2 cups milk

salt and black pepper to taste

For the biscuits: Preheat oven to 425°F. In a food processor fitted with the grating/shredding blade, grate butter (butter will be fairly finely grated) or use the large holes of manual box grater over a bowl, but work quickly to avoid melting the butter. Gently scrape down sides of bowl with a spatula and place in freezer for about 5 minutes.

In a separate large bowl, combine flour, baking powder, baking soda and salt. Stir with whisk to combine. Add grated butter to dry mixture. Gently mix with a fork, coating the butter pieces with flour and breaking up any large clumps. You want to see a mixture that has lumps of butter between a pea and a garbanzo bean in size.

Add milk, combining with the fork; dough should come together fairly easily but will be a little shaggy. Add an extra bit of milk if mixture is too dry. Mix just until all flour is incorporated, but do not overmix. Form dough into a loose ball and turn out onto a lightly floured board.

Pat into a rectangle, roughly 6 inches wide, 8 inches long and 1 inch tall. Do this with a fairly light touch—don't pound it! Use a little flour on board and hands to prevent sticking. Trifold the dough, as if you were folding a letter, and then fold in half lengthwise. Repeat this at least three times—this is what forms the layers. It helps to use a bench scraper or a wide turner/spatula.

Pat dough into a rectangle, about 1½ inches thick. Cut/score the dough into desired serving size and place ½ to 1 inch apart on an ungreased baking sheet. If using a cookie or biscuit cutter, cut straight down and do not twist the cutter or it may seal the edges (and the biscuits may not rise as much). Place pan in refrigerator for 10–15 minutes to allow the gluten to relax and the butter to be really cold when it goes into the oven. Brush tops and sides of dough with cream or milk.

Bake 16–19 minutes until golden brown; cool slightly before serving.

For the gravy: In a large nonstick skillet, brown sausage over medium to medium-low heat. Break up the sausage with a spoon to crumble. Remove sausage with slotted spoon, leaving the rendered fat. Drain sausage on a paper towel–lined plate.

Add enough butter or bacon fat to equal 2 tablespoons of fat total and melt over medium-low heat. Whisk in flour, stirring constantly for 30–60 seconds. Gradually whisk in milk. Bring to a simmer over medium heat and then reduce the heat to prevent burning. Cook about 2 minutes, stirring occasionally. Add sausage back to pan and adjust salt and pepper to taste. Serve immediately with warm biscuits. Serves 6.

Eli Castro.

Keeping It Brewed in Austin

Eli Castro, Grubbus (grubbus.com)

Austin didn't used to be a coffee town. Once upon a time, if you wanted really top-notch coffee, you had to mail order it, often paying as much for shipping as you did for the beans. Now, all that's changed.

Cuvee Coffee, Third Coast Coffee and Casa Brasil are roasting world-class beans in Austin, and well-trained baristas at places like Caffe Medici, Houndstooth Coffee, Once Over Coffee Bar, Progress, Thunderbird and Cenote know what to do with a perfectly roasted bean.

Mastering the art of brewing coffee can take years, but at the very least, you need fresh whole-bean coffee and cold filtered water.

Beans start to lose their flavor as soon as they are roasted, and go even more quickly once they are ground. Try to use the beans within a week or so of being roasted and don't grind them until you are ready to brew. (Think of it like a loaf of bread. If you put a good crusty loaf of bread on the counter, it'll still be pretty tasty when you cut into it tomorrow. If you put a big pile of breadcrumbs on the counter overnight, they'll be as stale as little pebbles by morning.)

If you have the time, a burr grinder is the absolutely best way to grind beans into a uniform size, but they run from $40 to $150. (The more common blade grinder, which whirs around like a little blender, creates an erratic combination of coffee dust and coffee boulders. Blade grinders are better than nothing, but not by much.)

As for brewing devices, there are many ways to make good coffee, as well as a few things to look out for.

Chemex. Unchanged since the 1940s, this simple glass vessel is shaped like an hourglass. Water poured over the grounds in the top is filtered through a paper or metal filter to produce the coffee, which collects in the bottom.

Hario V60. Hario filters work in much the same way as Chemex, but there's no container to collect the finished beverage. Set the Hario filter on top of whatever you want to brew coffee into (Mason jars work great) and pour the water over the grounds.

French press. With a French press, place the grounds directly into the container, pour the water over them, give a little stir and wait about four minutes before pushing the filter down, which traps the grounds at the bottom of the container. A French press will often give a little fuller body than the Hario or the Chemex and may bring out earthier flavors.

Each of these methods requires fresh grounds (finer grinds for the pour-overs, coarser for the French press) and water that has been heated to about 200°F, which is

about half a minute after a boil. Even though they're the best coffee brewing methods on the planet, they're cheap! Chemex, Hario V60 and French press coffeemakers retail starting at about twenty dollars.

Got an electric coffeemaker? No problem. You can still get great coffee, though I've found that even for really amazing electric drip machines, the flavors tend to decline over time due to mineral deposits that build up inside all the tubing. The very best electric drip makers I've used are from Technivorm and Bonavita; both do a great job keeping the process simple and getting the water to the right temperature.

So that's it. Good, fresh beans. Filtered water, just off the boil. A burr grinder. A simple, clean brewing device. There is no reason at all that the coffee you sit down with in the morning can't be on par with the very best cup of coffee available at any shop anywhere in the world.

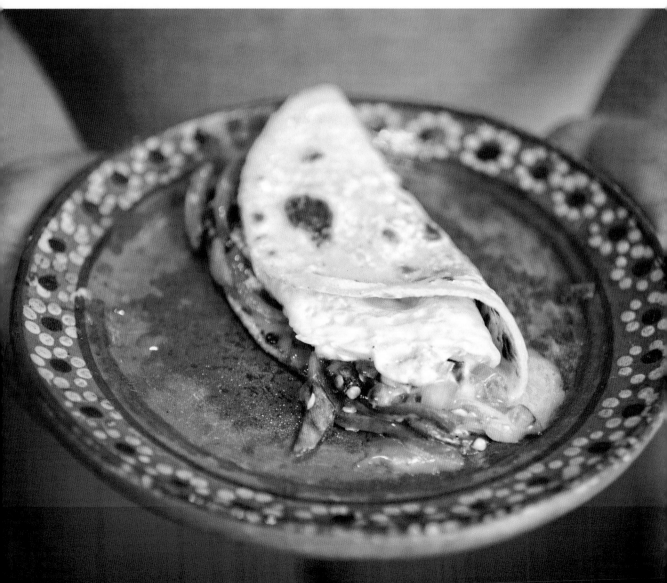

Fried Egg Taco

Mando Rayo, Taco Journalism (tacojournalism.com)

I heart huevos. Those of you who know me know that I gotta have my eggs for breakfast, especially after a night of muchas cervezas or, if you have kiddos in your casita like me, lots of long, muy long nights. Anyways, una noche after many tequilazos, I created the Fried Egg Taco, which has evolved into the World Famous El Mundo de Mando Fried Egg Taco! I make this taco with everything from my carnies (chorizo and bacon) to whatever leftover veggies my beautiful wife makes me eat. I like mine picosos, but if dos roasted jalapeños is too much for your tongue, try just a sliver or two instead. (My favorite is letting the yolk gush out and licking it off pretty much anywhere it lands.)

2 teaspoons olive oil

1 huevo (2 if you're really hungry)

Poquito grated cheese (American cheese, Muenster to cotija, whatever you have on hand)

2 corn tortillas (homemade by your abuelita)

2 jalapeños, roasted, peeled and sliced

⅛ onion, sliced

Heat the oil in a frying pan over medium-high heat and fry the egg until it's mostly todo cookiado, except for the middle gooey stuff. Put the cheese on top so it starts to melt onto the pan and fries a little, too. When the egg is cooked a su gusto, remove from the pan and lightly fry or just heat the corn tortillas—as in dos, 'cause everybody knows you can't eat a taco on just one corn tortilla! Top with the roasted jalapeños, onions y mas (whatever you want). Fold in half and eat.

Fried Egg Taco. *Joel Salcido.*

Moroccan Eggs Benedict

Jack Yang, Eating in a Box (eatinginabox.com)

I was asked to be featured as a guest chef at a local Moroccan food trailer. I decided to design a four-course meal much in the same way my bento boxes are designed for my blog. I chose two traditional dishes and designed two of my own. This is my interpretation of eggs benedict, Moroccan style: a sandwich round topped with a kefta patty, sous-vide poached egg and finished with a tomato harissa sauce. If you're able to sous-vide poach your egg, I highly recommend it; the texture is an amazingly rich cream custard that normal poaching cannot produce. I had plenty of customers coming back for more eggs. My friend described it as "what I thought gold should taste like."

Notes: For the bread, I used whole wheat sandwich rounds, but you can substitute any bread and cut it round. Pita would be a good alternative. If you do not have an immersion blender, you can use a food processor or blender with a couple of pulses. If you do not have access to a sous-vide machine, then a traditional poached egg can be substituted.

For the harissa paste:

3 canned ancho chiles

2 cloves garlic, peeled and smashed

½ teaspoon cumin

½ teaspoon salt

¼ cup extra virgin olive oil

For the eggs benedict:

6 large eggs

1 14-ounce can whole tomatoes with liquid

½ cup harissa paste, divided

½ pound ground beef

½ pound ground lamb

1 medium onion, finely chopped

2 teaspoons paprika

1 teaspoon cumin

1 teaspoon salt

½ teaspoon ground cinnamon

½ teaspoon hot cayenne pepper

¼ teaspoon black pepper

¼ teaspoon ground coriander

¼ cup fresh parsley, chopped

2 tablespoons canola oil

6 sandwich round halves

For harissa paste: Place chiles, garlic, cumin and salt in a food processor. While pulsing the ingredients, stream in olive oil until everything comes together in a paste-like consistency.

For eggs benedict: Set your sous-vide machine for 147°F. When the target temperature has been reached, carefully submerge all of the eggs. The eggs will be done in 45 minutes but can be held for up to 1.5 hours.

In a saucepan over medium heat, cook the tomatoes in their liquid with ¼ cup harissa paste. Carefully stir together and let simmer for 30 minutes.

Using an immersion blender, roughly blend the mixture into a chunky sauce. (This can be done ahead of time; just reheat the sauce before serving.)

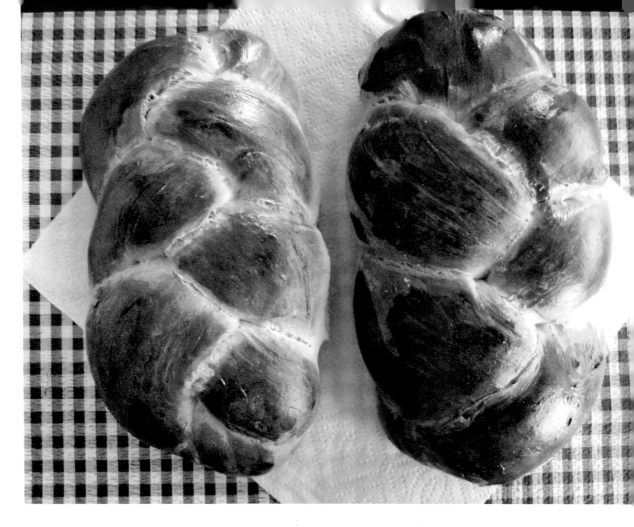

Italian Easter Bread. *Cecilia Nasti.*

In a large mixing bowl, combine beef, lamb, onion, paprika, cumin, salt, cinnamon, cayenne, black pepper, coriander and parsley. Gently mix until fully combined.

Divide the meat mixture into 6 equal-sized balls and flatten into thin patties 4–5 inches in diameter.

Bring a skillet with canola oil to medium-high heat. Cook patties 2–3 minutes per side.

To assemble: For each sandwich, place one "sandwich round half" soft bread side face up on a plate. Place meat patty on top of the bread and spoon on extra harissa paste. Carefully crack poached egg on top. Serves 6.

Italian Easter Bread

Cecilia Nasti, Field & Feast (fieldandfeast.com)

Friends and extended family of the Nasti clan reveled in the joys of Easter Bread (from a recipe that came from my mother's family) when my mother and father were still alive. It

is a slightly sweet, dense, braided bread, drizzled with a confectioners' sugar icing. Mom and Dad worked together to make this tasty baked good every Easter until physical ailments prevented them, but it lives on through their children. They began a week or more in advance, freezing the loaves.

The night before Easter, my dad would bring armfuls of the bread up from the freezer in the basement and then set the golden, braided loaves side by side on the kitchen counter to await glazing. Mom made a lemon glaze and let us kids drizzle it over the Easter Bread. We then bedecked each loaf with a colorful array of jellybeans—our playful contribution to the traditional recipe.

On Easter, friends and family would descend on our home, sit around our kitchen table and eat big slices of the Easter bread slathered with butter. Jams and jellies were also available, but there was nothing as good as Easter Bread topped with soft butter and a good cup of coffee—surrounded by friends and family—to make a person feel right with the world.

For the bread:
1 package active dry yeast (2¼ teaspoons)
¼ cup warm water (80–90°F)
½ cup (1 stick) unsalted butter
2 teaspoons salt
½ cup sugar
1 cup scalded milk
4½–5 cups all-purpose flour
2 large eggs, slightly beaten
¼ teaspoon mace
zest from one lemon (juice used below)
1 cup golden raisins (optional)
1 teaspoon neutral oil, such as grapeseed, vegetable or canola

For the icing:
2 cups sifted confectioners' sugar
½ teaspoon melted butter
2 teaspoons milk
1 teaspoon fresh lemon juice (may use more if you like a tangy icing)
1 bag jelly beans

For the bread: In a small bowl, mix together yeast and warm water and set aside. In a large bowl, blend the butter, salt and sugar.

Scald the milk by heating it to 82°F and pour it over the butter/salt/sugar mixture; blend and allow to cool. Once the milk mixture has cooled slightly, begin adding the flour a little at a time. After you've added 2–3 cups of flour, add the yeast mixture and mix until incorporated, then mix in another cup of flour. Mix in beaten eggs, then add mace, lemon zest and raisins and incorporate into the dough. Continue adding flour, a quarter cup at a time, until the dough forms a loose ball.

Transfer the dough to a floured work surface and knead, adding more flour as required to prevent dough from sticking to your hands. Once the dough no longer sticks to hands, oil a large bowl with the teaspoon of oil and place dough in bowl. Allow the dough to rise in a warm place, covered with a dampened tea towel or waxed paper, until doubled in size. Once doubled, punch down the dough and let it rise again.

Preheat oven to 350°F. Divide the dough in two and cut each half into thirds. Roll each piece into ropes and braid three together to form a loaf. Repeat with remaining dough. Put the braided loaves onto a baking sheet lined with parchment paper and let rise until doubled. Place

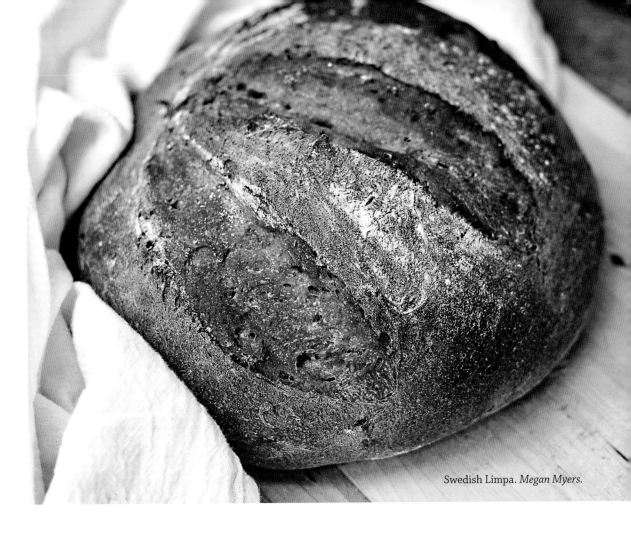

Swedish Limpa. *Megan Myers*.

loaves in the center of the oven and bake for 20–30 minutes, until the loaves are a light golden brown. Cool before icing.

For the icing: In a large bowl, mix together sugar, butter, milk and lemon juice (or more milk if preferred). If the icing is too runny, add more powdered sugar. Drizzle over cooled loaves in random patterns and place jelly beans in the crevices of the braids. Serve with soft butter or jam. Makes 2 loaves.

Swedish Limpa

Megan Myers, Stetted (stetted.com)

While Swedish food did not appear often at my grandfather's table, I have to wonder if he longed for it. He was a cook in the U.S. Navy and continued to use his skills at home, although cooking for the younger versions of my brother, my cousins and me probably did not lend to much experimentation when we were around. I do, however, remember there always being fresh loaves of vört limpa on the table. He would bake the limpa into small

loaves so they would be the perfect size for a quick bite.

Now that I live in Texas, the opportunities for homemade limpa only come in my own home, and I'm proud to share part of my food heritage with my son, who loves anything that can be called bread. Limpa is delicious with just a spreading of rich European butter, or try it with a slice of smoked salmon.

1¾ cups orange juice

¼ cup unsalted butter

⅓ cup molasses

¼ cup brown sugar

1 teaspoon fennel seeds

1 teaspoon caraway seeds

2¼ teaspoons yeast

1 tablespoon salt

2½ cups rye flour

2–3 cups all-purpose flour

Preheat oven to 300°F, turning off immediately once heated.

In a small saucepan, combine orange juice, butter, molasses, brown sugar, fennel seeds and caraway seeds. Heat just until butter is melted, sugar is dissolved and liquid feels about the same temperature as your inner wrist. Pour into a mixing bowl and whisk in yeast and salt. Stir in rye flour, then add in all-purpose flour gradually until dough is soft and pliable. It should still be somewhat sticky. Let rest for 20 minutes.

Turn dough out onto a lightly floured surface and knead gently for about 5 minutes, adding more flour as needed to prevent sticking. Set in a large greased bowl, cover with a tea towel and put into warmed oven. Let rise until doubled, approximately 1 hour.

Punch down dough, divide in half and shape into round or rectangular loaves. Place loaves on a lightly floured baking sheet or in a greased bread pan. Cover and let rise on the counter until doubled, about 1 hour. While dough is rising, preheat oven to 375°F. Once ready, slash loaf tops with a floured serrated knife. Place bread in oven and bake for 30 minutes, or until loaves are dark and crusty. Makes 2 loaves.

Simple Homemade Granola

Kristin Schell, The Schell Café (theschellcafe.com)

I love Austin. Long before the quirky little town became home, I remember childhood road trips to A-town. Approaching from the north, I swear—and my siblings will attest—that if you squinted just right with all your might, you could see the tippy top of the capitol from as far away as the Candle Factory exit in Georgetown. There wasn't much to obstruct the view on that last stretch of interstate back in the '70s.

Even as a child, I recognized the unconventional spirit of Austin. A little bit country. A little bit rock-and-roll. Two parts hippie. One part granola. It's the secret recipe that keeps Austin unique—or, as some would say, weird.

I recently bought several "Keep Austin Weird" T-shirts for some friends up north. They had heard our unofficial motto before but wondered aloud why we would want to keep our

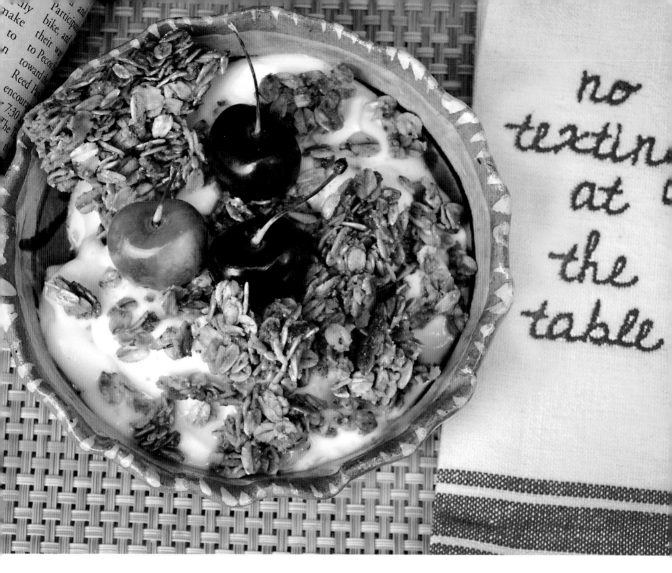

Simple Homemade Granola. *Kristin Schell.*

town weird. I thought of the million reasons I could've shared but just quietly shrugged. Clearly, they ain't from here.

I suppose I should have told my friends that Austin has grown up a lot in the forty years I've known it. The free-loving spirit turned entrepreneurial along the way, making us more dot-com than crunchy. We've stayed true to our musical roots, but hole-in-the-wall stages have morphed into mega musical musts, like SXSW and the ACL Festival. And our hippie health food beginnings paved the way, giving us bragging rights for our internationally acclaimed foodie scene.

Nowadays, Austin is more apt to be called hippie chic than weird. I don't know about you, but I still love a little granola. This recipe is adapted from *Chef Bobo's Good Food Cookbook*.

5 cups old-fashioned rolled oats

½ cup packed brown sugar

1 teaspoon salt

1 teaspoon ground cinnamon

2 tablespoons ground flaxseed

⅓ cup canola oil

¼ cup pure maple syrup

¼ cup honey

1 tablespoon vanilla extract

Preheat oven to 300°F. Line a baking sheet with parchment paper and lightly grease with cooking spray.

In a large bowl, mix oats, sugar, salt, cinnamon and flaxseed. In another bowl, stir together the oil, maple syrup, honey and vanilla. Pour the honey mixture over the oats and stir together until well combined.

Spread the granola mixture evenly onto the prepared pan. Bake for 30 minutes or until edges begin to turn golden brown. Cool completely. Crumble granola into big chunks and small bits. Store in an airtight container for a week. Serves 6–8.

Thyme and Four Cheese Corn Muffins. *Melissa Skorpil.*

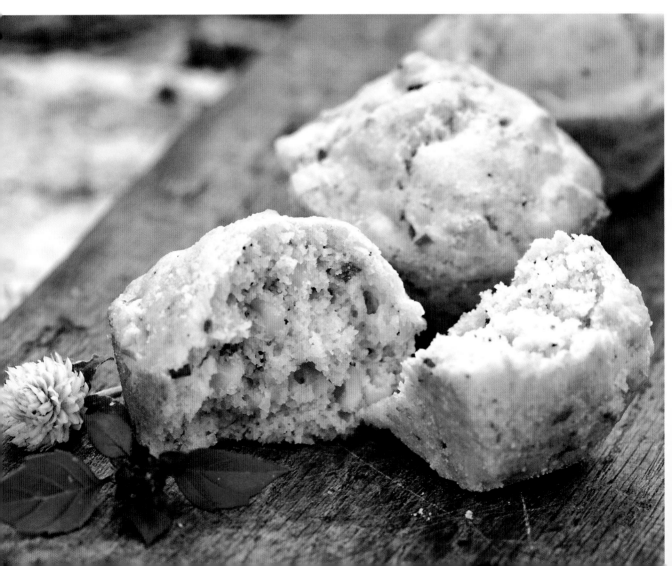

Thyme and Four Cheese Corn Muffins

Rachel Daneman, Dinner with Daneman (dinnerwithdaneman.com)

This recipe was inspired by some corn muffins I sampled at a restaurant called Marquee Grill & Bar in Dallas. I had bought stone-ground cornmeal a while back and had never really found a use for it. It's a very versatile recipe that I first found on a blog called Dreamy Dish. I've added a four-cheese blend and thyme, but you could add whatever cheeses and herbs you'd like.

1 cup all-purpose flour

1 cup coarse or stone-ground yellow cornmeal

¼ cup sugar

1½ teaspoons baking powder

¼ teaspoon baking soda

¼ teaspoon salt

1 cup buttermilk

1 large egg, lightly beaten

¼ cup vegetable oil

2 teaspoons fresh thyme leaves, minced

¼ cup Mexican four-cheese blend, shredded

1 cup fresh or frozen (thawed) corn kernels (optional)

Preheat oven to 375°F. Grease regular or mini-muffin tins with cooking spray or butter. In a large bowl, sift together flour, cornmeal, sugar, baking powder, baking soda and salt. In a medium bowl, whisk together buttermilk, egg and oil. Add the buttermilk mixture into flour mixture and mix with a wooden spoon until combined.

Add the minced thyme and shredded cheese and stir to combine. Stir in corn kernels if using. Fill muffin cups about three-quarters of the way if using standard-sized muffin tins or about a tablespoon in each cup for mini-muffin tins.

Bake in preheated oven for 9–11 minutes, or until the tops are golden and a toothpick inserted comes out clean. Cool on a wire rack. Makes about 48 mini-muffins.

Cinnamon Breakfast Bread

Gemma Matherne, Curious Confections (curiousconfections.com)

The first time I met my future mother-in-law, Pat Matherne, we had traveled to Louisiana to spend Thanksgiving with her. She made a cinnamon and fruit bread as a breakfast option, and I just couldn't get enough of it. At the end of the trip, I had obviously made an impression, as she gifted me with the recipe.

Fast-forward several months later, and I was missing the toasted teacakes of my native England, but I hadn't ever figured out a way to make them myself. Eventually, I realized that their description matched that of this bread, which explained why I loved it so much. I took to tinkering with it (since it was originally for a bread machine) until I had a loaf that I was dying to cut into the moment it came out of the oven.

Now I make it as a breakfast treat as often as I dare. It's just wonderful toasted up with the butter slowly dripping off it, and the lingering aroma tempts you into "just one more slice."

1 cup milk

½ cup water

2 teaspoons active dry yeast

2 cups bread flour

1 cup all-purpose flour

2 tablespoons sugar

1 teaspoon salt

¾ cup dried fruit (I tend to go for cranberries, but raisins, sultanas and currants all work well)

2 teaspoons ground cinnamon

3 tablespoons butter, softened

Gently heat the milk and water to 90°F; it will feel barely cool to the touch if you don't have a thermometer handy. Mix in the yeast and set to the side until it has started to bubble. If after 10 minutes it isn't bubbling, your yeast is dead, and you'll have to start over with some fresh yeast.

In your main bowl, mix together both the flours, sugar and salt. Take a tablespoon of the flour mix and use it to coat the dried fruit; set aside. Add the cinnamon, softened butter and yeast to the flour; stir to bring together.

Start kneading; by hand, this will usually take about 10 minutes on a lightly floured surface, and by stand mixer, usually 5 minutes. Occasionally, differences in flour batches and humidity may require you to add a little more water or flour. You're looking for a moist but not sticky dough.

Just before you've finished kneading the dough, add in the dried fruit and finish kneading so that the fruit is well distributed. Roll the dough into a ball and place into a greased bowl, top with some greased cling wrap and leave alone in a warm place (no more than 100°F) for about an hour or until doubled in size.

Grease your bread loaf tin and have it nearby. Dust your countertop with flour, turn out the dough and gently knock it down. Gently flatten the dough and then roll it so it resembles a log.

Place the dough roll into the loaf pan seam side down, then press on the top to make it as flat as possible—it helps create a more evenly sized loaf. Cover with plastic wrap and leave another hour, until doubled in size. It should rise nicely above the edges of the tin.

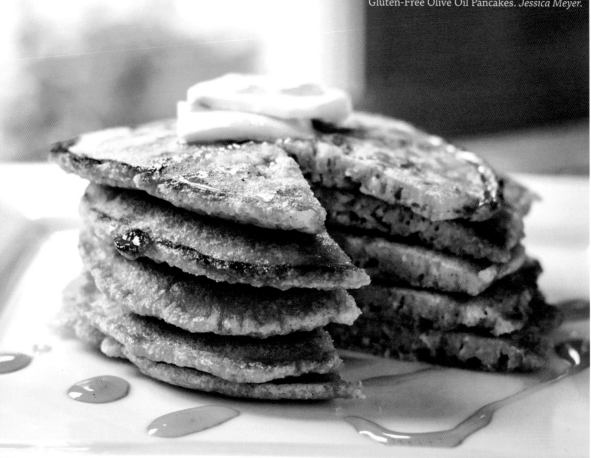

Gluten-Free Olive Oil Pancakes. *Jessica Meyer.*

Preheat oven to 350°F. My old oven takes a good 30 minutes to get to temperature, so I start it halfway through the rise.

Gently remove the plastic wrap from the loaf and place into the center of the oven. Bake for 10 minutes, then turn the oven down to 300°F to finish baking, about 30 minutes. If you have a probe thermometer, the center of the loaf should be about 190°F. You can also tap on the loaf, and it should produce a hollow sound rather than a thump. Remove bread from pan and let cool before storing in an airtight container. Makes 1 loaf.

Gluten-Free Olive Oil Pancakes

Jessica Meyer, ATX Gluten-Free (atxglutenfree.com)

Pancakes have always had a special place in my heart. Growing up, I remember my parents' house would have the sweet aroma of homemade pancakes floating around. My dad used to make them for us every Saturday—a Meyer family tradition. My brother, sister and I would sit around the kitchen table and gobble up one pancake after another. Sometimes, we

would even have a contest to see who could eat the most pancakes. (I don't recommend that now.) It was fun family bonding, and I will always cherish the laughs, full bellies and love that we shared during those times.

Since I've been gluten-free, I have not had a good gluten-free pancake until I perfected this recipe. These pancakes have been my breakfast staple as of late. I love a fluffy, regular pancake. Just ordinary flavors, married with maple syrup and rich butter. These pancakes are particularly special because the fat used is extra virgin olive oil. The olive oil adds a delicate flavor to the pancake. I like to call this my "simple pancake recipe" because it is just that. Simple, flavorful, memorable...just like my dad's pancakes.

4 ounces brown rice flour

3 ounces sweet sorghum flour

1 ounce tapioca starch

1 teaspoon salt

1½ teaspoons baking powder

2 eggs

8 ounces water

¼ cup mild extra virgin olive oil

½ teaspoon vanilla

oil, for cooking

Measure dry ingredients using a kitchen scale, and place all in large bowl. Add salt and baking powder. Whisk to aerate dry ingredients. Add in eggs, water, olive oil and vanilla. Mix until ingredients are combined and smooth. Preheat skillet to medium-high heat. Make sure it is warm before adding oil. Add one tablespoon of cooking oil (or preferred fat) and pour pancake batter onto skillet in small circles. Cook until golden brown on edges; there will be bubbles around the edges. Flip to finish cooking, about 1–2 minutes. Serve warm. Makes 10–12 pancakes.

Challah à la Dana Baruch

Mike Krell, Austin Food Carts (austinfoodcarts.com)

I couldn't resist submitting this recipe for the AFBA cookbook. It's not my recipe, but since my spouse makes the best challah in town, I had to share. This recipe has been adapted over the years (especially thanks to the Texas heat and moisture), and Dana has taught challah-making classes for friends and Jewish organizations in Austin since we moved here eighteen years ago. The recipe is a favorite in our house, and Dana loves to share it with others. Now if only I could actually cut a whole piece for toast in the morning—the "inside" always seems to be missing.

1 cup sugar

2 cups very warm water

2 packages rapid rise yeast (4½ teaspoons)

7–9 cups bread flour

1½ tablespoons kosher salt

2 beaten eggs for the dough, plus 1 beaten egg for the glaze

½ cup vegetable oil

about 1 tablespoon poppy and/or sesame seeds

kosher salt for sprinkling on top

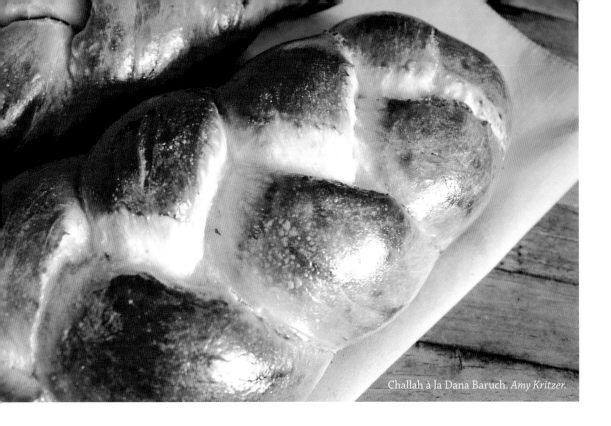

Challah à la Dana Baruch. *Amy Kritzer.*

In a medium bowl, dissolve sugar in warm water, then add 2 packets of yeast. Let mixture sit until ¼ inch of foam forms on top.

Pour into mixer bowl—preferably a stand mixer with dough hook. Add 2 cups of flour and the 1½ tablespoon salt and blend well. Mix in 2 beaten eggs and oil, blending well after each.

Add additional flour until the dough begins to pull away from side of bowl. It should still be sticky. Finish by hand on the counter, adding flour and kneading until the dough is smooth and elastic. It should feel a little bit sticky and tacky but not dry.

Form into a ball, lightly grease and place in a large bowl. Cover with plastic wrap or a towel and let rise in a warmed oven for about 45 minutes, until doubled. Remove from oven and punch down dough. Preheat oven to 350°F.

Divide dough in half for two loaves (or thirds for three loaves) and then divide each one into thirds. You will have six small balls for two loaves and nine small balls for three loaves. Roll out each small ball into a "snake," measuring approximately 15 inches long. Braid into two or three loaves, place on a greased sheet pan and brush with egg. Sprinkle with kosher salt and seeds if desired.

Bake for 30–40 minutes at 350°F (or 28–30 minutes at 335°F in a convection oven). Loaves should have a deep brown crust. Remove loaves and place on rack to cool.

Kolaches with Cream Cheese, Prune and Cherry Filling

Dawn Orsak, Svacina Project (svacinaproject.blogspot.com)

Kolaches are the quintessential Texas-Czech food—at once traditional but also highly adaptable to ingredients and eating habits of modern Texans. This recipe is an adaptation from two wonderful Czech bakers, my grandmother and a second cousin. Both prunes and cream cheese are very traditional fillings, but combining the prunes with cherries and then filling the kolaches with both cream cheese and the fruit has a wider appeal for non-Czechs. They are not difficult to make and so worth the effort. I feel strongly that baking kolaches should not be an art lost to commercial bakeries. I make them when I'm feeling nostalgic about family and also to treat my sons, ingratiate myself with neighbors and impress coworkers. There's no one who doesn't like a warm kolach!

Kolaches with Cream Cheese, Prune and Cherry Filling. *Jane Ko.*

For the dough:

1½ envelopes yeast (scant 3½ teaspoons)

¼ cup warm water

½ cup unsalted butter, softened

½ cup sugar

1 tablespoon salt

1 egg

2 cups milk

6–7 cups all-purpose flour

melted butter for brushing on the kolaches

For the prune and cherry filling:

6 ounces dried, pitted prunes

6 ounces dried, pitted cherries

½ teaspoon cinnamon

½ cup sugar

½ teaspoon grated lemon or orange peel

For the cream cheese filling:

16 ounces cream cheese, softened

2 egg yolks

½–1 cup sugar (to taste)

grated rind of 1 lemon or 2 teaspoons
 lemon juice

1 teaspoon vanilla extract

For the posipka (butter crumbles):

1 cup unsalted butter, melted

2 cups sugar

1 cup all-purpose flour

For the dough, sprinkle the yeast over the warm water in a large bowl and set aside.

In a stand mixer with a paddle, beat the butter, sugar, salt and egg together until fluffy and set aside.

Warm the milk, but it shouldn't be hot. Pour the warm milk over the yeast. Add three cups of flour and beat by hand. Add this flour-yeast mixture to the mixture in the stand mixer bowl and beat until fluffy. Replace the paddle in the stand mixer with the dough hook. Add three more cups of flour gradually until the dough is no longer sticky. You may need to add a bit more, a tablespoon at a time, until the dough no longer sticks to the side of the bowl. Cover the dough with a dish towel and let it rise until it doubles in size.

Make the fillings while the dough rises. Place the prunes in a bowl and cover them with boiling water to rehydrate them. Drain the liquid off and mash the prunes

thoroughly with a fork or run them through a food processor. Add the cherries, cinnamon, sugar and lemon zest. Mix thoroughly.

For the cream cheese filling, beat everything together in a medium bowl. Use a tablespoon to scoop out pieces of dough. Roll into balls and place on greased cookie sheets or hotel pans in rows of 4 by 6. You should have two pans of 24 pieces of dough each. Butter the dough balls and let rise.

Make the posipka while the dough balls rise. In a bowl, combine softened butter, sugar and flour and mix thoroughly with a wooden spoon. Begin to add the melted butter, but only ⅓ to ½ of the cup. Use your fingers to combine the ingredients and crumble into bits by hand. Add more flour if it is too moist. Reserve the rest of the melted butter to brush on the dough before baking.

Once dough has doubled in size, use both index fingers to punch down the center of each ball and create a well big enough to hold a tablespoon of filling. Scoop a ½ tablespoon of each of the prune and cream cheese fillings into each well. After filling, brush the kolaches with butter and then sprinkle posipka on top of each one. Let rise one last time for about 30 minutes.

During the final rise, preheat oven to 350°F. Bake until golden on top (15–22 minutes; just keep checking them). Brush them with butter one last time after removing from the oven.

Kolaches are best the day they're made, but if they linger, you can soften an individual kolach in the microwave before eating for about 10 seconds. Makes 24 kolaches.

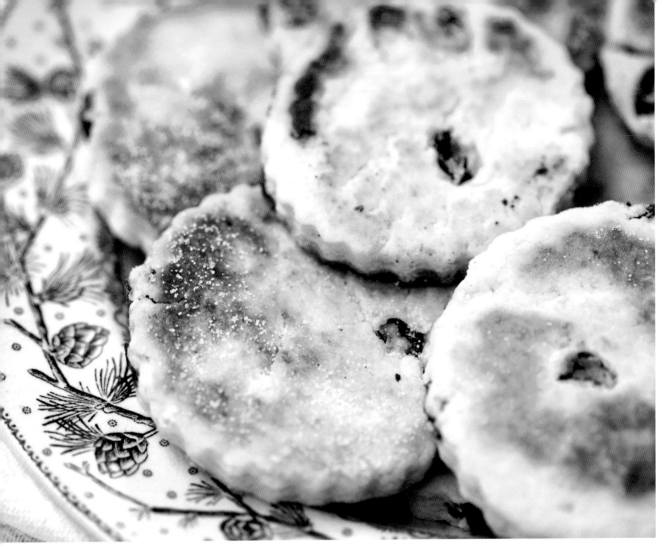

Welsh Cakes. *Melissa Skorpil.*

Welsh Cakes

Gemma Matherne, Curious Confections (curiousconfections.com)

As miners headed down into the Welsh coal mines, these little griddlecakes fit perfectly into their pockets—little presents from loving mothers or wives. Similar to scones, the Welsh enjoy them as an accompaniment to their morning cups of tea or coffee.

I spent two years working in a restaurant in Wales, and every single morning, we would start our day with a cup of tea, a Welsh cake and a good gossip. I prefer them served with butter, but split in half and filled with jam is just as traditional.

3⅔ cups all-purpose flour

2 teaspoons baking powder

pinch salt

7 tablespoons shortening

7 tablespoons butter

⅔ cup sugar

⅔ cup raisins

1 egg

1½ tablespoons milk

butter for greasing

sugar for sprinkling

Sift the flour, baking powder and salt in a large bowl. Cut in the shortening and butter until the mixture resembles breadcrumbs. Add the sugar and raisins and mix to combine.

In a small bowl, beat the egg and milk together and then add to the mixture. Bring it together until a soft dough is formed.

Roll out the dough onto a floured surface to ¼ an inch thick. It's very important to have them as consistent as possible so they cook at the same rate. Cut them out with a 2½-inch round cutter. I like the fluted-edge cutters just to look a tiny bit fancier.

Warm up your griddle (a heavy-bottomed frying pan works perfectly as an alternative) to a medium heat and lightly grease with butter.

Turn the heat to low and cook a few at a time to a deep golden color. Then flip and cook the other side. It is important to make sure that the outside doesn't get golden before the center is cooked through. When both sides are cooked, transfer to a cooling rack and sprinkle both sides with sugar while still warm. Makes 24 cakes.

Sweet Baked Phyllo with Cheese (Knafeh)

Sahar Arafat-Roy, TartQueen's Kitchen (tartqueenskitchen.com)

The origins of the dish are in my father's hometown of Nablus, which is just north of Jerusalem. In fact, it is known throughout the Arab world that the best knafeh comes from there. This is a classic way to make knafeh: two layers of shredded phyllo dough (kataifi) with farmer's cheese (Jebne Nabulsi) sandwiched in between. You then bake the dough, soak it with syrup flavored with orange or rose water and then garnish it with pistachios. To watch the men in the stalls in Nablus or Amman, where there is a large Palestinian population, making knafeh (and only knafeh) is like watching fine art being created.

There are variations made in Jerusalem (made into a roll) and in Turkey (where it is served on bread and sprinkled with sesame seeds).

The traditional cheese used in knafeh is called "Jebne Nabulsi," or Nablus cheese. It can be found in Middle Eastern markets. Because the cheese shipped here is soaked in brine, it must be boiled first before it can be used in any dessert.

The dough is essentially a shredded phyllo dough (kataifi). It's better to buy it already shredded than try to shred the whole phyllo sheets yourself. It'll almost always be in the freezer case.

Qatr (simple syrup):

2 cups sugar

1½ cups water

1 teaspoon lemon juice

1 tablespoon orange or rose water (optional)

Knafeh:

1 pound knafeh (kataifi) dough, thawed

2 pounds farmer's cheese (Jebne Nabulsi), or
 fresh mozzarella

¼ cup sugar

1¼ cups clarified butter

1 teaspoon knafeh coloring (optional)

¼ cup chopped pistachios (optional)

Make the qatr. In a medium saucepan over medium heat, mix together the sugar and water until the sugar is dissolved. Bring to a boil. Let the syrup boil for 3 minutes. Add the lemon juice and boil for 2 more minutes. Remove the saucepan from the heat and stir in the orange blossom or rose water, if using. Set aside and let cool.

Make the knafeh: If using the *farmer's cheese*, you will need to soak and cook the cheese to remove the salt. To do this, thinly slice the cheese (almost to the point of shaving it) and place in a large bowl. Cover the cheese with water and let soak for two hours, changing the water every 30 minutes. Drain the cheese and place in a large saucepan. Cover again with water. Bring the water to a simmer (do not let it boil) and cook the cheese for 10 minutes. Drain. Repeat the process at least two more times. Taste the cheese. It should be salt-free. If not, repeat the process until it is. If using the *fresh mozzarella*, slice the cheese thinly. Taste. If there is a salty taste, soak the cheese in water for about 30 minutes to 1 hour. Drain and taste again. Soak again if needed. Drain the cheese on paper towels to remove some of the excess moisture. Toss the cheese with the ¼ cup sugar and set aside.

Take the knafeh dough and chop it up into approximately 1-inch pieces. Have 1 cup of the clarified butter heating in a large saucepan over medium heat. Add the dough. Stir and cook the dough until it has absorbed the butter. Remove the saucepan from the heat and let sit until cool enough to handle.

Preheat the oven to 400°F. Prepare your two baking sheets. (I like to line mine with foil.) Spray the foil with nonstick spray. Mix the remaining butter with the knafeh coloring (if using). Pour the butter over the bottom of the sheet and spread evenly.

Take half of the dough and spread it as evenly as possible over the bottom of the baking sheet. Spread the cheese over the top in an even layer. Top the cheese with the remaining dough.

Place in the lower third of the oven and bake for 30 minutes. After the first 30 minutes, remove the knafeh from the oven, place the second sheet over the top and carefully flip the knafeh. Remove the top baking sheet and place the knafeh back into the oven, now bottom side up, for another 10 minutes.

Once the knafeh is done, take out of the oven and set the baking sheet on a rack. Pour the qatr over the knafeh. Top with the pistachios. Let cool slightly before eating. Serves 10–12.

Drinks

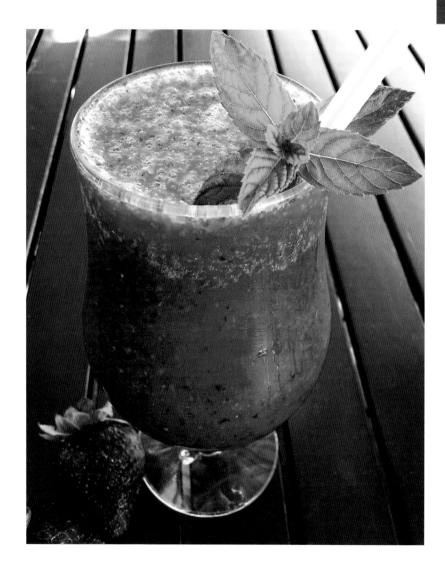

Mango Lassi

Shefaly Ravula, Shef's Kitchen
(shefskitchen.wordpress.com)

Mango Lassi. *Shefaly Ravula.*

Dripping with bright orange nectar, the mangos best suited for lassi (a refreshing dairy beverage from the Indian subcontinent) are the Kent or Alphonso varieties, both of which are difficult to procure in a regular supermarket. Try an Indian store, but if that's not an option, use overripe Ataulfo or other regular supermarket mangos at the height of their season. I'm not opposed to canned mango pulp as well, as long as it's 100 percent all-natural mango pulp. Mango juices tend to be diluted and/or combined with extra sugar. All Indians know that a real mango needs no extra sugar!

This recipe came about from the idea to make mango lassi slightly healthier, or at least to have the option to do so. The topping is just an extra touch and is completely optional.

For the lassi:
1 cup peeled and chopped mango
½ cup homemade yogurt, any plain yogurt or
 Greek-style plain yogurt
1 cup milk, 1 or 2 percent
pinch of salt
2 teaspoons granulated sugar, plus more to
 taste
handful ice

For the topping:
2 tablespoons chopped pistachios, raw and
 unsalted

2 pinches of saffron threads (optional)
seeds from 2–3 green cardamom pods (or ¼
 teaspoon ground cardamom)
1 teaspoon granulated sugar
lightly sweetened whipped cream (optional)

Place lassi ingredients in a blender and blend until frothy and all chunky fruit and ice pieces are puréed. Taste for sugar and add more if desired. Pour into clear, tall glasses. The consistency should be slightly thinner than an American milkshake: pourable and drinkable but thick. Note that if you use Greek yogurt, you may want to add a little extra milk or water (start with 1–2 tablespoons) to get the desired consistency. Set the lassi drinks aside.

Add a dollop of whipped cream to the lassi, if using. With a mortar and pestle, a miniature food processor or a chef's knife, crush the ingredients for the toppings to a coarse consistency. Sprinkle on top of the lassi. Serves 2.

Melissa Skorpil.

Cocktails

Chris Perez, Metropochris (metropochris.com)

There are many differing stories on the origin of the cocktail. The one I like the most is that of innkeeper Betsy Flanagan. On a particular evening in the middle of the American Revolution, she found her inn filled with soldiers serving George Washington, then a general. To feed the hungry troops, she de-feathered and roasted several whole chickens. She then mixed up a combination of rum, rye and apple juice for drinks, adorning each glass with a tail feather from the chickens. The meal and libations bolstered spirits, leading one officer to shout, "More cocktail!" The rest of the troops joined in the officer's accord, the drinks kept flowing throughout the night and a legend was born.

I enjoy that story because it speaks to the essence of what a cocktail is. A cocktail signifies a celebratory occasion, an official "night out." It symbolizes generosity from the host and embodies the American spirit to enjoy and savor life.

Just as chefs are introducing new levels of creativity into the restaurant scene, bartenders are elevating themselves into mixologists, crafting drinks with handmade ingredients and intriguing infusions. I don't think it's a coincidence that the best restaurants in Austin—including La Condesa, Contigo and Bar Congress—are also those that offer the most outstanding cocktails. The city's best-known bartenders—including Bill Norris at the Alamo Drafthouse; Nate Wales at La Condesa; Bar Congress's Jason Stevens; and Josh Loving, who is behind the stick at several local watering holes of note, including Weather Up and Midnight Cowboy—do more than complement a meal. They set the mood for the entire dining experience. And if you've already eaten, the cocktails are the stars of the show.

In the following pages, you'll find a variety of cocktail recipes you can make at home, whether you're looking to simply unwind on a Friday afternoon or wanting something to serve your guests at a dinner party. Use them to create an atmosphere for celebration, define the mood of your event and toast to life. Cheers!

Arugula, Ginger Beer and Tito's Vodka

Natalie Paramore, Food Fetish (natalieparamore.com)

This cocktail was inspired by the ever popular Moscow Mule. I love crisp and refreshing cocktails that are not too sweet, and I enjoy the tickle that the ginger beer gives on the back of my throat. I added the club soda for a little extra fizz. Top it off with some fresh lemon juice, and you've got yourself quite the crisp cocktail.

4 ounces ginger beer

1 ounce vodka, preferably Tito's

2 leaves fresh arugula

1 ounce club soda

½ small lemon, seeds removed

lemon slice for garnish

Pour ginger beer into a martini shaker with crushed ice. Add vodka and shake. Pour into a serving glass. Lightly muddle the arugula into the drink; do not completely crush the leaves. Add club soda and squeeze in fresh lemon juice. Stir all together and serve. Garnish with lemon. Serves 1.

Caliente Mexican Martini

Chris Perez, Metropochris (metropochris.com)

If you're from Austin or have visited someone from there, chances are you've had a Mexican Martini. It's the unofficial drink of the city, complete with a controversy on who made it first (the Cedar Door or Trudy's?). Regardless of who made it, the drink is damn good—combining the citrus drinkability of a margarita with the briny goodness of a dirty martini.

The Mexican Martini is legendary to me, and I knew when I made my own version that it would have to be done right and with some personal flair. So, I invited over my friend Tolly Moseley, who is the blogger behind Austin Eavesdropper (austineavesdropper.com), and we set out to make a spicy version of the "Austin Cocktail."

coarse salt for rim

6 jalapeño slices

20 whole black peppercorns

3 ounces silver tequila (we used Sauza Hornitos)

2 ounces Gran Marnier

1½ ounces fresh-squeezed lime juice

2 ounces orange juice

1 ounce olive juice

olives, for garnish

Rinse two martini glasses in cold water, rim the glass with lime juice and then dip the rim in coarse salt. Place the glasses in the freezer to chill as you make the cocktail.

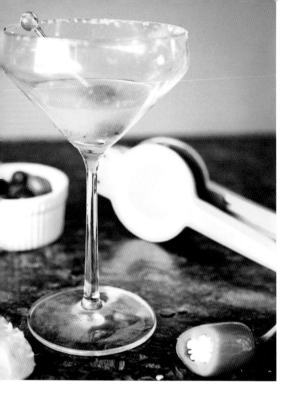

Caliente Mexican Martini. *Chris Perez.*

Place the jalapeño slices and peppercorns in the bottom of a cocktail shaker and muddle. Make sure you grind and "pop" all of the peppercorns. Add the tequila, Gran Marnier, lime and orange juices. Fill shaker with ice, top with the other end and shake until ice cold. Remove martini glasses from freezer and strain the drink mixture into each glass. Top each with a splash of olive juice. Garnish with an olive. Makes 2 cocktails.

White Port Rocca

Laura McCarley, Way Out West Austin (wayoutwestaustin.com)

Muscat Canelli is an up-and-coming varietal in the Texas wine industry. The grapes, originally from Italy, thrive in our sometimes harsh climate, producing a fruity, citrusy wine. I first had this White Port Rocca at a party at William Chris Vineyards in Hye, near Johnson City. The people at William Chris take their winemaking seriously, but not themselves, and they came up with this fun summer sipper.

375 ml (½ bottle) Texas Muscat Canelli wine (Chardonnay, Viognier and Pinot Blanc
 are fine substitutes)
½ liter tonic water
3 lemons
1 bunch mint leaves, roughly torn
at least 2 cups ice

Pour wine and tonic into a 2-liter pitcher. Squeeze two lemons into pitcher, carefully straining out the seeds. Slice the other lemon into rounds and add to pitcher. Add mint and ice and stir. Serves 6–8.

Hibiscus Mint Sun Tea Cocktail

Katie Inglis, Liberty and Lunch
(libertyandlunch.com)

My mom always made sun tea in the summer when I was a kid. I never made my own until she gifted me with a bag of organic dried hibiscus flowers from her adventures in Mexico. So, on the first hot summer day in Austin, I taught myself how to make sun tea from the flowers. Because it's not "sun tea" without actual tea, I added some dried black tea that I've always liked and a bunch of the mint that was swiftly taking over a corner of my garden. After a day in the full sun, the tea brews into a beautiful red-orange infusion of flavors. Not too sour or acidic, nor too minty, this tea is flavorful and incredibly refreshing. It's so refreshing that, after enjoying an extra-cold glass, I also created a cocktail out of it! A little local vodka, lemon, honey and a sprig of mint, and the sun tea is transformed into a light and bright cocktail.

For the tea:
½ cup dried hibiscus flowers
¼ cup Assam black tea leaves
6 large sprigs of fresh mint
3 quarts filtered water

For the cocktail:
2 ounces Hibiscus Mint Sun Tea
1 ounce vodka, preferably Tito's

Hibiscus Mint Sun Tea. *Kate Inglis.*

½ teaspoon local honey
juice of ¼ lemon
sprig of mint and lemon wedge for garnish

To make sun tea, combine the hibiscus flowers, dried tea leaves, mint and filtered water in a gallon jar. Cover and place the jar outside in the sun on the morning of a hot day. By sunset, your sun tea will be brewed perfectly and ready to drink. Enjoy the tea strained, over ice, with a sprig of fresh mint and a straw. Makes 3 quarts tea.

To turn your tea into a cocktail, place large ice cubes into a cocktail shaker and add tea, vodka, honey and lemon juice. Shake well to dissolve the honey, then pour into a highball glass over more ice. Add a lemon wedge and sprig of mint for a garnish and enjoy! Makes 1 cocktail.

Lemon Syrup

Kate Payne, Hip Girl's Guide to Homemaking (hipgirlshome.com)

I came up with this recipe for a summer beverages class I taught in Los Angeles. It was May, and everywhere I looked, lemons were hanging from trees. Back home in Austin, we are lucky to have a winter filled with citrus, including Meyer lemons, my favorite to use in this recipe. It's kid-friendly to use in a homemade, local organic soda, and cocktail-friendly for adults (just add bubbly or liquor). You could even use it in combination with an infused vinegar (try peach or blackberry) to sweeten a shrub, an old-fashioned vinegar-based drink.

1 cup sugar

4 large or 5 medium lemons, juiced and
 strained (to yield 1 cup juice)

zest of one lemon, reserved in a small bowl

6 allspice berries

In a small saucepan over low heat, dissolve sugar in ¼ cup water. Bring to a boil where bubbles are about the size of a dime and then remove from heat. Add lemon juice to the sugar syrup and bring it back to a boil. Remove from heat and let cool. Pour into a pint jar to allow to cool on the countertop.

Once jar has cooled considerably (warm is okay, but not piping hot), add lemon zest and allspice berries. Cap jar and allow it to infuse in the fridge overnight or for up to 3 days. Strain syrup and enjoy in a soda, cocktail or added to a shrub infusion. Keeps in the refrigerator for up to 2 weeks. Makes 1 pint.

Manipulating Light: Five Tips for Better Food Photography

Mary Helen Leonard, Mary Makes Dinner (marymakesdinner.typepad.com)

The famous French photographer Henri Cartier-Bresson said, "Your first ten thousand photographs are your worst." For me, that figure could probably be bumped up to ten million. As a tender-footed tot, I started shooting with a vintage Fisher-Price. My favorite make-believe camera was later replaced by the real thing: a snazzy plastic rectangle with 110 film. By the time I reached drinking age, I had become a full-blown Polaroid addict, flashing bulbs with reckless abandon. My early work was nothing if not abundant. Later, when I started using a manual camera, taking pictures of still products and raw ingredients professionally, it was like starting from scratch. My meter reset, and one by one, I began shooting another ten thousand bad photos.

After working as a professional blogger and product photographer for the past five years, I'm starting to finally feel confident about my art. The best advice I can give to someone who is just starting out, or hoping to bump up their game, is to simply keep taking photos. Every bad photo brings you a step closer to a good one. After the first ten thousand are out of the way, you are bound to improve.

The second best piece of advice I can offer is to get to know light. Light is the essential element in the mechanics of photography; it plays a major role in your ability to sculpt each and every image you take. Here are a few tips to help you manage the light so you can take better pictures:

Mary Helen Leonard.

Light: Start with the best-quality light available. Natural light is ideal, but you can still produce beautiful photos in synthetic light.

Balance: If your camera has a white balance setting, start by making sure it's on the right setting for the light in which you are working. White balance has a dramatic effect on the colors and tone of your photos.

Softness: If you are working in bright sunlight or under harsh bulbs, it can be helpful to diffuse the light before taking photos. Place a sheet of sheer white paper or fabric between your light source and your dish. This will soften the light, giving your photo a more beautiful appearance.

Bounce: You can create or disperse shadows by bouncing light off reflective surfaces. Try using a piece of white foam board or a sheet of foil to enhance the light around your dish.

Frame: Another way to control the light and reflections in your photo is to try approaching it from different directions. Move closer, move away and move around your subject to find a sweet spot.

And keep snapping away!

Italian Grapefruit Cocktail with a Texas Twist

Lindsay Robison, Apron Adventures (apronadventures.blogspot.com)

Italian Grapefruit Cocktail with a Texas Twist.
Melissa Skorpil.

Growing up, grapefruit was a super-bitter, light-pink fruit that my mom ate every morning, and I just couldn't figure out why. As an adult, I finally tried one of the grapefruits from south Texas that are bright red and super sweet, and my mind was made up—I love grapefruit! My favorite way to enjoy them has been in cocktails, whether in an old-school Salty Dog (with gin) or classed-up a bit like in this cocktail. I've also always loved how the addition of a fresh herb to a simple syrup makes all the difference. I've used basil here, but you could easily swap in rosemary or mint.

For the basil simple syrup:

2 cups water

2 cups sugar

1 bunch basil

For the cocktail:

3 Rio Star grapefruits

2 cups Champagne or Italian sparkling water

First, make the basil simple syrup. Combine the water and sugar in a medium saucepan and simmer until sugar evaporates. Stir in basil and simmer 5 minutes. Strain out the basil leaves and place in refrigerator to chill thoroughly.

When you're ready to make the drinks, juice the grapefruit so you have about 2 cups. Add grapefruit juice to a pitcher and mix in 1 cup basil simple syrup and the Champagne or Italian sparkling water. Taste and add additional simple syrup to match your preference. To serve, pour over ice into glasses. Makes 4 cocktails.

Spring Tonic

Katie Inglis, Liberty and Lunch
(libertyandlunch.com)

The Spring Tonic is a nod to the classic
summertime gin and tonic, made a bit
more interesting and lighter in flavor with
the addition of Texas grapefruit, mint and
cucumber. Using the local Waterloo Gin in
favor of a more traditional London dry gin
lends a brighter floral flavor to the cocktail.

5 thin slices cucumber

1–2 sprigs fresh mint, plus additional for
 garnish

¼ teaspoon sugar

1–2 grapefruit segments, skin and seeds
 removed

2 ounces gin, preferably Waterloo Texas Gin

1 ounce tonic water

ice

In a lowball or rocks glass, muddle cucumber,
mint and sugar. Add four large ice cubes,
grapefruit and gin, and stir. Top off with a
splash of tonic, a sprig of mint and a stir stick.
Makes 1 cocktail.

Spring Tonic. *Melissa Skorpil.*

Strawberry Mo-Daiquiri

Elizabeth Van Huffel, Local Savour
(localsavour.com)

I am not one to drink many foo-foo cocktails, but the Local Savour Blogoversary called for a celebration. Sweet Texas strawberries were exceptionally ripe, so a Local Savour Mo-Daiquiri was born. Mojito meets daiquiri in this tasty, frozen adult beverage that uses heavenly local strawberries and fresh mint and basil from the garden. Dripping Springs Vodka is my local go-to spirit for this drink.

1 pound fresh strawberries, washed, hulled and chopped

2 cups ice

¾ cup vodka (more if you prefer a stronger drink)

¼ cup roughly chopped fresh basil leaves

¼ cup roughly chopped fresh mint leaves

¼ cup water

1 heaping tablespoon organic sugar

juice of 1 medium lime

Place all ingredients into a blender and blend on high speed for 1–1½ minutes. Serve right away in chilled glasses and garnish with a few mint sprigs. Serves 2–4.

Strawberry Mo-Daiquiri. *Elizabeth Van Huffel.*

Avocado Margarita

Chris Perez, Metropochris (metropochris.com)

The food scene in Austin may be the best in Texas. The owners behind the restaurants are passionate about what they do, and the adventurous diners are enthusiastic about new tastes and experiences. A famous concoction you may have heard about is the Avocado Margarita at Curra's Grill.

I must admit, I myself was even a little reluctant to try it as it sounded like the equivalent of drinking a bowl of guacamole. But once I took a sip, I realized how wrong I was. The drink was simply amazing—smooth and savory from the avocado, with bite and punch from the lime and tequila. When I can't go to Curra's, I whip up this version at the home for myself and a few friends. It's weird, it's Austin and it's always a hit.

Avocado Margarita. *Chris Perez.*

4 limes
2 large avocados (about 1 pound)
6 ounces silver tequila
4 ounces triple sec
⅓ cup sugar, plus additional for rimming
 glasses
ice

Rinse serving glasses under cold water and rim with some sugar. Place the glasses in freezer to chill while you make the drink.

Juice limes over a mesh strainer directly into a blender; you should have about 4 ounces total. Cut and pit avocados and scoop out the flesh with a spoon. Place avocado flesh in blender with the lime juice.

Add tequila, triple sec and sugar to the blender, then fill with ice. Blend at high setting until desired consistency is achieved. Serve avocado margarita into chilled glasses. Makes about 4 cocktails.

Coffee Liqueur

Christy Horton, Epicuriosities (epicuriosities.com)

Long before the Dude abided, I was a fan of the White Russian. It was my first legal drink in a bar. Tastes kind of like Nesquik with a kick! The key ingredient in a good White Russian is a quality coffee liqueur. The name-brand ones can be kind of pricey, and it is so easy to make your own. You can substitute your favorite strongly brewed coffee or espresso for the water, omitting the instant stuff. My favorite vanilla is Danncy Mexican vanilla, but you can use your favorite or even split a whole vanilla bean and let that steep in the liqueur.

4 cups water

⅓ cup instant coffee grounds

2 cups brown sugar

dash of salt

3 cups vodka

2 tablespoons pure vanilla extract

Combine water, instant coffee, brown sugar and salt in a large stockpot. Bring to a rolling boil over high heat. Turn heat off and let mixture cool to room temperature. If you add the vodka before the coffee syrup is cool enough, the vodka will evaporate, so it is important to let it cool. Stir in vodka and vanilla and pour into a sealable jar or bottle. Makes about 4 cups.

Melissa Skorpil.

Two Wines We Can't Live Without

Lindsay Bailey, The Hobbyists (thehobbyists.ca)

The Hobbyists—a group food blog between friends who now live in Austin and Vancouver—wouldn't exist without the shared love of enjoying great food and stunning wines among friends at the end of a long week. When living together in Vancouver, we started a blog to keep track of all of our "hobbying"—including finding a red and a

white wine that will pair with just about any appetizers and spreads that we would set out on the fly during one of our get-togethers.

First, the food: homemade pickles, confit, antipasti and various sauces from The Hobbyists' pantry are the perfect complement to just about any combination of cheese, charcuterie and, if you're lucky enough to live close to the Pacific, gravlax made with fresh local salmon.

A good Pinot Noir always has a place in our Friday evening hobbying. Recently, we have particularly been enjoying Pinots from the Santa Rita Hills in California. Most Santa Rita Hills producers will give you a Pinot with velvety, silky tannins with strong red cherries and raspberries, with occasional black cherry flavors coming through and which will have an elegant balance and finish. We love to pair a wine like this with some preparation of duck or chicken and our homemade HP sauce, a sweet Commonwealth favorite in the same family as ketchup or steak sauce.

Viognier, a white wine with a very aromatic, floral nose that belies its fresh, crisp structure, can handle strong, spicy flavors and is naturally paired with a comte, gruyère or fresh chèvre cheese. The light citrus balances salty, house-cured gravlax or a bold, spicy confit, served with grilled bread. While traditionally you would see us leaning toward the French stalwarts, Texas wineries are really starting to make some nice Viognier, a varietal that grows well in the heat.

Appetizers

Gravlax. *Margaret Christine Perkins.*

Gravlax

Lindsay Bailey and Lauren Macaulay, The Hobbyists (thehobbyists.ca)

Since moving to Austin from the west coast of British Columbia, I had really missed having a steady supply of my dad's smoked salmon. Although I had been learning his recipe over the years, I was too busy enjoying the great, new variety of produce in the Austin area to buy a home smoker. So, learning how to make a home-cured gravlax seemed like the natural course to a revival of this staple in Austin.

For a great recipe to learn from, we turned to The Hobbyists' favorite chef and close friend, Sandi Irving, who is the executive chef of Nimmo Bay Wilderness Lodge with previously held positions at both the world-renowned Sooke Harbour House and Camille's in the Victoria area. Over a great visit back to Vancouver, she taught us this recipe, which she had learned from an older Swedish gentleman while working on the west coast over the years.

It is a traditional Swedish recipe that can be adapted by adding any fresh herbs that you like—parsley, chives or basil—or a few fresh chiles to spice it up.

4 tablespoons coarse sea salt

4 tablespoons sugar

1 lemon

1 lime

1 orange

1⅓-pound filet fresh wild salmon

¼ cup roughly chopped fresh dill

Combine the sea salt and sugar together. Zest the lemon, lime and orange using a handheld zester. Cut the filet into two pieces. It will work best if the two pieces are the same size.

Lay one piece of salmon down in a glass casserole dish. Cover the salmon with half the sea salt and sugar mixture. Also cover it with half of the citrus zest and dill. Cover the other piece of salmon with the sugar and salt mixture. Place the remaining zest and dill on the first piece. Place the second piece on the first piece to sandwich them together. Cover the casserole with plastic wrap or the casserole dish lid and store in the fridge overnight.

The mixture will cook the salmon, and as it does so, the salmon will throw off a lot of liquid. The next day, remove both pieces of salmon from the dish and drag each piece, flesh side down, through the liquid. Sandwich the filets together again (fleshy parts toward each other). Repeat this twice each day. Flip the sandwich stack so that each filet gets equal time sitting in the liquid mixture. If the fish looks like it has thrown off too much liquid and may be overcooking the piece on the bottom of the filet sandwich, pour some of the liquid off so that it does not overcook the fish. Keep them covered in the fridge for 48 hours.

After 48 hours, the salmon will look very bright and colored. Taste the brine to determine the flavor and confirm whether to leave to sit in the brine further. Since the salmon will still be quite moist, place the two pieces on a drying rack in a large pan in the fridge in order to dry out them out.

The gravlax can be sliced quite thinly and served with the zest as the garnish for its first serving. You may serve it with rye bread or crackers, cream cheese and capers, on salad, on eggs benedict in lieu of ham or just on its own. The gravlax can keep for up to five days in the fridge.

This recipe can be increased as large as you would like depending on what is available fresh in the markets. If whole salmon are on special, you can cut the salmon in half, debone it and follow the instructions above to prepare the gravlax. Serves 8–10.

Bora Bora Fireballs

Melissa Joulwan, The Clothes Make the Girl (theclothesmakethegirl.com)

These meatballs came to me in a dream. I woke up with tumbling thoughts about a lush combination of pineapple, succulent pork and creamy-sweet coconut. I was haunted by images of Tikis and luaus. The only way to clear my mind was to surrender to the kitchen gods. After three attempts, something still wasn't quite right. Later, I landed on the fiery name while lost in photos of tropical beaches and coral reefs, and the rest of the recipe fell into place. These taste even better the second day, so you will be rewarded if you can endure the wait.

1½ cups shredded coconut

½ teaspoon plus ½ teaspoon salt

¾ teaspoon plus 1 teaspoon ground cayenne pepper

1 can crushed pineapple, sugar-free, packed in its own juice

2 tablespoons coconut aminos

1½ teaspoons dried ginger

3 cloves garlic, minced (about 1 tablespoon)

3–4 scallions, white and green, very thinly sliced (about ¼ cup)

½ fresh jalapeño, seeds and ribs removed, finely minced (about 2 teaspoons)

2 large eggs, lightly beaten

2 pounds ground pork

Preheat the oven to 375°F. Cover a large baking sheet with parchment paper or aluminum foil. Heat a large nonstick skillet over medium-high heat and then add the coconut. Toast, stirring often with a wooden spoon, until golden brown, about 3 minutes. Remove from the heat and sprinkle with ½ teaspoon salt and ¾ teaspoon cayenne pepper. Set aside to cool.

Drain the can of pineapple in a sieve placed over a bowl to catch the juice. You're going to use the juice later, so save it! Press the pineapple pulp against the sieve with a wooden spoon to extract the excess moisture. Place 1 cup of the drained pineapple in a large mixing bowl and save any leftover pineapple for dessert later.

To the pineapple, add ½ teaspoon salt, 1 teaspoon cayenne, coconut aminos, ginger, garlic, scallions, jalapeño and eggs. Beat with a wooden spoon until combined. With your hands, crumble the pork into the bowl and knead until all of the ingredients are incorporated.

Bora Bora Fireballs. *David Humphreys.*

Arrange the bowls of pineapple juice, spiced coconut and seasoned pork for easy access. Measure a level tablespoon of pork to make a meatball. Lightly douse it in the pineapple juice, then roll it in the coconut, pressing the coconut shreds into the meat by lightly rolling the ball between your palms. This is a rare case in which more isn't better—don't go too cuckoo with the coconut. Line up the meatballs on the prepared baking sheet, about ½ inch apart.

Slide the meatballs into the oven and bake for 25–30 minutes, or until sizzling and golden brown. Serves 6–8.

Smoked Salmon Hush Puppies with Green Peppercorn Tartar Sauce

Derrick Stromberg, Fork and Spoon (forkandspoon.typepad.com)

Restaurants are some of my favorite sources of inspiration for recipes at home. Last year, Second Bar & Kitchen tweeted a photo of one of its new menu items: smoked salmon hush puppies and preserved lemon with green peppercorn tartar sauce. Though its intention was most likely for me to come to the restaurant and buy the dish, I had a batch of preserved lemon in my fridge that had just finished curing, and I wanted to put them to use. After a brief trip to the market to pick up a few ingredients, I was back in the kitchen in no time.

The preserved lemon brings a nice tartness to the hush puppies and is a natural pairing with smoked salmon. The tartar sauce was great for dipping, and I used the leftover sauce for a fried cod sandwich. The green peppercorns, which you can find packed in water next to the capers at the grocery store, gave a nice subtle crunch to the sandwich, as well as a nice peppery punch, without being overpowering.

1 package (2¼ teaspoons) active dry yeast

¼ cup warm water (~110°F)

1 teaspoon sugar

¾ cup whole milk, warmed (~110°F)

1 large egg, beaten

2 tablespoons olive oil

¾ cup diced smoked salmon (about 6–7 ounces)

¼ cup minced chives

1 tablespoon minced preserved lemon, zest only, flesh and pith removed

¼ teaspoon cayenne pepper

1¼ cups all-purpose flour, sifted

¾ teaspoon salt

½ cup cornmeal

canola oil for deep frying

salt and freshly ground black pepper

1 lemon, cut into wedges

Dissolve the yeast and sugar in the warm water in a bowl and let stand at room temperature for 10 minutes. The resulting mixture should be extremely foamy. If it is not, your yeast is likely dead, and you should purchase new yeast. Whisk in the milk, egg and olive oil. Stir in the smoked salmon, chives, preserved lemon and cayenne pepper. In a separate bowl, mix together the flour, salt and cornmeal. Add the wet ingredients to the flour mixture. Fold gently just until the mixture comes together; do not overmix. Let the batter rise at room temperature for at least 30 minutes.

In a Dutch oven or other large, deep pot, add enough canola oil so it has a depth of 2–3 inches. The oil should not fill more than one-third of the pot. Heat the oil until a deep-fry thermometer reads between 365°F and 375°F. Adjust the heat throughout the cooking process to ensure a constant temperature.

Working gently so as to not deflate the batter, drop tablespoons of the batter into the oil and fry until golden brown and crispy, about 2–3 minutes. Fry in batches of about 6–10, depending on the size of your pot. Turn the hush puppies as necessary to ensure even browning. When they are done, remove the hush puppies from the oil and drain on paper towels. Season with salt and pepper as soon as the hush puppies are removed from the oil.

Serve the hush puppies immediately with the green peppercorn tartar sauce and lemon wedges.

For the tartar sauce:

1 cup mayo

3 tablespoons minced green peppercorns

½ cup minced cornichons

juice of ½ lemon

½ teaspoon shichimi togarashi (a Japanese chile mixture available at Asian stores; can substitute other ground pepper, such as cayenne, or red pepper flakes)

salt and freshly cracked green peppercorns, to taste

Combine all ingredients in a bowl. Stir to combine and season to taste. Serve the hush puppies with a dollop of tartar sauce and more to taste.

Phyllo Cheese Triangles (Tiropites)

Tracy Blair-Nicolaou, The Bee Cave Kitchen (beecavekitchen.blogspot.com)

I am fortunate to have married into a Greek American family and have learned some fantastic recipes from my mother-in-law. My all-time favorite is her recipe for tiropites. These buttery phyllo triangles filled with delicious, creamy cheese have become a favorite of family and friends. My husband added a "Texas twist" to them by adding cream cheese to his mother's recipe, which makes them truly divine. Because it can take a long time to fill all those triangles, this dish is perfect for large gatherings, where guests can help roll the triangles.

6 eggs

1 large white onion

1 bunch green onions, ends trimmed

1 bunch Italian parsley (about 1½ cups loosely packed)

16 ounces cottage cheese

12 ounces crumbled feta

8 ounces whipped cream cheese

salt and pepper to taste

4 packs phyllo dough, thawed

4 sticks of clarified, melted, unsalted butter, kept warm in a double boiler

In a food processor, combine eggs, white and green onions and parsley; blend until finely minced. In a large bowl set into an ice-filled bowl, combine cottage cheese, feta and

Phyllo Cheese Triangles. *Margaret Christine Perkins.*

whipped cream cheese and crack some fresh pepper and salt to taste.

On a clean work surface, unroll phyllo dough and cut stack into 3-inch strips. Place a slightly damp towel on the remainder of the phyllo pack to keep it from drying out.

Place a strip of dough on the clean work surface, and with a pastry brush dipped in butter, paint the strip. Cover it with another strip of dough and paint with butter. Then

place a tablespoon of filling at the bottom of the strip.

Fold the bottom corner over the filling and continue to fold the phyllo just like a flag until it forms a nice little triangle. Seal the edges with melted butter. They can be cooked immediately, but we "cure" the tiropites in the freezer in a large container in a single file, with layers of wax paper in between. Then, once they are frozen, we place them in airtight freezer bags for later use and to keep them fresh.

To cook, preheat an oven to 350°F. Place either the fresh or frozen tiropites in a single layer on a baking sheet and bake for about 25–30 minutes, until golden brown. These will be smoking hot, so be sure to let them have a little rest for about 10 minutes before devouring. Makes about 60 triangles.

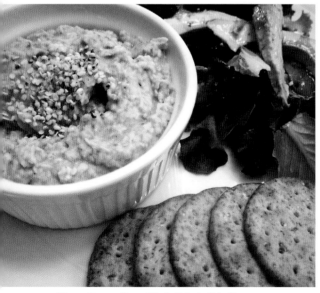

Hemp Butter Bean Pâté. *Kristin Schell.*

Hemp Butter Bean Pâté

Tara Miko Grayless, Happy Hemp (happyhemp.wordpress.com)

Hemp seeds are packed with good-for-you fatty acids, and in this recipe, I like to purée them with beans and mushrooms to create a vegan pâté.

4 tablespoons olive oil, divided

2 cloves garlic, minced

1 (15-ounce) can butter beans, drained

1 cup mushrooms, chopped

salt and pepper, to taste

¼ cup raw hemp seeds

2 tablespoons chopped chives, for garnish

In a skillet over medium heat, add 2 tablespoons of olive oil and the garlic. Lightly brown the garlic. Add in butter beans and mushrooms, followed by a pinch of salt and pepper. Sauté until soft, approximately 5–10 minutes. Remove from heat and cool slightly.

Pour ingredients in food processor and add the hemp seeds. Pulse to combine, lightly drizzling in the remaining olive oil until the mixture starts to become creamy. Add a sprinkle of crushed red pepper for some extra flavor if you wish. Pour into a serving dish and add chives to the top. Serve with fresh veggies, crackers or toasted bread. Serves 4.

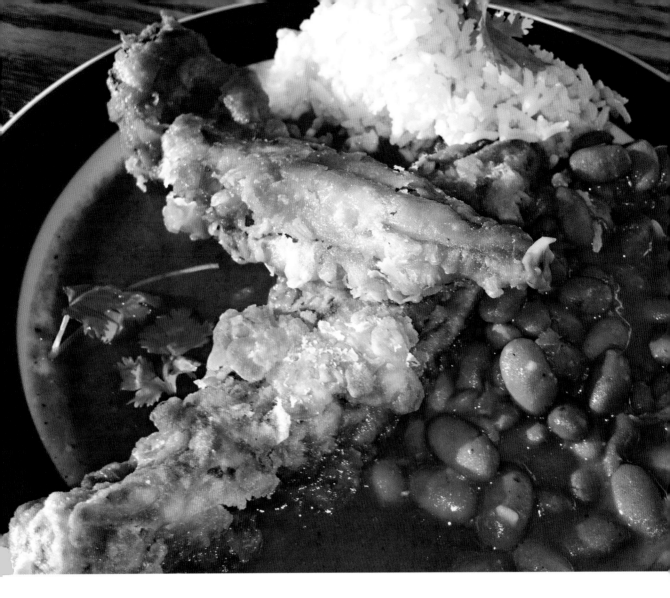

Goat Cheese–Stuffed Hatch Chiles

Joshua Kimbell, The Avocado Apex (theavocadoapex.blogspot.com)

I created this recipe while working at Central Market, which has a Hatch Chile Fest every year to promote everything Hatch. I decided to combine my love for Hatch chiles, goat cheese and spice into one dish, and we used it for the festival. These peppers go great with rice, beans or you name it.

Goat Cheese–Stuffed Hatch Peppers. *Joshua Kimbell.*

12 Hatch chiles

8 ounces goat cheese

1 cup all-purpose flour

1 teaspoon baking powder

1 teaspoon baking soda

1 teaspoon salt

1 teaspoon canola oil

2 eggs, beaten

1 teaspoon ancho chile powder

1¼ cups canola oil

Place Hatch chiles directly on the flame of a gas stove and roast them until they are black and charred. Throw the roasted chiles into a plastic bag (produce bags work well), squeeze out the air and let rest for 30 minutes.

Remove Hatch chiles from the bag, and the skins should peel right off. Discard the black and charred skins.

Place chiles on a cutting board and gently make a slit down the middle of each pepper, being careful not to cut all the way through to the other side. You just want one clean slit on the top. Fill each pepper with goat cheese so that it looks like a full pepper again, then close the top with wooden picks. Put the peppers on a plate or baking sheet and place it in the freezer.

In a large bowl, combine the flour, baking powder, baking soda, salt, canola oil, eggs and ancho powder. Mix together thoroughly.

Pour canola oil into a large sauté pan and turn the heat on medium. While the oil heats up, remove the peppers from the freezer and dip them into the batter you just mixed. Coat them well.

Test the heat of your oil by pouring a few drops of your batter into it. If it fries up, then you're ready to cook. Place your peppers into the oil to comfortably fill the sauté pan.

Cook both sides of the peppers until they are golden brown. Remove from heat and place them on some paper towels to pat dry. Remove the wooden pick from your pepper, and you are ready to serve. Serves 12.

Empanadas with Turkey, Feta and Preserved Lemons

Kristina Wolter, Girl Gone Grits (girlgonegrits.com)

The first food blogger potluck I attended back in April 2010 had me very nervous. I was so worried that I would not muster the creative culinary skills of other bloggers. After getting myself worked up the night before, I realized that I spent more time stressing than actually cooking. Anyway, at the last minute, I pulled some turkey and preserved Meyer lemons out of the fridge and quickly came up with this unorthodox empanada using a dough recipe adapted from a recipe by Laylita's Kitchen. (If you don't have preserved lemons on hand, use several hearty squeezes of lemon juice.)

When I got to the potluck, I was overwhelmed with the warmth and smiles. I quickly realized that it was not a competition, but rather a special community where people who love all aspects of food come together

for the sole purpose of social communing. It's a special joy when you find "your people," as Kristi Willis said to me that day. I feel honored to be among the Austin Food Bloggers, as they truly are my people.

For the empanada dough:

2 cups all-purpose flour

¼ teaspoon baking powder

1 teaspoon salt

½ cup (1 stick) unsalted butter, frozen and cubed

1 egg, lightly whisked

4–5 tablespoons milk

For the filling:

½ cup diced onion

1 tablespoon minced garlic

1 tablespoon olive oil

1 pound ground turkey

1 teaspoon lemon pepper

salt to taste

2 tablespoons minced fresh parsley

1 tablespoon fresh minced sage

1 tablespoon minced preserved lemons

4 ounces crumbled feta cheese

1 egg, whisked, for brushing on empanadas

For the dipping sauce:

1 16-ounce container of plain Greek yogurt

⅓ cup minced scallions

3 tablespoons minced preserved lemons

1 teaspoon garlic powder

1 tablespoon minced fresh sage

1 tablespoon agave nectar (or honey)

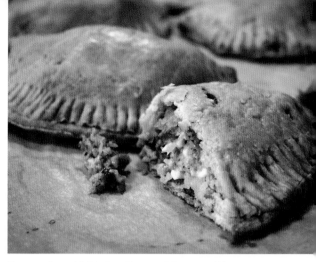

Empanadas with Turkey, Feta and Preserved Lemons. *Addie Broyles.*

For the dough: Combine the flour, baking powder and salt. In a food processor, pulse the flour mixture with the cold butter until you get a crumbly mixture. Transfer to a bowl. Add the egg and milk and knead to form a sort of dough. Dump the dough onto a lightly floured surface and bring together into a ball. Pat into a circle of 1-inch thickness and wrap tightly with plastic wrap. Refrigerate for at least 30 minutes.

For the filling: Sauté onion and garlic in olive oil until translucent. Then remove from pan and place in a large bowl. Set aside.

Sauté turkey in the same pan and sprinkle with lemon pepper and salt to taste (not too much salt because the cheese is quite salty). When finished, drain and add the turkey to the bowl of onions. Let cool for about 5 minutes and then add the herbs, preserved lemons and feta and mix to distribute the filling ingredients evenly. Set aside.

Preheat the oven to 350°F. Roll the dough out to about ¼-inch thickness and cut out circles of desired size. At this point, they can be small appetizer size or larger, if desired.

Place a spoonful of filling (depending on size) in the middle of the dough circle and slowly fold it over to create a moon shape. Seal the dough, making crimp marks with a fork, and place on a parchment-lined baking sheet. Mix whisked egg with 1 tablespoon water and brush mixture on top of each empanada. Place the baking sheet in the preheated oven and bake until golden, about 25–35 minutes, depending on size, until lightly browned. Serve with the sauce below.

For the sauce: Mix all the ingredients together and refrigerate for at least 30 minutes before serving with the empanadas. Reserve extra sauce in the fridge for dipping raw vegetables, such as carrots or broccoli. Serves 8.

Preserved Lemons

Kristina Wolter, Girl Gone Grits (girlgonegrits.com)

We're lucky enough to live in a climate where citrus, including fragrant Meyer lemons, grow well. Once you've made all the lemonade and limoncello you can drink, consider preserving lemons in salt and oil for use in vinaigrettes, sauces, soups and salads throughout the year.

Place a quartered, washed and patted-dry Meyer lemon in a clean Mason jar. Pour kosher salt all over and in between the lemon quarters. Push with your fingers to squish it down and place another quartered lemon on top. Continue to pour more salt until the lemons are completely covered. Place the lid on tight and turn upside down. Now place in your fridge for a couple days. When the juice has risen to the top, open, drain off and pour a layer of olive oil over it. It should stay preserved in your fridge for months. When you are ready to use your lemons, make sure you rinse a lemon wedge really well to remove all the salt off of it. Then mince very finely in dishes such as empanadas and paella.

Mushroom and Bacon Egg Rolls with Yuzu Sauce

Jen Daugherty, Zesty Bean Dog (zestybeandog.com)

I came up with this recipe when entering Marx Foods' Fourth Annual Morel Recipe Challenge. I was looking to create something "outside of the box," and this was my end result. I love how it turned out; it's a great party snack and definitely not your average egg roll.

For the filling:

1 ounce morels, dried (or wild mushroom of choice)

½ cup shredded Parmigiano-Reggiano cheese

4 slices crisply cooked bacon, diced

1 green onion, green part only, sliced very thin lengthwise and chopped

1 tablespoon butter, melted

¼ teaspoon fresh ground black pepper

1 egg, beaten

6 egg roll wrappers

peanut oil, enough for frying

For the sauce:

4 tablespoons yuzu juice

3 tablespoons light soy sauce

2 tablespoons agave nectar, preferably light

½ clove garlic, minced

4 purple scallions or shallots, sliced about a centimeter thick

5–6 thin slices peeled ginger

Reconstitute morels by soaking in cold water. Meanwhile, make the sauce by whisking together ingredients, then place in fridge.

Chop morels and combine with cheese, bacon and green onion, melted butter and pepper. Divide into 6 balls.

Lay out egg roll wrapper on a flat surface, place a ball of the mixture on the top corner and roll down until it's a triangle, then fold in the corners and finish rolling, sealing with egg wash on the seams. Repeat with remaining wrappers and filling.

Heat fryer oil to 350°F. Once hot, place egg rolls in oil and cook for about 5 minutes or until golden, turning occasionally throughout the duration of cooking. Transfer onto paper towel to drain before serving. Makes 6 whole egg rolls or 12 halves.

Trailer Food: A Short History on Austin's Love Affair with Curbside Cuisine

Tiffany Harelik, Trailer Food Diaries (trailerfooddiaries.blogspot.com)

Austin isn't just the live music capital of the world, it's also the trailer food capital of the world. Offering a mecca of flavors from food carts, food trucks and less-than-mobile airstream trailers, food trailer chefs come from every walk of life and every part of the globe. You can order their unique recipes for "grab and go" or sit down to enjoy them under the oak trees and year-round Christmas lights of a local food trailer park.

While the interest in food trailers fairly exploded in 2010, the seeds of the excitement were planted much earlier. In 2002, Hudson's on the Bend owner Jeff Blank was contacted by the Austin City Limits Music Festival to help create festival-friendly fare that would properly honor the Austin food scene. His response—which he named the "Mighty Cone"—became Austin's first food trailer. The original "Mighty Cone" contains Hot 'n' Crunchy (the trade name for a breading used on fried fish at Hudson's restaurant) fried chicken tenders with mango-jalapeño slaw and ancho sauce wrapped in a tortilla and served in a paper cone. The "Mighty Cone" was such a hit that, in 2009, Blank set out to make the cones a year-round offering, and he opened a food trailer to sell them on South Congress. It wasn't long before three more operations—"Hey Cupcake!," "Torchy's Tacos" and "Flip Happy Crepes"—joined the scene, and the trailer food movement was born. You can still find all four of the founders doing a brisk business as trailer food icons in Austin.

Not all trailer chefs are created equal in terms of culinary expertise. Starting a food trailer has a certain allure: relatively low overhead, short time from concept to opening and the independence of running your own business. What it does not require is experience in the food industry. After interviewing hundreds of food truck owners, I've come to find three key ingredients these chefs have in common: they are entrepreneurs who do not want to work for anyone else, they have at least one really good recipe and they love community. Some of the best food I've eaten from trailers was made by self-taught home chefs who have a knack for a niche food item. The owners of "Gourdough's Big. Fat.Donuts," for example, were in real estate before opening their donut trailer. And the "Peached Tortilla" was started by an attorney who traded in his briefcase for an Asian/ Southern Comfort fusion truck. There are immigrant stories, stories of families pulling together and corporate superstars, all now part of the food trailer community.

Several of Austin's noteworthy chefs got their start from owning and operating food trailers here. Bryce Gilmore gained fame with "Odd Duck Farm to Trailer" and then opened Barley Swine, where he was voted a best new chef by *Food and Wine*. Aaron Franklin of

"Franklin BBQ" debuted his brisket and coffee-tinted sauce from a trailer under Interstate 35 and now runs a restaurant serving the country's most talked-about brisket. Paul Qui, who started the "East Side King" trailer as a side project from his job at Uchiko, won both Season Nine of *Top Chef* and a James Beard Award.

Tips for eating at trailers in Austin:

Pick a trailer park. Food trailers tend to congregate in lots, or "trailer parks," that have three to eight trailers per park. If you go with a group of friends, you can get food from each of the different trailers and share it.

Get social. Check Facebook and Twitter accounts for their location, hours and recent developments.

BYOB. While all the trailers will serve drinks, none is allowed to serve alcohol.

Japan Meets Morocco Roll

Jack Yang, Eating in a Box (eatinginabox.com)

As part of my night as featured chef at a local Moroccan food trailer, I created two dishes that took something foreign and put a Moroccan spin on them. One dish was a Japan-meets-Morocco roll. I sous vide poached a chicken breast with a blend of spices, and instead of traditional sushi rice, I made a saffron rice. I crusted the whole thing with panko, fried it up and served it with a bit of dynamite sauce. Not being a professional chef, that night proved to be very memorable both in terms of how scared I was and how out-of-control busy it got. I'm not sure I'd make it in the food trailer business, but I'm glad to have had an opportunity to try it for a night.

Note: If you have no way to sous vide the chicken, you may prepare it by baking. Do not attempt to grill, as the paprika and cayenne will burn and give you a "blackened" chicken. You can find nori and kombu (two kinds of seaweed), sushi rice, Sriracha and Kewpie mayonnaise at your local Asian market. Normal mayonnaise is an acceptable substitute, but you can tell the difference.

1½ cups flour

2 large eggs

2 cups panko

3 tablespoons Sriracha hot sauce (or more for more heat)

1 cup Kewpie mayonnaise

2 tablespoons paprika

1 teaspoon cumin

1 teaspoon coriander

1 teaspoon salt

1 teaspoon cayenne

4 boneless skinless chicken breasts

3 pinches of saffron thread

3 cups short grain "sushi" rice

1 4-inch piece of kombu

8–10 sheets nori

additional salt, to taste

Special equipment needed:
sous vide machine
fryer
bamboo sushi roller mat

Set sous vide cooking device to 146°F. Heat fryer or a pot of oil up to 350°F. Prepare dredging station with bowls for the flour, eggs (beaten) and panko.

To prepare the dynamite sauce, mix together Sriracha hot sauce and Kewpie mayonnaise. This can be done ahead and placed in the refrigerator.

Mix paprika, cumin, coriander, salt and cayenne and gently dust the chicken on both sides. Place chicken in vacuum bag and seal. Place the bags in sous vide device, and when the temperature reaches back to 146°F allow the chicken to poach for a minimum of one hour. The chicken can be held for a maximum of four hours at this temperature. Once complete, remove the chicken from the bag and cut into ½-inch strips from the long side of the breast, yielding about four to five pieces per breast. This step may be completed ahead of time and the chicken held in the refrigerator.

Steep saffron in two tablespoons of boiling water for two minutes. Prepare rice per package instructions or by rice cooker, adding in the saffron and kombu. When finished, put the rice in a large mixing bowl and gently toss to cool. Add salt to taste and cover with a wet paper towel.

Place one piece of nori on the bamboo mat. Wet your hands, take a handful of the rice and spread it from the bottom of the nori to short of 1½ inches from the top of the sheet. Flatten the rice and make sure that the rice is no more than one to two grains thick. You should be able to still see the dark nori behind the rice. Place two slices of chicken at the bottom of the nori sheet so that they cover the width of the roll. Then gently roll until chicken is tucked under the nori and rice and squeeze gently to ensure that it stays together. Continue until you are at the riceless part of the nori. Wet your finger, dampen the exposed nori and finish rolling into a cylinder. Repeat with remaining nori and chicken.

Cut each roll in half. Lightly cover each roll in flour. Then dip into the egg wash for a light coat, then the panko. Continue until all rolls are complete. Fry each roll for about 3 minutes until golden. To serve, slice on a bias and drizzle with dynamite sauce. Makes 16–20 mini rolls.

Soups and Salads

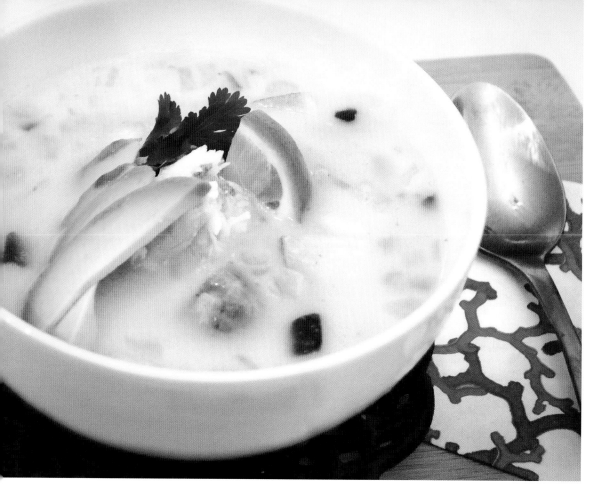

Gulf Shrimp and Corn Chowder

Kristi Willis, Kristi's Farm to Table (kristisfarmtotable.com)

Some of my fondest childhood food memories involve summer shrimp and crab boils, piping hot shellfish poured onto the table with potatoes and corn peeking out of the piles. During the summer of 2010, I followed the British Petroleum (BP) oil spill in horror, shocked that the accident might devastate an industry that is such a big part of culture on the Gulf Coast.

Texas shrimpers and fishermen were suffering even though the spill had little impact on Texas shores, and I decided to show my support by cooking Texas seafood even more often than normal. I made this chowder as a more refined way to capture the flavors of a shrimp boil without having to get your hands quite so dirty.

In a nod to cooking lighter, I substituted the traditional cream used in chowders with a combination of milk and a corn purée that give the soup the weight of a chowder without

Gulf Shrimp and Corn Chowder. *Natalie Paramore.*

the calories. If crab meat is not easily available or affordable, you could substitute a few grilled shrimp as a topper for the chowder. I suggest grilling them in their shells and then removing the shell before you serve to make it easier for your guests to enjoy the dish.

2 tablespoons butter

1 onion, peeled and chopped

2 large poblano peppers, roasted, peeled, seeded and chopped

2 ears of corn, kernels removed

1 pound new potatoes, cut into quarters (or ⅛, if they are large)

1 can corn, processed in food processor with ½ cup of liquid

1–2 tablespoons salt

3 cups broth (shrimp or chicken will work)

1 cup milk

2 pounds shrimp, peeled, deveined and chopped

2 pounds crabs, boiled and meat removed

1 avocado, sliced

handful of cilantro, chopped

1 lime, sliced for garnish

4–5 tablespoons of cream for a richer textured chowder (optional)

Melt the butter over medium heat in a large pot. Add the onions and poblanos and sauté until tender, about 5 minutes. Stir in the corn kernels, potatoes, puréed corn, salt and the broth. Cook for about 10 minutes, until the flavors begin to meld.

Lower the heat, add the milk and cook for another 5 minutes. Add the shrimp and cook another 5 minutes or until the shrimp are cooked through.

Ladle the soup into a bowl and top with a small handful of crab and a slice of avocado. Serve with cilantro and lime as garnish. Serves 6.

A How-to Guide for Eating Seasonally

Carla Crownover, Austin Urban Gardens (austinurbangardens.wordpress.com)

No matter if you are eating vine-ripened tomatoes in May, the first sweet corn in June or the last peaches in August, produce tastes better once you have anticipated and awaited its arrival. Sure, you can buy these things year round at the grocery store, but they are often grown far from the store, picked before they're ripe and carried long distances by truck or boat—losing most of their flavor and nutrients in the process.

In Austin, we are so fortunate to have farmers' markets, local farms with farm stands and a variety of CSAs (community-supported agriculture, or farm share programs) from which to choose. If you can't get to a farmers' market or a farm stand, sign up with a CSA and let it bring its bounty to your doorstep. Eating seasonally is satisfying and nutritious and allows for a greater appreciation of the foods available at a given time of year. Here are a few tips to improve your farmers' market shopping:

Read the market report before you go so that you know what is in season. Most markets have a newsletter that has a summary of what's new and notable at the market each week.

Go early; it's cooler and more comfortable then, and you reduce the risk that what you want may be sold out.

Take your own bags—one for meat and one for produce. If you plan to buy meat or dairy, you might take a cooler for the car.

Take cash—smaller bills are best. Many farmers don't take credit cards.

If you plan to make jam, let the farmer know and ask for "seconds," fruit that is bruised, flawed or nearly overripe, which won't matter for jam and may be less expensive.

Get to know the farmers. Ask questions. They're happy to help you learn about your food and how it's grown.

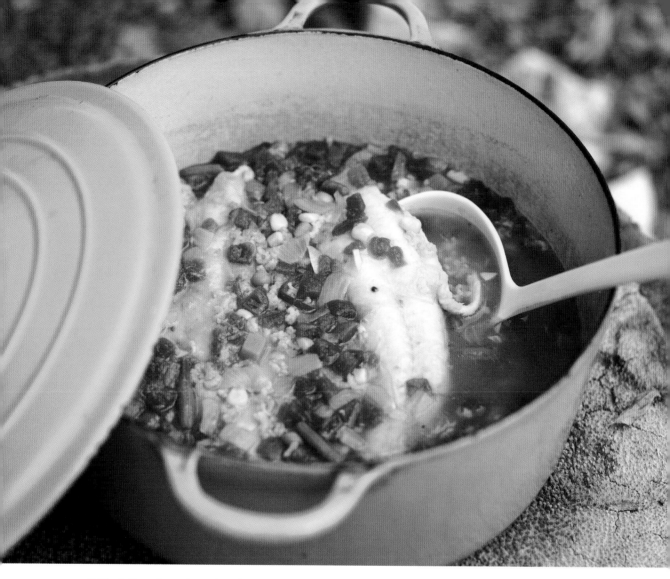

Caldo de Pescado. *Melissa Skorpil.*

Caldo de Pescado

Heather Santos, Midnite Chef (midnitechef.wordpress.com)

Un pez is a fish. *Un pescado* is a caught fish. This was one of the first nuances of the Spanish language that I learned. Apparently, you cannot make Caldo de Pez because that would require you to make it in the river or other body of water in which the fish is swimming. *Un pez* is as free as Willy. So, to make this soup, you have to catch the fish first.

6–8 tablespoons olive oil

1 small white onion, diced

2 cloves garlic, minced

3 cups stock (any flavor)

2 cups water

1 bay leaf

1 (15-ounce) can diced tomatoes

1 cup frozen corn kernels

1 cup frozen vegetable mix (lima beans, carrot, peas)

1 hot pepper, sliced

½ cup uncooked white rice

salt and pepper to taste

1 pound firm white fish fillets (such as tilapia, sea bass or catfish)

lime wedges for serving

Sauté the onion and garlic in a soup pot. Add the stock, water, bay leaf, tomatoes, vegetables, hot pepper and rice. Bring to a rapid boil. Reduce to medium and simmer for 10 minutes. Adjust seasoning. Add the fish fillets and cook until opaque, about 5 minutes. Serve with lime wedges. Serves 4.

Summer Soup

Kristin Vrana, Food Fash (foodfash.com)

Who says you can't eat soup when it's hot outside? I don't mind browsing the chilly produce section of Central Market during a hot summer day to buy ingredients for a vegetable-heavy soup like this. With lime, cilantro and serranos, the soup is fresh, tangy and spicy, perfect for sweating out one of those triple-digit summer days.

12 cups water

4 bouillon cubes

½ cup chopped, packed fresh cilantro

Summer Soup. *Kristin Vrana.*

1 bunch green onions, chopped

¼ pound shiitake mushrooms, sliced

1 serrano pepper, sliced (remove seeds and veins if you're sensitive to spice)

juice of 4 limes

2 heads of baby bok choy, chopped

8 ounces udon noodles

Bring water to a boil and add everything but the bok choy and udon noodles. Let boil for 5 minutes and then add the bok choy and noodles. Boil for an additional 6 minutes and then remove from heat. Let cool for a few minutes and then serve. Serves 6–8.

Sorta Gumbo Z'Herbes

Lisa Rawlinson, Full and Content
(fullandcontent.blogspot.com)

This has become my favorite way to prepare hearty greens. I would in no way claim authenticity, which is why I call this "Sorta" gumbo, but I tip my metaphorical hat to my neighbors to the east for their influence on the food that goes onto my plate.

1 tablespoon butter

¾ pound Andouille sausage, cut into bite-sized pieces

2 cups yellow or white onion, diced

1 cup summer squash of your choice, cut into bite-sized pieces

1 tablespoon dried parsley

¼ teaspoon rubbed sage

3 tablespoons flour

2 cups chicken stock

3 tablespoons cider vinegar, plus more to taste

kosher salt, to taste

2 cups chopped greens (which may include collard greens, sweet potato greens, beet greens, kale or a mix of leafy greens)

cooked white rice

hot sauce, for garnish

Sorta Gumbo Z'Herbes. *Lisa Rawlinson.*

Heat a large pan over medium-high heat. Melt butter, then add the sausage and onions. Cook, stirring frequently, until the onions begin to become tender and the sausage begins to brown slightly.

Add squash and cook, stirring frequently until the squash is just tender. Add the parsley and sage and stir well. Add the flour and stir to distribute it evenly. Add the stock and stir well until the flour has been absorbed evenly into the liquid.

Add 3 tablespoons of cider vinegar, stir well and then taste. Add more vinegar as desired and salt to taste.

Add greens, lower heat and keep stirring until the liquid starts to thicken and the greens are wilted. Cook about 1 more minute, stirring constantly, then remove from heat.

Serve over white rice with hot sauce on the side. Serves 4.

Natalie's Get Better Chicken Soup

Joshua Kimbell, The Avocado Apex (theavocadoapex.blogspot.com)

My girlfriend, Natalie, and I work together at a local grocery store. One day, she wasn't feeling good, so I left work before her, bought a ton of ingredients, went to her place and made her a big pot of chicken soup, but with a unique twist. The end result was a soup of brilliant colors and wonderful flavor, and best of all, it helped her get better.

For the stock:

1 3-pound free-range chicken (innards removed and cleaned)

2 carrots, cut into large pieces

1 large orange, cut into thick slices (reserve ⅓ of the slices for garnish)

1 turnip, cut into quarters

3 celery stalks, cut into large pieces

1 large white onion, halved

1 head garlic

4 sprigs fresh thyme

2 bay leaves

1 tablespoon peppercorns

For the soup:

3 tablespoons olive oil

1 medium red onion, chopped

3 garlic cloves, chopped

2 celery hearts, finely diced

2 carrots, peeled and julienned

4 sprigs fresh thyme

2 bay leaves

2 quarts chicken stock, strained (from recipe here)

8 ounces green tea noodles (available at any Asian market)

sea salt, to taste

lime juice, to taste

hot sauce, such as Cholula chile lime flavor, to taste

finely chopped cilantro, for garnish

For the homemade stock, place stock ingredients in a large soup pot. Cover with water. Turn the heat on medium and bring to a boil slowly.

Once boiling, reduce heat to low and simmer for about two hours, periodically skimming the top. Add more water as needed to make sure you have enough stock.

Take the chicken out of the stock, place on a plate and allow to cool for about 30 minutes. Once cool, remove skin and bones and shred the meat. Set aside.

Heat olive oil in a sauté pan on low until hot. Add chopped red onion, garlic, celery, carrots, thyme and bay leaves and sauté until sweated.

Strain the stock into another large pot using a strainer lined with a coffee filter. Add the sautéed vegetables and herbs from the sauté pan into the strained stock. Slowly bring to a bowl.

Add shredded chicken and green tea noodles and continue to cook until noodles are soft. Add salt, lime juice and hot sauce to your taste.

Reduce heat to low and simmer for 15–20 minutes, then ladle into bowls and garnish with chopped cilantro and orange slices. Serves 4–6.

Strawberry Balsamic Spinach Salad with Feta

Jane Ko, A Taste of Koko (atasteofkoko.com)

Here's a fresh summer strawberry salad with spinach, feta and candied walnuts and dressed in a balsamic vinaigrette. You can make your own vinaigrette with olive oil and balsamic vinegar, but I just use a bottled dressing. Sliced grilled chicken or crumbled bacon could turn this salad into an entrée.

2 cups baby spinach
1 pint fresh strawberries
½ cup thinly sliced red onion
¼ cup crumbled feta cheese
¼ cup candied walnuts
bottled balsamic vinaigrette

Wash baby spinach and use a salad spinner to whisk away the excess water. Remove spinach stems, if desired. Wash and slice strawberries. In a large bowl, toss together all the ingredients, except the vinaigrette. After ingredients are mixed, dress with vinaigrette and serve immediately. Serves 2.

Strawberry Balsamic Spinach Salad with Feta. *Jane Ko.*

Watermelon Salad with Gorgonzola

Natalie Paramore, Food Fetish (natalieparamore.com)

Summertime in Austin means huge, juicy watermelons. I can't let a good watermelon go to waste, so I thought, why not use it in a salad? Cool and fresh, the watermelon is a great complement to greens and creamy gorgonzola. If you prefer, you can cube the watermelon and toss ingredients together instead of serving the salad on top. Want to make enough salad for two? Double the recipe.

Watermelon Salad with Gorgonzola. *Monica Riese.*

1 cup spring mix greens or arugula
1 tablespoon olive oil
1 teaspoon balsamic vinegar
pinch garlic salt
freshly ground black pepper, to taste
1 6-inch wedge watermelon (about 1 cup cubed)
1–2 tablespoons gorgonzola
cucumber and strawberry slices for garnish (optional)

In a large bowl, combine greens, olive oil, balsamic, garlic salt and black pepper. Toss until well combined. Next, place the watermelon wedge on a plate. Place tossed greens on top of watermelon. Crumble gorgonzola over top of greens and watermelon. (Use as little or as much as you like.) Garnish with slices of cucumber and strawberry, if using. Serves 1.

Southwestern Salad with Seared Scallops. *Kristin Sheppard.*

Southwestern Salad with Seared Scallops

Kristin Sheppard, Mad Betty (madbetty.com)

I've made this light, delicious dinner for family and friends countless times, and it's always a hit. The sweet charred corn is a nice balance with the succulent, savory scallops. The bright flavors of the dressing awaken the palate and keep the dish light, healthy and simply divine. A perfectly cooked scallop can make your day!

2 ears corn, shucked

bag of mixed lettuce, enough for four salads

½ pint of cherry tomatoes, sliced in half

¼ red onion, finely chopped

1 ripe avocado, cut into long slivers

1 tablespoon butter

1 tablespoon olive oil

1 pound medium scallops

salt and pepper, for seasoning

For dressing:

2 tablespoons extra virgin olive oil

½ cup packed cilantro

zest of 1 lime

juice of 2 limes

juice of 1 orange

½ teaspoon salt

⅛ teaspoon ground black pepper

Preheat oven to 375°F. Place corn on baking sheet and roast for 20 minutes, turning every few minutes. Corn will be finished when fairly charred all over. Let cool and then remove kernels from cobs with a sharp knife.

Divide lettuce into four dinner bowls. Top with tomatoes, onion, avocado and corn. Set salads aside.

Heat butter and olive oil in a large pan over high heat. Quickly dry scallops with a paper towel and season with salt and pepper. When oil/butter mixture is smoking hot, carefully place scallops in pan. Allow them to sear for 2 full minutes before turning over. Turn and cook them on the other side for 2 more minutes. Scallops should be cooked through, or very close. If you wish, bake them in a 350°F oven for an additional 5 minutes. When finished, divide scallops onto salads.

To make dressing, place all ingredients in food processor and pulse into well blended. Immediately drizzle the dressing over salads and serve. Serves 4.

Side Dishes

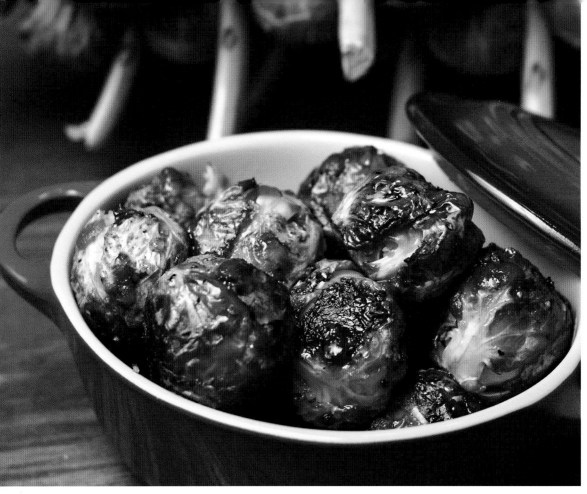

Roasted Brussels Sprouts with Sriracha Lemon Caramel Vinaigrette. *William Burdette.*

Roasted Brussels Sprouts with Sriracha Lemon Caramel Vinaigrette

Kathryn Hutchison, ATX Gastronomist (austingastronomist.com)

1 pound Brussels sprouts

3 tablespoons grapeseed oil

½ teaspoon sea salt

3 tablespoons sugar

3 tablespoons Asian fish sauce

2 tablespoons fresh lemon juice, plus extra for seasoning

1 teaspoon Sriracha hot sauce (to taste), or your favorite Asian-style chile paste

1 clove garlic, crushed

¼ teaspoon black pepper

Preheat oven to 400°F. Trim the sprouts by cutting off the stem end and peeling back a layer of leaves. Cut any large sprouts in half. Rinse sprouts in a bowl of cold water and dry with a clean tea towel. Place in a single layer on a foil-lined cookie sheet and drizzle with grapeseed oil. Toss to coat and sprinkle generously with salt. Bake for 25–35 minutes, stirring after 20 minutes until crispy and tender. The outer leaves should be very dark, and the sprouts will be tender and fragrant when they are finished cooking.

During last 10 minutes of cooking, place sugar in a 12-inch frying pan over medium-high heat. Stir frequently with a wooden spoon until sugar is melted and amber colored. This should take about 2–3 minutes. Add ½ cup of very hot water (mixture will bubble) and stir until caramelized sugar is completely dissolved. Stir in fish sauce, lemon juice, Sriracha, garlic and black pepper. Continue to cook, stirring constantly for 4–5 minutes, until mixture reduces. Remove from heat and set aside.

Arrange cooked Brussels sprouts on a serving dish and top with warm caramel vinaigrette. Taste and season sprouts with additional lemon juice, salt and pepper before serving. Serves 4.

Horseradish Cheese Grits

Susan Stella Floyd, Stella Cooks (stellacooks.com)

I invented this on a whim because I love cheesy grits and horseradish. It gives the dish an unexpected twist and a slight kick—once you try it, cheesy grits will never taste the same again.

1½ cups whole milk (or water)

¼ teaspoon salt, plus additional to taste

¼ teaspoon freshly ground black pepper

½ cup stone-ground yellow grits

2 tablespoons butter

¾ cup grated sharp cheddar cheese

Horseradish Cheese Grits. *Tracy Blair.*

Pad Prik King. *Jane Ko.*

2 tablespoons prepared horseradish
1 tablespoon heavy cream (optional)
pepper to taste

Bring milk, salt and pepper to a boil in a medium saucepan. Add grits and whisk until thoroughly mixed. Reduce heat to low and continue stirring regularly as the mixture thickens (about 25–30 minutes). Add more milk (or water) if needed.

Add butter and cheese and stir until melted into grits. Add horseradish and cream (if using) and stir lightly until thoroughly incorporated. Serve immediately with additional salt and pepper as desired. Serves 4.

Pad Prik King

Jam Sanitchat, Thai Cooking with Jam (thaicookingwithjam.blogspot.com)

I haven't made my own curry paste for a while now. Although I love the fresh smell of newly made paste, I just can't seem to dedicate the time that goes into making the paste. Having a toddler running around, the less time it takes to prepare my meals, the better. So, I have found my favorite canned paste, Maesri, which is what I use in the cooking classes at my restaurant, Thai Fresh.

One of our most popular dishes is Pad Prik King, a super-easy dish if you have the paste stocked in your pantry. Kaffir lime leaves are freezable, so you can just have a stash frozen for convenience. I grow my own tree, which does well in Austin, so I have a fresh supply year round.

2 tablespoons vegetable oil

1 (4-ounce) can Maesri red curry paste

1 pound chicken, cut into bite-sized pieces

2 cups green beans, trimmed and halved

1–2 tablespoons sugar

½ tablespoon fish sauce, plus more to taste

4–5 kaffir lime leaves, julienned
 (about 2 tablespoons)

Heat up a sauté pan or wok over medium-high. Add the oil and wait until the oil is hot before adding the curry paste. Stir-fry until fragrant over medium heat, about 3–4 minutes. Add chicken and sauté until chicken is cooked, about 5 minutes. Add green beans and 1 cup of water and continue to cook until green beans are cooked but still have a bite to them, about 7 minutes. Add more water if it becomes too dry. Season with sugar and fish sauce. Add kaffir lime leaves and sauté for about 30 seconds. Serve over hot white or brown jasmine rice. Serves 4.

Damir's Broccoli

Ryan Schierling and Julie Munroe, Foie Gras Hot Dog (foiegrashotdog.com)

This recipe came from our wonderful neighbor, Damir Sarajcic, when we lived in Seattle. It is not a traditional Bosnian recipe; it's all Damir and is simply divine when made with good fresh feta cheese in brine. We consider Damir a part of our family, and this recipe gets the same reverence reserved for all fantastic family favorites.

 Wonderful as a quick and easy side, we've also found that when served over mashed

Damir's Broccoli. *Ryan Shierling.*

potatoes it is truly comfort food of the highest order. The recipe has been tested several ways, and it is best with the aromatic fresh-chopped garlic added at the end, not sautéed with the broccoli.

2 tablespoons butter

16 ounces broccoli, lightly steamed

½ cup sour cream

6 ounces fresh feta cheese, roughly
 crumbled

4 large cloves garlic, crushed and minced

freshly ground black pepper, to taste

In a saucepan, melt the butter and add the broccoli. When the broccoli is both hot and tossed in the butter, add the sour cream, crumbled feta and minced garlic. Stir together and gently bring back up to heat. Season to taste with freshly ground black pepper and serve at once. Serves 4.

Coconut Sriracha Cauliflower Rice. *Melissa Skorpil.*

Coconut Sriracha Cauliflower Rice

Brittanie Duncan, Three Diets One Dinner (threedietsonedinner.com)

The Paleo diet is a lifestyle of eating natural foods designed for the human species. Those include nutrient-dense foods like meat, vegetables, healthy fats and fruit in moderation—food that looks, tastes and behaves like food found in nature. Our ancestors lived on foods they could hunt and gather before the advent of agriculture. The Paleo diet eliminates modern processed foods, wheat and grains, legumes, dairy and sugar.

Cauliflower is an ingredient that Paleo cooks use often because it is an excellent substitute for rice. Cauliflower is also a fantastic vessel for sneaking vegetables into kids' dinners. This dish is inspired by the spices of India, with a kick of heat from the Sriracha, an Asian-style chile sauce. It is a great side dish for any meal.

1 large head of cauliflower, chopped

1 (14-ounce) can coconut milk

juice of ½ lime

1½ tablespoons curry powder

1–2 tablespoons Sriracha hot sauce

Place half the cauliflower in a food processor. Pulse a few times until the cauliflower resembles rice, then place in a medium saucepan. Repeat with remaining cauliflower.

Stir in the coconut milk and bring to a simmer. Cook, stirring occasionally, over medium heat until the cauliflower is tender but not mushy, about 12–15 minutes; remove from heat. Stir in the lime juice, curry powder and Sriracha, to taste. Serve warm or cold. Serves 4–6.

Zucchini Pancakes

Hilah Johnson, Hilah Cooking (hilahcooking.com)

I don't recall when I started making these, but it must have been during my single, poor and lazy days. I love this recipe because there are only four ingredients, and I almost always have them in my kitchen. These are a perfect quick snack or meal when you just can't be bothered with complicated food.

1½ cups grated zucchini (or yellow squash)

1 egg

2 tablespoons flour

½ cup crumbled feta cheese (or cotija or parmesan, grated)

¼ teaspoon salt (this is optional; you might not need it if your cheese is very salty)

¼ teaspoon black pepper

2 teaspoons butter or olive oil for frying

Mix the grated zucchini, egg, flour, cheese and seasoning. Heat a skillet over medium-high heat. Lube it up with a teaspoon of oil or butter. When it's hot, pile the mixture on in about ¼-cup amounts and pat out the piles into 3- by ½-inch circles. (You may need to cook them in two batches.) Cook for about 4 minutes—they should be very brown underneath. Flip carefully and cook another 4 minutes. Serve right away. Serves 1–2.

Zucchini Pancakes. *Melissa Skorpil.*

Austin's Grocery Store Paradise

Meredith Bethune, Biscuits of Today (biscuitsoftoday.com)

Promises of Tex-Mex food, live music and cowboy boots weren't enough to sell me on Austin. Over a year ago, my fiancé and I moved here from New York City for his job. One question tormented me before the big move: where would I buy urad dal, curry leaves and tamarind paste? I was thrilled to move to the home of the Whole Foods mothership, but no one had told me that Austin is a grocery store lover's paradise.

Fiesta Mart specializes in Mexican products but also has a great selection of foods from around the world. Even HEB feels pressured to cater to my yuppie needs with bulk spice bins, organic milk and tortillas made in house. Quality Seafood brings in the freshest fish, shellfish and bivalves, and we now have two specialty cheese shops: Henri's and Antonelli's. In North Austin, you'll find huge Asian supermarkets, as well as smaller stores specializing in Middle Eastern, Indian and/or Korean ingredients.

In a city of great grocery stores, Wheatsville Co-op has a special place in my heart. I visit the store almost daily to wander the aisles, feeling out which lovely food product will "speak" to me. Will it be the fresh black-eyed peas or the local goat cheese? I actually rely on the friendly staff for most of my local products like meat, produce and dairy. The store is a great alternative for those of us who can't always make it to the Saturday farmers' markets by 1:00 p.m. Sometimes it's too hard to drag yourself out of bed after a Friday night out in Austin.

Wheatsville is opening a second location in South Austin, and Trader Joe's (a California favorite) will open its first store in Austin in 2013. Central Market, the upscale sister to the ubiquitous (and Texas-based) HEB chain, has two locations, and Whole Foods now has four area stores. One of the most interesting additions in the past year has been In.gredients, a packaging-light and zero-waste grocery store that opened recently in East Austin.

It's unbelievable but true: buying food in Austin is actually more fun than it was in New York. I have easy access to everything, but I don't have to haul my treasures home on the subway and carry them up four flights of stairs. Now I just toss them in my trunk or bike basket and still have time to enjoy the rest of my day. The neighborhood where I could afford to live in New York City was a food desert, but you might describe Austin as a food oasis.

Grilled Lime-Paprika Broccoli. *Jessica Meyer.*

Grilled Lime-Paprika Broccoli

Jessica Meyer, ATX Gluten-Free (atxglutenfree.com)

We love to grill in our family. We especially love to entertain. When we do entertain, there is always a dish on the menu that is grilled. I became particularly fond of grilling when my oven broke. It was broken for several months, so I had to find some other way to cook besides the stovetop. Grilling lends such a wonderful flavor to food, and one of my favorite things to grill is broccoli. Grilling in the Texas heat can be hot, but this tangy lime-paprika broccoli can help cool you down. It's refreshing, light and healthy.

2 medium broccoli heads

¼ teaspoon garlic powder

¼ teaspoon paprika

1 tablespoon canola oil or extra virgin olive oil

¼ teaspoon salt, or less depending on size of broccoli

3 tablespoons lime juice

Preheat grill to medium-high heat. Wash and dry broccoli. Slice broccoli into quarters, while keeping the stems intact. Place in a plastic container or plastic bag and add salt. Add garlic powder, paprika, oil and lime juice. Shake to evenly distribute seasoning on broccoli. Let mixture stand for at least 15 minutes.

Place broccoli on grill. Using high-heat safe tongs, rotate broccoli randomly throughout the 10-minute grill time. Finished broccoli should have nice grill marks and caramelized tops, and the texture should still have a bite. Serves 2–4.

Entrées

Chocolate Chili. *David Humphreys.*

Chocolate Chili

Melissa Joulwan, The Clothes Make the Girl
(theclothesmakethegirl.com)

In sixth-grade English class, we read a story about a Native American tribe in the Southwest. I've forgotten all but one fascinating detail of that story: the family ate meat cooked with chocolate. Thanks to my dad's rule that we must at least try everything once, I ate a lot of weird stuff as a kid (raw lamb in kibbeh, sweetbreads, capers), but this was something I simply couldn't fathom. Chocolate! With meat! Now, I'm a sucker for anything that's sweetly savory, and every time I reach for the cocoa, I smile at the memory of eleven-year-old me. This chili is spicy but not hot. Reminiscent of mole, the flavors are rich, mellow and deep.

2 tablespoons coconut oil

2 medium onions, diced (about 2 cups)

4 cloves garlic, minced (about 4 teaspoons)

2 pounds ground beef

1 teaspoon dried oregano leaves

2 tablespoons chili powder

2 tablespoons ground cumin

1½ tablespoons unsweetened cocoa powder

1 teaspoon ground allspice

1 teaspoon salt

1 (6-ounce) can tomato paste

1 (14.5-ounce) can fire-roasted, chopped or diced tomatoes

1 (14.5-ounce) can beef broth

Heat a large, deep pot over medium-high heat, then add the coconut oil. Add onions when the oil is melted. Stir with a wooden spoon and cook until they're translucent, about 7 minutes. Add the garlic, and as soon as it's fragrant (about 30 seconds), crumble the ground meat into the pan with your hands. Mix with the wooden spoon to combine. Continue to cook the meat, stirring often, until it's no longer pink.

In a small bowl, crush the oregano between your palms to release its flavor. Then add the chili powder, cumin, cocoa powder, allspice and salt. Combine with a fork, then add to the pot, stirring like you mean it. Add tomato paste and stir until well combined.

Add the tomatoes with their juice, beef broth and 1 cup of water to the pot. Stir well. Bring to a boil and then reduce the heat so the chili enjoys a gentle simmer. Simmer uncovered for at least two hours before serving. Do not skimp on the simmer! Serves 6–8.

Creole Barbecue Shrimp

Margaret Christine Perkins, From Maggie's Farm (frommaggiesfarm.blogspot.com)

Barbecue shrimp—neither cooked on a "barbie" nor slathered with sauce of the same name—is a drippy, garlicky, herby, buttery, delightful mess of a dish, adored by one and most, and certainly yours truly. The dish originates in New Orleans, but this Texas transplant takes every advantage of the fresh gulf shrimp she buys at local farmers' markets to share her take on one of her favorites with Texas friends.

2 pounds large to jumbo shrimp, heads on is preferable*

2 small lemons, sliced thinly

1 small onion, minced finely

2–3 heads garlic, broken into cloves but left unpeeled

2 sticks butter, melted

1 small lemon, juiced

2 tablespoons crushed dried rosemary

¼ cup chopped parsley

1 bunch scallions, green ends, sliced

1 tablespoon creole seasoning salt

1 teaspoon crushed red pepper flakes, or more to taste

1 tablespoon Szechuan peppercorns

1 bay leaf

1 cup dark beer

¼ cup Worcestershire sauce

hot pepper sauce, to taste

crusty french baguette and/or prepared warm grits to serve

*I like to keep the heads on because, as the fat in the head melts, it lends extra flavor to the broth

Preheat oven to 375°F. Layer shrimp, sliced lemons and chopped onion in a baking dish. Toss in the garlic cloves. Combine the remaining ingredients and cover dish. Bake for 10 minutes, turn shrimp and bake an additional 10–15 minutes or until shrimp are pink and opaque. Uncover and allow to cool until temperate enough to handle.

Serve with a crusty French baguette and/or freshly cooked grits and don't forget a warm, damp cloth napkin, 'cause it's heavenly messy. We fish out the garlic cloves, pop them from their skins and enjoy them whole, along with a crusty toasted baguette for "sopping" the buttery broth. This is not optional. This is mandatory. Serves 8 as an appetizer, 4 as an entrée.

Beer Carne Guisada with Uncle Billy's Baltic Porter

Jennie Chen, Miso Hungry (misohungrynow.blogspot.com)

I don't judge a Mexican or Tex-Mex restaurant by its tacos. Having grown up on the southern coast of Texas, I had my fair share of carne guisada, and it is that dish, not tacos, that lets you know whether a restaurant is worth its salsa.

When making carne guisada at home, I don't like to add potatoes, though you certainly could. I like to add beer, preferably Uncle Billy's Smoked Baltic Porter. If you can't find our local Uncle Billy's Smoked Baltic Porter, try a local microbrew porter that is accessible in your area. However, don't use a hoppy beer or you'll end up with an excessively hoppy dish. Salt and pepper to taste as you please—the supertaster in me tends to be easy on the salt.

2–3 pounds ribeye*

olive oil

1 tablespoon fresh chopped garlic

2 medium onions, diced

4 jalapeños, seeded and chopped

2 tablespoons chili powder

½ teaspoon cumin

¼ teaspoon cayenne (or to taste)

salt (to taste)

2 cups beer (I used Uncle Billy's Smoked Baltic Porter)

45 ounces canned tomatoes

*sirloin can be used instead, but be sure to cut the pieces very small to prevent overdrying

Sear those ribeye steaks just until they get those grill marks. Remove the steaks from heat and allow to cool. Slice the ribeyes into bite-sized pieces, discarding the excess fat.

Coat the bottom of a large pot, like a Dutch oven or soup pot, with a tablespoon of olive oil. Heat it over medium heat and add the chopped garlic, onions and jalapeños. Sauté until the garlic and onions are translucent and the jalapeños are soft.

Add the chili powder, cumin and cayenne to the pot and allow it to cook and sizzle with the veggies. Once the spices have filled your kitchen with some awesome aromas, add in the seared and sliced ribeyes. Give the ingredients a good mixing so that the smoky spices have coated the meat and allow to cook for about 2–3 minutes.

Add the beer. If the beer is "fresh," it ought to foam and bubble up, releasing beer and spice aromas. Add in the tomatoes and allow the pot to come up to a simmer. Taste it now and add salt and pepper as needed. I tend to like my carne really spicy, so beware if you have this dish at my house.

At this point, you can add the mixture to a slow-cooker, or you can continue to cook on the stove top. If you decide to use a slow-cooker, you'll probably need to leave it for 4–5 hours on medium. If you cook it on a stovetop (be sure to check on it frequently so the bottom doesn't scorch), you'll probably need 2–3 hours on a simmer. Regardless, cook until the meat is fork tender.

You can serve the carne guisada now, or you can serve it the next day. Traditionally, it is served with warm tortillas. I also like to serve it with chopped cilantro. You might also serve it with traditional Tex-Mex fixings such as rice, beans, pico de gallo, sour cream, guacamole and salsa. It is one of those dishes that tastes better the next day. You can also freeze it for later. Now do enjoy my beer carne guisada! Serves 6–8.

Local Beer Adds to Austin Flavors

Shaun Martin, Bitch Beer (bitchbeer.org)

For almost a century, Shiner (from Spoetzl Brewery, established 1909) was the only independent brewery of note in Central Texas. Then, in 1996, Real Ale opened its doors, and Live Oak followed in 2000. Inspired by the success of these breweries among beer connoisseurs and encouraged by the camaraderie of the "Drink Local" movement, the industry slowly began to thrive. Independence Brewing Company opened its doors in 2004, and the battle for a place on Austin's taps accelerated.

Caroline Wallace.

However, it wasn't until 2008 that Austin's craft beer scene truly exploded. That year, (512) Brewing opened, followed shortly by Twisted X in 2009. Thirsty Planet and Circle Brewing joined the movement in 2010, with Jester King and Austin Beerworks opening in 2011. In 2012, the trend hit full throttle, with Hops & Grain, Rogness, Adelberts and South Austin Brewing Company all opening their doors within a six-month time span.

The rapidly growing food scene in Austin has helped to foster local brewing, as well as the movement toward buying and supporting local industry. With increased focus on greener lifestyles came the demand for quality local goods and services. Austin brewers have met that demand with passion and a broad range of products. From American IPAs to sour Saisons, Austin brewers continue to push the envelope with innovative styles to challenge and excite the palate.

As demand continues to grow, local craft beer is becoming more and more accessible, making its way into grocery stores, restaurants and even gas stations. Brewpubs and craft beer bars, in particular, have gone from novelty to the norm. Local hangouts such as Easy Tiger Bake Shop & Beer Garden, Banger's Sausage House & Beer Garden and Hopfields pride themselves on carrying a variety of local beers, as well as rare brewer collaborations and limited-edition kegs and casks. New brewpubs such as Uncle Billy's, Black Star Co-op, Pinthouse Pizza and Whip In (a convenience store that now includes a gastropub and brewery) have joined institutions such as Draught House and North by Northwest, further proving that while Austinites can appreciate fine cuisine, we can be just as won over with a really good beer.

Behind any great beer is a great brewer, and Austin is teeming with local beer crafters and aficionados. Through our research and writing, the women of Bitch Beer have been lucky enough to meet many of the people who make Austin's beer great. Their vision, combined with their love and appreciation of beer, are the driving force behind the craft beer movement. Not only do we appreciate them, we're insanely jealous of their career choice.

Pork Cascabel Tacos

Heather Santos, Midnite Chef (midnitechef.wordpress.com)

Living in Texas has influenced my choices in quickly prepared meals. Tacos are the ubiquitous fast food here, and there are as many ways to prepare them as there are fire ants in your backyard. Some like it hot—some as hot as an inferno. Others keep chiles out of the equation. Do you like avocado? Loads of diced vegetables? The selections of meats and different cuts within each type of meat are enough to send your tongue into a tizzy. Today, I had some pork stew meat ready to be made into something delicious, like these tacos. You can prepare the pork in advance and keep it in the fridge in a sealed container. The flavors will marry even more.

For the pork:
1½ pounds pork stew meat*
1 15-ounce can diced tomatoes
½ yellow onion, diced
5 dry cascabel chiles
1 poblano pepper, diced
salt and pepper, to taste

Pork Cascabel Tacos. *Melissa Skorpil.*

For the pico de gallo salsa:
1 tomato, diced
¼ cup diced red onion
2 tablespoons diced poblano pepper
⅛ teaspoon salt
corn or flour tortillas, for serving
grated sharp cheddar cheese, for garnish
salt and pepper to taste

*carnitas meat could be used as well

Place the pork, tomatoes, onion, chiles, poblano pepper and ½ cup of water in a crockpot. Cook on low for about 6 hours or until the meat is tender. You could also do this on the stove at a very low simmer. Pull the pork apart using two forks when it is finished cooking.

To make the fresh salsa, place the tomato, red onion, poblano pepper and salt in a bowl and combine. For the tacos, warm up tortillas in a small frying pan over low heat. Top

each warm tortilla with grated sharp cheddar cheese, shredded pork and pico de gallo salsa. Serves 4–6.

Texas Coffee Ribs

Sommer Maxwell, The Seasonal Plate (seasonalplate.blogspot.com)

3½ pounds rack of St. Louis–style ribs

⅓ cup brown sugar

1 tablespoon coffee grounds

1 tablespoon salt

½–1 tablespoon cayenne

1 teaspoon paprika

1 teaspoon garlic powder

1 tablespoon fine black pepper

1 teaspoon coarse black pepper

Remove membrane on both sides of ribs by sliding your fingers or a knife to pull the membrane off. You may need a paper towel to pull the entire membrane off. Rub the ribs with a rub made from the ingredients above. Place in the smoker meat side up and smoke at 225°F for 4½ hours or until the meat begins to pull away from the end of the bones about ¼ inch.

Texas Wine Industry

Rob Moshein, Austin Wine Guy (austinwineguy.com)

The Texas wine industry has come a long way since Spanish missionaries first started producing wines near El Paso in the 1600s.

In fact, a viticulturist from Denison named Thomas Munson is credited with helping save the wine industry in France in the late nineteenth century. At the time, a phylloxera epidemic was wiping out vineyards throughout Europe. Munson sent phylloxera-resistant rootstocks grown in Texas to France, which allowed the winemakers to successfully replant the vineyards that now produce some of the finest wines in the world.

The modern Texas wine industry dates back to the mid-1970s with the opening of Fall Creek Vineyards, just north of Tow, and Messina Hof Winery near Bryan. Now, the state's $1.7 billion industry includes more than 260 wineries from every corner of the state. Most of the grapes are grown in the High Plains area southwest of Lubbock, but some winemakers have had success growing heat-loving varieties in the Hill Country south and west of Austin.

A large part of the industry's economic impact comes from the nearly 1.5 million tourists who travel to the wineries to sample the wines, tour the facilities or even spend the night. More than thirty unique and visually stunning wineries participate in the Texas Hill Country Wine Trails, held four times a year.

Rather than trying to mimic the wines from California or the Pacific Northwest, Texas winemakers have embraced varietals such

as Sangiovese or Tempranillo, which grow well in similarly dry and hot regions in the Mediterranean. At Alamosa Vineyards, Jim and Karen Johnson blend Sangiovese, Tannat and Petit Verdot to create their spin on a Super Tuscan that they call Texacaia.

One of the brightest spots among Central Texas wines is the quality of the Viogniers, which are not only fruity but also well balanced and quite competitive in price. Recent vintages from Duchman and Pedernales prove the case. Quite a few Texas winemakers, including Cap Rock, have begun to focus on affordable Rhone-style whites, such as Marsanne and Roussanne.

In much the same way that wines from Italy or France or Spain complement the foods native to their country, Texas wines may work their best magic when paired with the stars of the local cuisine. You can find spicy, smoky reds that enhance the taste of carne asada; savory, full-bodied whites that go splendidly with grilled fish; and fruity reds that are awesome with Texas ribs or a thick steak. So the next time you decide to throw a porterhouse steak on the grill, pick up a bottle of a Texas red. And if Aunt Martha's fried chicken is making its way to the table, try it with one of those Texas Voigniers. Really!

Cactus Fruit–Glazed Tilapia

William Burdette, No Satiation (nosatiation.com)

As written, this recipe is for adventurous cooks with time on their hands who want to hang out by the grill, collaborate with others and make things from scratch. If you are really adventurous, you can forage your own cactus and tunas and even catch your own fish. But one person can also buy all the ingredients and assemble it in a matter of 30 minutes.

Here are some time-saving tips for a quicker version. If cooking with cactus is not your thing, Tears of Joy in Austin sells an outstanding house-made "Texas Cactus Hot Sauce," which is available at the store and online. Alternately, you can buy prepared nopales at a store that specializes in Latin cuisine and add them to your favorite salsa verde. Use canned corn and black beans for the salad, making sure to rinse them in a strainer to get rid of some of the excess sodium. There is no real substitute for fresh avocado in the salad, but you can buy some frozen mango puree. Thaw a bit of it, add it to the lime juice and use it to dress the salad. If you don't feel like firing up the grill, prepare the fish the same way but broil it over high heat in the oven until the glaze caramelizes.

For the glaze:

12 red tunas or cactus fruit

16 ounces red wine vinegar

½ cup sugar

1–2 chipotle peppers in adobo sauce

For the salad:

12 white corn tortillas

¼ cup olive oil

2 cups black beans

1 mango, chopped into 1-inch pieces

1 large avocado, diced

½ cup chopped cilantro

juice of 1 large lime

2 ears of corn

For the salsa verde with nopales:

4 medium-sized prickly pear cactus pads
 (nopales), spines removed

1 whole onion, halved

1 head garlic

3 jalapeños

1 cup cilantro

juice of 2 limes

salt and pepper to taste

6 tilapia fillets

salt and pepper, to taste

2 tablespoons olive oil

Take red tunas or cactus fruit and cut off tops and bottoms, watching for spines. Halve the cactus fruit and place them in a large skillet over medium heat. If you can't find red cactus fruit, pomegranate or watermelon makes a good substitute. In all cases, don't worry about the seeds. They will be strained out. Pour the vinegar into the pan and sprinkle in all of the sugar. Cut the chipotles in half and add to the pan. Let the syrup reduce until it coats the back of a spoon. Strain into a glass container and set aside, along with a basting brush.

Preheat the oven to 350°F. Drizzle tortillas with olive oil and salt and pepper to taste. Place the tortillas over upside-down silver bullet sauce cups, ramekins or small, oven-safe bowls. The tortillas should droop over the cups, forming a bowl or wide taco shape. Bake for 20 minutes or until golden brown. Set aside, uncovered, at room temperature.

In a large mixing bowl, combine all the ingredients for the salad except for the corn. Press some plastic wrap over the salad, compressing it in the bowl so as little air as possible reaches the avocados. Refrigerate until ready to serve.

Prepare the vegetables for the grill. Leave the corn and jalapeños intact. With the back of a knife, scrape off any spines from the prickly pear cactus pads. Cut off the top of the onion and cut it in half. French the onion halves without removing them from the root. Chop off the top of the garlic head.

Fire up the grill with a three-zone fire, banking the charcoal to one side of the grill. Before you put the grate on top, place the corn directly on the coals, rotating it every few minutes. When you can see the kernels through the corn husk, it is done. Let it cool, then remove the corn from the cob and set aside for the salad.

Place the clean, well-oiled grate on the grill. Place the cactus pads and the jalapeños

directly over the coals and char them on all sides. Place the onions and garlic, cut side down, in the middle zone of the fire. For a smokier salsa, add some soaked wood chips to the coals. When the jalapeños and cactus are totally charred, the tops of the garlic are golden brown and the onions have started to sweat, remove all the vegetables from the grill. Place the jalapeños and cactus pads in a bowl with a plate or plastic wrap on top. The heat from the vegetables will help steam off their charred skins. After a few minutes, remove the charred skins and stems from the jalapeños. (For a spicier salsa, leave the seeds in.) Remove the root from the onion. Remove the garlic cloves from their skins. Place all ingredients (don't forget the cilantro and lime juice) in a food processor and pulse. Salt and pepper to taste.

Prepare the fish for the grill by oiling it very lightly with olive oil and salting and peppering it liberally. Brush on the glaze on one side and cook it over the hottest part of the grill, just until the glaze is caramelized and grill marks are seared into the fish. Brush the other side with glaze and flip it. Cook the other side just until the glaze is caramelized and the grill marks are seared into the fish. Remove it from the grill. If the fish breaks while you are transferring it from the grill, do not worry. If the fish stayed intact, break each piece in half, for 12 total pieces.

Add the corn to the salad. Place three tortillas on each plate. Layer the salad in each crisp and top with a piece of fish. Serve with salsa verde on the side. Serves 6.

Sausage-Stuffed Quail. *Kristin Vrana.*

Sausage-Stuffed Quail

Meredith Bethune, Biscuits of Today (biscuitsoftoday.com)

Quails are popular game birds throughout Texas. This particular recipe is my attempt to re-create a product I purchased from Dai Due, a favorite artisan food company in Austin. I used my homemade Italian sausage, but you could experiment with other types.

For the brine:

¼ cup salt

6 bay leaves

4 semi-boneless quails

For the stuffing:

2 tablespoons olive oil, plus additional for rubbing on quail

1 tablespoon red pepper flakes

1 yellow onion, diced

2 cloves garlic, chopped

½ cup dried breadcrumbs

2 links sweet Italian sausage

black pepper, to taste

In a heavy-bottomed pot, combine 2 cups water, salt and bay leaves. Bring to a simmer to dissolve the salt. Turn off the heat and let the brine return to room temperature. Place the quails in the brine and then place the pot in the fridge for 2–3 hours.

While the quails are brining, make the stuffing. Heat the olive oil in a skillet with the red pepper flakes. Add the onion and cook until golden. Next, add the garlic and cook for about 2 minutes longer.

Place the onion and garlic mixture in a medium bowl and let cool slightly. Add breadcrumbs to the bowl. Squeeze the sausage from their casings into the bowl, and using your hands, mix to combine all the ingredients evenly.

Preheat the oven to 400°F. Remove quail from brine and pat dry with paper towels. Stuff the sausage into the cavities of the quails. Rub with olive oil and season with black pepper. Roast for 20–25 minutes or until internal temperature reaches 165°F. Serves 4.

Ancho Cherry-Raisin Glazed Pork Medallions with Toasted Almonds

Anna Ginsberg, Cookie Madness (cookiemadness.net)

When my daughter was very young, I took up a new hobby: entering recipe contests. While my favorite things to bake have always been sweets, I found the recipes that did the best in contests were entrées. This entrée, which I created for a California Raisins contest, won $10,000.

⅓ cup cherry preserves

2 tablespoons fresh chopped cilantro, divided

2 teaspoons ancho chile powder

Ancho Cherry-Raisin Glazed Pork Medallions with Toasted Almonds. *Melissa Skorpil.*

1 teaspoon sugar

⅛ teaspoon ground cinnamon

2 tablespoons balsamic vinegar

2 teaspoons fresh lemon juice

1 teaspoon cornstarch

1 pound pork tenderloin

¼ teaspoon salt

¼ teaspoon black pepper

1 tablespoon vegetable oil

⅓ cup sliced almonds

½ cup Riesling, divided (you could also use white grape juice)

½ cup raisins

In a jar or container with a tight-fitting lid, combine cherry preserves, 1 tablespoon of the cilantro, ancho chile powder, sugar, cinnamon, balsamic vinegar, lemon juice and cornstarch. Set aside.

Slice pork tenderloin crosswise into 1-inch-thick slices. Place slices in a heavy-duty resealable plastic bag and pound to about ¾-inch thickness. Sprinkle pork with salt and pepper.

Heat oil over medium heat in a large nonstick skillet. Add almonds and cook them for 2–3 minutes or until lightly browned. Remove almonds with a slotted spoon, leaving behind remaining oil. Add pork

medallions to skillet and cook for 2 minutes over medium heat. Add ¼ cup of the Riesling and continue cooking pork for another 6 minutes, turning the medallions halfway, until they are just cooked through.

Shake jar with cherry mixture and pour it into the skillet. Add raisins and stir over medium heat until sauce starts to thicken. Stir in remaining ¼ cup of Riesling. Place glazed pork medallions on serving platter. Sprinkle with toasted almonds and remaining cilantro. Serves 4–6.

A Vegan Pilgrimage

Stephanie Bogdanich, Lazy Smurf's Guide to Life (lazysmurf.wordpress.com)

Whether you're talking barbecue, tacos or sausages, Texas cuisine has long been dominated by meat, but in a place like Austin, vegan eats abound. I love it when out-of-town guests come, and I get to show them just how diverse (and delicious) vegan eating can be.

The first thing any vegan learns when planning a trip to Austin is to try the popcorn tofu at Wheatsville Co-op. Wheatsville is such a great grocery store that you can forget how lucky we are to have it until you are showing someone from another town the fresh produce from local farms, the raw kale chips and vegan queso made in Austin and even Mexican chocolate donuts from the city's vegan collective Red Rabbit Bakery. But the best are the morsels of tofu coated with a seasoned batter, then deep fried and served either on their own or in the popcorn tofu po' boy sandwich, a crusty baguette nicely sauced with the most deliciously creamy cashew tamari dressing and piles of vegetables.

That sandwich isn't the only reason why Austin's vegans aren't all skinny. Another is right up the street at Sweet Ritual, where you can find chocolate-coated homemade waffle cone sundaes with every imaginable veganized topping, from marshmallows to whip cream. An ever-changing array of flavors and the not-ella milkshake keep us coming back.

Grocery stores in Austin are some of the best anywhere, and it is always really fun to take vegans to the Whole Foods mothership. Their eyes light up like Christmas trees as they come upon the huge produce section, the array of breakfast tacos and Bar Lamar, where both wine and beer are on tap.

In fact, breakfast tacos are the one thing that I am always sure to recommend to vegans making a pilgrimage to our city. The options just keep getting more and more plentiful as time goes by, from the tofu scramble at Bouldin Creek Coffeehouse and the homemade vegan chorizo at Mr. Natural to new spots like the "Vegan Nom," an all-vegan taco truck on North Loop, and the vegan bakery trailer "Capital City Bakery." Other popular vegan/macrobiotic eateries include Casa De Luz, JuiceLand, "Wasota African Cuisine" (another

trailer) and the trailer-cum-restaurant, Counter Culture.

The vegan community is an active group, with bloggers rushing to cover new spots, a million posts on the Vegans Rock Austin message board and even our own Texas Veg Fest. And for the last few years, Green Island Catering has hosted a vegan party barge on Lake Austin—a public event that always sells out. As a community, of course, vegans also campaign to stop animal cruelty by protesting treatment of animals at the circus, working to make Austin a no-kill city with Austin Pets Alive and fundraising for Sunny Day Farms Animal Sanctuary through a bake sale in the fall of 2012.

So the next time you find out that your thirteen-year-old niece has started listening to Morrissey or your old college roommate has gone gluten-free/vegan/oil-free/low-carb, tell them to come for a visit to our own vegan mecca, right in the heart of Texas.

Creamy Chipotle Sweet Potato and Quinoa Casserole

Mary Helen Leonard, Mary Makes Dinner (marymakesdinner.typepad.com)

I don't mind admitting that I am just a little bit obsessed with quinoa. This nutty-flavored, perfectly chewy and super nutritious little grain has me by the heartstrings. I've used quinoa in countless dishes, but this casserole might be my favorite. The mildly spicy, slightly creamy layer of cheese and sweet potato that tops this dish isn't bad either. This recipe is a family favorite, and since my family is a mix of vegetarians and omnivores, I'm thrilled to have a recipe handy that will please them all. Served with a garden salad or green veggie, this hearty casserole makes a complete meal that will leave everyone at your table full and happy.

½ teaspoon salt

1½ cups dried quinoa

1 (15-ounce) can black beans, rinsed

2 medium tomatoes, seeded and diced

1 jalapeño pepper, minced

juice of 1 lime

salt and pepper to taste

3 cups shredded mozzarella cheese, divided

2 pounds sweet potatoes, thinly sliced

¼ cup mayonnaise

½ cup heavy cream

¼–½ teaspoon chipotle powder

Bring 3 cups of water with ½ teaspoon of salt to a rapid boil over high heat. Stir in quinoa, bring water back to a boil and then reduce heat to low. Simmer, covered, for 15 minutes or until quinoa is al dente and has absorbed the water. Mix the quinoa with the black beans, diced tomato, jalapeño and lime juice. Add salt and pepper to taste. Pack the mixture down firmly into the casserole dish, then top with one cup of shredded mozzarella.

Preheat the oven to 400°F.

Slice the sweet potatoes thinly using a knife or a mandoline. You can peel the sweet potatoes if you like, but it is not necessary. Set aside.

In a small bowl, combine the mayonnaise, heavy cream and chipotle powder. You can add a little more or a little less chipotle based on your taste and spice tolerance. Season with salt and pepper to taste.

In a large mixing bowl, toss together the sauce, sweet potato slices and 1 cup of shredded cheese. Don't worry about getting every slice coated evenly. They'll get more sauce when they are added to the casserole.

Spread the coated sweet potatoes over the layer of quinoa in your casserole dish, one slice at a time. Try to overlap each slice just a little to form a tight seal out of the sweet potatoes. When they have all been laid down, pour the remaining sauce over the top. Sprinkle the top with the remaining cup of mozzarella. If you like, you can sprinkle a little black pepper or dried parsley on top to make it more attractive.

Bake the casserole in the oven for 50–60 minutes or until the sweet potatoes have become fork tender, and the cheese has melted and browned. Let the casserole sit for about 10 minutes after removing it from the oven and then serve right away. Makes 8 servings.

Black Bean and Quinoa Burgers

Suzanna Cole, South Austin Foodie (southaustinfoodie.blogspot.com)

This recipe started out as a Latin-influenced black bean salad with jicama and other vegetables. I wanted a way to stretch the recipe, so I added the quinoa. After seeing a quinoa and bean burger recipe, I got the idea to adapt my existing one, so after a few trials, this is what I've come up with. You can cut the recipe in half, but you will still most likely need both eggs to help bind the mixture.

The raw quinoa "batter" will keep 2–3 days in the fridge, tightly covered; it may need a quick stir before making more patties. As an alternative to burgers, this makes a great

Black Bean and Quinoa Burgers. *Melissa Skorpil.*

filling for vegetarian tacos. You may want to make oblong shapes (like kefta) for cooking. Have fun experimenting and don't be afraid to play with your food!

5 tablespoons olive or grapeseed oil, divided, plus additional for cooking

¼ cup sliced green onion or diced red onion

1 medium red bell pepper, diced

1 ear corn, kernels removed from cob (or ½ cup frozen or canned)

1 jalapeño, minced

1 15-ounce can black beans, rinsed and drained (or 2 cups beans, prepared from dry beans)

2 cups cooked quinoa, cooked with broth or bouillon

1 teaspoon ground cumin

2 tablespoons lime juice

1 cup sharp cheddar cheese, shredded

2 eggs, beaten

½ cup flour

salt and pepper to taste

Heat 1 tablespoon of oil in a large skillet over medium heat. Add onions, bell peppers and corn, sautéing 3–4 minutes, until softened a bit. Add jalapeño halfway through, stirring occasionally. Place vegetables in a large bowl and allow to cool for a few minutes. Add black beans and combine well. Add cooked quinoa once it has cooled and toss to combine.

In a small bowl, whisk together cumin, a pinch of salt and lime juice. Add 3 tablespoons oil, whisk well to combine and pour over quinoa mixture; toss well. Add cheese, eggs and flour and gently but thoroughly combine.

Heat skillet over medium heat; add remaining tablespoon of oil to coat the bottom of the pan. Using your hands, gather a tennis ball-sized portion of the quinoa mixture and press into a patty, about ¾- to 1-inch thick. Place in skillet and repeat. (I usually get about 4 burgers per skillet batch; you don't want to crowd the skillet too much, or they will be harder to flip. You can also make them whatever size you wish, but when larger, they are harder to keep together when flipping.)

Cook 3–4 minutes per side, until golden and crispy. Additional oil may be needed when flipped. Remove from pan; serve or place on wire rack in low temp oven to keep warm while finishing cooking.

A trick to preparing them if you plan on cooking them on the grill or freezing them is to prebake the patties in the oven, preheated to 350 degrees. Be sure to grease the pan with a small amount of olive oil, lay the patties out in the desired size and bake for 15 minutes. This either allows them to keep their shape through the grilling process or makes them ready to be heated in a skillet once defrosted from the freezer.

Serve with your favorite burger accessories. Makes about 12 burgers.

Rancher's Pie

Kristin Sheppard, Mad Betty (madbetty.com)

A southwestern take on traditional shepherd's pie, this dish can be made ahead of time and heated up for a warm, comforting dinner. This hearty meal with layers of flavor will satisfy the hungriest of herders.

5 Yukon gold potatoes, peeled

2 tablespoons unsalted butter

½ cup sour cream

1 4-ounce can diced chiles, drained

1 teaspoon salt

½ teaspoon pepper

½ pound fresh Mexican-style chorizo

2 tablespoons olive oil

2 medium onions, roughly chopped

1 pound lean ground beef

1 red bell pepper, chopped

3 cloves garlic, minced

1 cup corn, canned or fresh

1 14.5-ounce can fire-roasted tomatoes

1 teaspoon cayenne

½ teaspoon cumin

1 teaspoon chili powder

½ teaspoon paprika

1 teaspoon salt

1 tablespoon flour

1 cup light Mexican beer, such as Tecate

1 cup beef broth

1 cup shredded cheddar cheese

chopped cilantro, for garnish

Rancher's Pie. *Margaret Christine Perkins.*

In a large pot, boil potatoes in water for 35 minutes or until easily pierced with a fork. Mash with butter, sour cream, chiles, 1 teaspoon salt and ½ teaspoon pepper. Cover and set aside.

Preheat the oven to 325°F.

Brown chorizo over medium heat in a deep skillet. Remove meat and drain fat. Add olive oil and chopped onions and cook until soft, about 7 minutes. Add ground beef to the onions and cook through, stirring frequently.

Add bell pepper and garlic and cook until soft, about 5 minutes. Drain the corn if using canned and add it to the skillet along with the tomatoes and their juices. Finally, add the cooked chorizo. Stir in the cayenne, cumin, chili powder, paprika, salt and flour. Pour in beer and broth and let simmer and thicken for 25 minutes.

Pour mixture into a large pie plate. Carefully top with mashed potatoes, smoothing to the edges and covering the entire dish. Bake in oven for 30 minutes. Sprinkle cheddar evenly on top and cook for an additional 10 minutes, until cheddar is melted. Garnish with fresh cilantro and serve. Serves 8.

Rainbow Soba. *Mary Helen Leonard.*

Rainbow Soba

Mary Helen Leonard, Mary Makes Dinner (marymakesdinner.typepad.com)

This recipe came together on a sketchpad before it made it into the kitchen. At last year's Texas Book Festival, I watched a demo with Tyson Cole, chef and owner of Uchi. He issued a challenge that stuck with me when he asked the crowd to create a dish based on color as much as flavor. I remembered the challenge one afternoon while I was sketching some food illustrations. How would I paint a bowl of noodles? I added red and yellow peppers, orange mandarin, green herbs, pink shrimp and purple eggplant to a swirl of nutty brown noodles. In the kitchen, I topped it with a sauce that goes down like a good romance—sweet as sugar, hot as flame. This is a dish that I cook mostly for myself, as it is tailored exactly to my personal taste and imagination. Rainbow Soba packs a hefty punch of heat, so if your taste buds are timid, be sure to omit some or all of the hot chile paste/sauce.

1 8-ounce package of dry soba noodles

3 tablespoons turbinado sugar (demerara or brown sugar would also work)

2 tablespoons soy sauce

1 teaspoon hot chile paste (Sriracha, or any hot chile sauce would also work)

1 teaspoon ginger powder

1 teaspoon garlic powder

3 tablespoons cooking oil (vegetable, peanut or canola are good choices)

1 Japanese eggplant, halved and sliced

1 yellow bell pepper, sliced into strips

1 Fresno or jalapeño pepper, seeded and sliced

½ bunch scallions, shredded or sliced

2 small mandarin or clementine oranges, peeled and divided into segments

8 ounces large raw shrimp, peeled and deveined

1 handful cilantro, leaves removed from the stem, roughly chopped

salt and pepper to taste

Cook the soba noodles according to package directions, then drain and immediately rinse with cold water until fully cooled. Set the cold noodles aside.

In a small saucepan, whisk together the ½ cup of hot water, sugar, soy sauce, hot chile paste, ginger powder and garlic powder. Heat the ingredients over high heat until it comes to a boil. Reduce to low and allow to simmer for 5 minutes. Remove from heat and set aside.

Add 2 tablespoons of cooking oil to a large skillet or wok and heat over medium. Allow the pan to heat up for about 30–60 seconds, then add the eggplant and cook for about 3 minutes or until it begins to soften. Add the bell peppers and cook for another two minutes before adding the Fresno peppers. Allow the veggies to cook together for another minute or so, then add the scallions and mandarin oranges. Cook for just a minute or so, then remove the veggies from the pan. Season the shrimp with salt and pepper in a separate bowl.

Return the pan to heat and add the remaining tablespoon of cooking oil. Allow the oil to heat for 30–45 seconds, then add the shrimp and sauté until they are just cooked through. As soon as they are opaque through the middle, they are done.

Add the veggies and noodles back to the pan, followed by the sauce. Toss the ingredients together to coat the noodles and heat everything through. Taste and then season with salt and pepper if needed. Add the cilantro and then serve immediately. Serves 2.

Sweet and Savory Goat Ragù. *Meredith Bethune.*

Sweet and Savory Goat Ragù

Meredith Bethune, Biscuits of Today
(biscuitsoftoday.com)

I made this dish after spotting Windy Hill Farm goat meat at Wheatsville Co-op, my favorite grocery store. Slow-cooking the goat meat renders it meltingly tender, and dinner is ready when you get home from work. This ragù, made slightly sweet with the addition of white wine and golden raisins, is particularly delicious served over gnocchi.

1 pound goat stew meat, cubed

salt and pepper, to taste

2 tablespoons olive oil, divided

1 yellow onion, diced

1 teaspoon dried thyme

1 teaspoon red pepper flakes

1 carrot, peeled and sliced into discs

6 cloves garlic, chopped

1 cup white wine

1 14-ounce can peeled whole tomatoes

1 sprig fresh rosemary

½ cup golden raisins

Dry the goat meat with paper towels and season it aggressively with salt and pepper. Add 1 tablespoon of the olive oil to the skillet and turn the heat up to medium high. When the oil is hot, add the meat to the skillet to get a good sear on it. Turn the heat off after about five minutes, remove the goat meat and place it in the slow cooker.

Place the skillet back on the stove and pour in the rest of the olive oil. Add the onions, dried thyme and red pepper flakes. Cook over medium heat.

Add the carrots after the onions become translucent. After five minutes, add the garlic and cook until just browned. Turn off the heat and scrape the vegetables into the slow cooker.

Pour the white wine and tomatoes into the slow cooker. Toss in the rosemary and raisins and stir to combine all of the ingredients. Turn on the slow cooker and cook for at least eight hours, but sixteen is even better. Shred the meat thoroughly with a fork before serving it over pasta or gnocchi. Serves 4.

Margherita Pizza. *Melissa Skorpil.*

Margherita Pizza

Michelann Quimby, CSA for Three (csaforthree.com)

This is my favorite pizza to date. It is incredibly fast and incredibly delicious. It uses ingredients I will have in my CSA box for much of the summer: cherry tomatoes, garlic and basil. There have been a lot of roasted cherry tomato recipes floating around the Internet, and I thought they might work on a pizza, even though the cooking time is so fast. Turning them cut side up keeps the juices from running all over the pizza, and steeping the herbs and garlic in the olive oil increases the flavor tremendously.

2–3 cloves garlic

⅓ cup basil (I have also used mixed herbs from my garden when I don't have basil)

¼ cup olive oil

1 small round fresh mozzarella cheese

1–2 cups cherry tomatoes

½ cup grated Pecorino Romano cheese

pizza crust of choice (I use a thin premade crust that I freeze and pull out right
 before baking)

Preheat oven to 425°F. Roughly chop garlic and chiffonade the basil. Combine with olive oil in a small bowl and set aside. Thinly slice mozzarella rounds, and halve the tomatoes.

 Brush crust generously with olive oil mixture, reserving most of the herbs and garlic. Arrange mozzarella slices on crust, keeping a 1-inch margin around the outer edge. Arrange tomatoes over the cheese, cut side up. Using a spoon or your hands, distribute the olive oil soaked garlic and basil over the cheese and tomatoes. Generously sprinkle with Pecorino Romano. Bake for 12 minutes or until cheese is melted and crust is crisp. Serves 6.

Tiffany's Fried Chicken

Tiffany Harelik, Trailer Food Diaries (trailerfooddiaries.com)

Fried chicken was the first dish I learned how to make when I was preparing to leave for college and realized that I was going to need a battery of go-to dishes to cook at the dorm. This turned out to be a favorite among friends and family, and I still make "Sunday Fried Chicken" to bring them together.

 I learned how to fry chicken from my mother (Patsy Hobbs Harelik), who learned from her mother (Tura Stephens Hobbs), who learned from her mother (Henrietta Samford Stephens); this brings us to at least four generations of Austinites frying chicken. With any luck, my daughter (Callie Michelle Lanier) will learn the art, too.

 Like my mom, I frequently modify recipes according to what I'm in the mood for and what I have in the kitchen. You can do the same with this fried chicken recipe, which has been adapted many times over the years. I've soaked the chicken in Royito's Hot Sauce, Italian salad dressing, Coca Cola or plain old buttermilk. The only things that never change: paprika in the flour mixture (something my grandmother always added) and the cooking vessel (a cast-iron skillet).

Tiffany's Fried Chicken. *Margaret Christine Perkins.*

Frying chicken is a labor of love and a time commitment. The whole process will take about an hour, so invite a friend over to help and share a glass of wine or two while you're at it.

2 boneless, skinless organic cage-free chicken breasts

16 ounces sweet tea

2¼ cups flour

2¼ cups Italian-style breadcrumbs (or panko or freshly grated day-old biscuits)

1 tablespoon paprika

1 tablespoon Tony Chachere's Original Creole Seasoning

1 tablespoon dried parsley

1 tablespoon herbes de Provence

1 tablespoon dried oregano

1 tablespoon sea salt

1 tablespoon cracked pepper

6 eggs

1½ cups buttermilk (you can substitute regular milk)

3–4 cups canola or vegetable oil for frying

½ cup mustard (I prefer brown mustard)

Rinse the chicken off with room-temperature tap water in a colander in your sink. Using kitchen scissors, cut the breasts into ¾- by ½-inch "tender" strips (depending on the size of the breasts, you should end up with about 15 tenders).

Place chicken in a resealable plastic bag or large bowl and pour the sweet tea over the tenders until each piece is fully submerged. Refrigerate marinating tenders for 20–30 minutes, but not much more.

Meanwhile, in a large bowl, stir together flour, breadcrumbs, herbs, spices, salt and pepper. In another large bowl, whisk together eggs and buttermilk.

In a cast-iron skillet, heat canola or vegetable oil over medium-high heat until the oil reaches 350°F or a pinch of the flour mixture sizzles loudly and floats a little. (Depending on the size of your pan, you may need to modify how much oil you are using because you'll need enough oil in the pan to partially immerse about 4–6 pieces of chicken at a time.)

While the oil is heating, place mustard in a small bowl, remove chicken from the fridge and, using your hands, slather each piece of chicken with a thin layer of mustard. Place chicken pieces on a baking sheet lined with a paper towel.

Working in batches of 4–5 pieces of chicken at a time (or however many will comfortably fit in your pan with lots of room to fry), dredge each piece in the flour mixture. To lightly pat the flour mixture into the chicken, toss between your hands like a hot potato. Then dip the floured tender in the buttermilk bath, immersing the tender completely for a quick second. Immediately dip your wet tender back in the same flour mixture. (Double-dredging like this makes for a thicker dough on your crust, which means tastier fried chicken. You can also shake the flour mixture and chicken in a paper bag, if you prefer.)

Drop prepared tenders into the oil and cook on one side for 3–4 minutes. (Don't let your oil get so hot that it smokes. You might have to turn down the heat to prevent it from overheating.) Use tongs to carefully flip each tender over so that both sides cook for equal amounts of time. Both sides of the tenders should turn the same golden

brown color. Remove the tenders from the hot oil and place on clean paper towels on top of a baking sheet to drain excess oil.

After the pieces have cooled slightly, use a fork and knife to cut into the center of the thickest tender to make sure the batch has cooked thoroughly. If you see any pink, fry the chicken longer until the meat is white but tender. Repeat this process until all of your chicken has been fried. If not serving immediately, you can hold the chicken in a 200°F oven to keep it warm. Leave the doors and windows open if you want the neighbors to stop by. Serves 4.

Baked Chicken on Bread (Musskhan)

Sahar Arafat-Roy, TartQueen's Kitchen (tartqueenskitchen.com)

Sumac is a spice from a bush by the same name. The "berries" are usually sold dried and ground in Middle Eastern markets. Sumac is used to give a lemony, astringent flavor to foods. It is used in the spice mix Za'atr to spice meats for kebabs and is even sprinkled on eggs and vegetables. It has a deep red to burgundy color. It is not to be confused with ornamental sumac bushes found commonly in the United States and Europe.

2 whole frying chickens, halved (about 4½–5
 pounds)
 or
10–12 chicken thighs

¼ cup dried sumac (be sure it's fresh)

juice of 1 lemon (approximately 2
 tablespoons)

2 teaspoons salt

1 teaspoon pepper

1 teaspoon allspice

¼ cup olive oil

3 large onions, cut in half and thinly sliced

1 teaspoon salt

1 teaspoon brown sugar

2 tablespoons sumac

¼ cup pine nuts

3 rounds of pita bread, split

½ cup olive oil

½ cup chicken broth

Wash and dry the chicken and place in a large bowl or zip bag. In a small bowl, mix together the ¼ cup sumac, lemon juice, salt, pepper and allspice. Pour over the chicken, making sure that the chicken is covered in the marinade. Let sit for at least 2 hours and up to overnight. The longer you let the chicken sit in the marinade, the stronger the flavor.

Heat the ¼ cup olive oil in a large skillet. Add the onions, salt and sugar. Lower the heat to medium-low. Slowly cook the onions until they are very soft but not caramelized. Stir in the sumac and pine nuts. Remove the skillet from the heat and set aside.

Preheat the oven to 375°F. Spray a deep baking dish. Lay the bread over the bottom of the dish. Spread the onions over the bread. Remove the chicken from the marinade and lay over the onions. Pour over another ¼ cup olive oil and ¼ cup chicken broth. Cover and bake for 20 minutes. After

20 minutes, uncover the chicken and continue cooking until the chicken is done, about another 20–30 minutes or until an instant-read thermometer registers 165°F when inserted into the thigh.

Serve the chicken with rice and *lots* of yogurt. Serves 6–8.

Persian Lamb Stew

Michelle Nezamabadi, Beyond Picket Fences (beyondpicketfences.com)

This Persian lamb stew is my family's standard Sunday meal. It's hearty, comforting and delicious. Best of all, it's easy to make. In Iran, this dish is called *abgusht*, which simply means "meat soup." It is a humble dish cooked in clay pots placed directly in a fire and slow-cooked for hours. Untrimmed bone-in beef cuts are also a good substitution for the lamb. You can find dried lemons at any Middle Eastern grocery store or specialty food store. Jalapeño peppers are not readily available in Iran, but the Texan in me had to have some heat. (You can remove the seeds for less heat.) I frequently make "Persian tacos" from this recipe with flour tortillas and use pickled vegetables as a salsa. This dish is Persian comfort food, Texas-style.

1½ cups dry white beans

1 cup dry garbanzo beans

1 lamb shank (2–3 pounds)

1–2 whole fresh jalapeño peppers

2 small-medium whole tomatoes

Persian Lamb Stew. *Sara Nezamabadi.*

2–3 dried lemons

2 tablespoons turmeric powder

2 teaspoons salt, plus more to taste

1 teaspoon ground black pepper

1 teaspoon garlic powder

3 large potatoes, peeled

1 8-ounce can tomato sauce

Thoroughly wash the beans and soak them for 30 minutes.

In a large, deep stew pot, place the whole lamb shank, beans, jalapeños, whole tomatoes and dried lemons and fill the pot with water, approximately 8–10 cups. Add the spices, mix and bring to a boil. Once boiling, reduce the heat, cover and let simmer for 2 hours. Add water as needed to maintain liquid level in the pot.

After two hours, the beans should be soft and the lamb falling off the bone. Add the potatoes and tomato sauce. Taste the broth

and add salt if needed. Let simmer for another hour until the potatoes are soft and starting to fall apart. Once the potatoes are done, drain the broth into a serving bowl and keep all the solid ingredients in the pot.

Pull all the lamb bones out, as well at the tomato skins and jalapeño stems. Mash the solid ingredients with a wooden mallet or potato masher or blend with immersion blender or food processor until mostly smooth but slightly chunky. If the mash seems a bit dry, add a few ladles of the broth to it and mix in.

There's no special way to eat this dish. You can spread the mash on a piece of warm pita bread or roll and dip into a bowl of the broth. You can eat the soup and the mash with fresh onion or pickles, or you can wrap the mash in tortillas and make Persian soft tacos. Whatever tastes good to you is the best way to eat it. Serves 8.

Linguini and Clams

Addie Broyles, The Feminist Kitchen (thefeministkitchen.com)

I'd never had linguini and clams before I met my husband, Ian, who does as much of the cooking in our house as I do, if not more. He often makes his version of "linguini alle vongole," a dish he fell in love with at an Italian restaurant in his hometown in southern Alberta, Canada. Over the years of re-creating it at home, his recipe, which our two little boys love as long as the clams are minced, has

Linguini and Clams. *Addie Broyles.*

come to involve pasta, lots of garlic and salt, mushrooms, olive oil and butter, dried parsley, heavy whipping cream, grated Parmesan cheese (blasphemous, I know), sliced green onions and regular old canned clams. (He'll substitute leftover chicken or shrimp if we're out of clams.) His comfort food has become my comfort food, but when I cook this, I like to throw in a few vegetables such as green beans, spinach or kale, cut down a wee bit on the cream and serve it with a salad to lighten things up. A splash of white wine, if you have an open bottle in the fridge or need an excuse to open one, adds a nice touch.

12 ounces dried linguini

2 tablespoons olive oil

1½ cups chopped green beans

2 tablespoons minced garlic

4 button mushrooms, finely chopped
 or minced

½ teaspoon salt, plus additional for
 pasta water

1 6½-ounce can minced clams, drained and liquid reserved

¼ cup heavy whipping cream

¼ cup grated Parmesan cheese

sliced green onions, for garnish (if desired)

In a large stockpot, bring 3 quarts water to a rolling boil and add several heavy pinches of salt. Place dried pasta in pot and cook according to package directions; drain and place pasta back in pot. (Ian insists on rinsing the cooked pasta and drizzling with more olive oil.)

While pasta is cooking, heat olive oil in a large sauté pan over medium-high heat. Add green beans and cook, stirring occasionally, for five minutes. Add garlic, mushrooms and ½ teaspoon salt to the pan and stir. Cook for two minutes, then add drained clams. Stir and add whipping cream and ¼ cups of the reserved clam juice. (If you have some white wine handy, splash the pan with it now.)

Pour the clam and green bean mixture over the pasta, add Parmesan cheese and combine. Top with sliced green onions when serving, if desired. Serves 4.

Bacon Corn Pesto Pasta

Lindsay Robison, Apron Adventures (apronadventures.blogspot.com)

Growing up in Texas with two parents from Iowa, I have a strong appreciation both for cooking with bacon and eating lots and lots of corn. Luckily, this recipe combines my love for both. It's now become a staple of summer for me and regularly makes appearances at potlucks and cookouts, not to mention Sunday lunch. I've taken to growing several basil plants in my garden window box just to supply enough for my pesto habit, and they always take a hit after preparing this recipe.

4 bacon slices, chopped

6 ears corn, kernels removed

1 large garlic clove, minced

salt and pepper to taste

1 cup freshly grated Parmigiano Reggiano cheese, divided, plus additional for serving

½ cup pine nuts, toasted and divided

¾ cup coarsely torn fresh basil leaves, divided

⅓ cup extra virgin olive oil

12 ounces tagliatelle or other pasta of your choice

Bacon Corn Pesto Pasta. *Lindsay Robison.*

Cook bacon in cast-iron skillet over medium heat until crisp and brown, stirring often. Using slotted spoon, transfer to paper towels to drain. Add corn, garlic and salt and pepper to taste to drippings in skillet. Sauté over medium-high heat until corn is just tender but not brown, about 7–8 minutes. Transfer 2 cups corn kernels to small bowl and reserve.

Scrape remaining corn mixture into a food processor. Add ¾ cup Parmigiano Reggiano, ⅓ cup pine nuts and ¼ cup basil leaves. With machine running, add olive oil through feed tube and blend until the pesto is almost smooth. Set pesto aside.

Cook pasta in large pot of boiling salted water until just tender but still firm to bite, stirring occasionally. Drain, reserving ½ cup pasta cooking liquid. Return pasta to pot. Add corn pesto, reserved corn kernels, and ½ cup basil leaves. Toss pasta mixture over medium heat until warmed through, adding reserved pasta cooking liquid by ¼ cupfuls to thin to desired consistency, 2–3 minutes. Season pasta to taste with salt and pepper.

Transfer pasta to large shallow bowl. Sprinkle with remaining ¼ cup basil leaves, 3 tablespoons pine nuts and reserved bacon. Serve pasta, passing additional grated Parmesan alongside.

Smokey Janes. *Michelle Fandrich.*

Smokey Janes

Michelle Fandrich, The Kid Can Cook
(thekidcancook.blogspot.com)

Growing up, one dinner my brother and I always looked forward to at our house was Sloppy Joe night. Ground beef mixed with a sweetly savory tomato sauce may not be haute cuisine, but it is high in comfort. This recipe, adapted from one on Whole Foods Market's blog, was inspired by those childhood memories.

1 tablespoon canola or vegetable oil

1 medium red onion, finely chopped

1 cup peeled and grated organic carrots

2 chipotles in adobo, drained and finely diced

1 pound lean ground turkey

1 teaspoon garlic powder

1 6-ounce can organic tomato paste

2 tablespoons organic yellow mustard

4 teaspoons balsamic vinegar

1 tablespoon honey

salt and pepper to taste

6 whole wheat hamburger buns

In a skillet over medium heat, add oil and sauté onions and carrots until soft. Add the diced chipotles and stir to combine, allowing the mixture to cook for a few minutes before adding the turkey. Cook until turkey is cooked through, separating the meat into small chunks with a wooden spoon or spatula. When turkey is fully cooked, add garlic powder, tomato paste, yellow mustard, balsamic vinegar and honey and stir to combine. Reduce heat and allow mixture to simmer for 5–10 minutes, stirring occasionally. Pile onto hamburger buns and serve warm. Makes 6 servings.

Condiments and
Canning

For the Birds Salsa

Rachel Matthews, And Then Make Soup
(andthenmakesoup.wordpress.com)

I like my salsas more sweet than hot, but I'm always looking for ways to use the chile pequins (or bird peppers) that grow around my yard. (Thanks to the birds for depositing seeds and giving me these plants.)

Understand that I am a Yankee, so this is not a traditional "salsa"; my version is only barely spicy, not hot at all. It is a salsa only in the sense that it has tomatoes in it and tastes delicious on chips. Like most of my "recipes," this one is pretty flexible. If you have a mango allergy, you can substitute peaches, and if you have a more heat-tolerant palate than I do, feel free to up the pepper amount.

The salsa is, of course, better the second day. If you don't have any bird chiles growing in your yard, I can probably supply them to you.

2 dried chile peppers
½ teaspoon coarse kosher or sea salt
1 pound fresh ripe tomatoes (about 3 cups),
 seeded and chopped

For the Birds Salsa. *Kristin Vrana.*

1 clove garlic, chopped very fine
½ medium red onion, chopped
1 or 2 Ataulfo mangos, peeled and cubed
1 bunch cilantro, roughly chopped
juice of 1 lime

Grind the chile peppers and salt together with a mortar and pestle. Combine all other ingredients in a medium-sized glass mixing bowl. Sprinkle with chile/salt mix and stir to blend well. Allow to sit at least 15 minutes before serving. Serves 4–6.

Lemon-Fig Jam Doth Not a Meal Make

Kate Payne, The Hip Girl's Guide to Homemaking (hipgirlshome.com)

You had a banner year in your arugula garden, but really, how many arugula salads can one person eat in a season? So you took the last few pounds and made your favorite arugula pesto—12 jars of it. What to do with it now?

Or Aunt Sally thoughtfully brought you a sack of her homegrown zucchini—10 pounds of the lovelies. Not knowing what else to do before it rotted in your fridge, you made enough zucchini bread to feed the population of Zambia. Now if only you could get it to Zambia (if they actually liked zucchini bread).

These are the sorts of problems that vex home cooks. Now, there's a solution, one that's been used by home cooks for centuries—maybe forever—and only recently has been revived: food swaps. Hosting a swap—where you'll trade those jams or breads or cookies for the spaghetti sauce, pecans and pickles that your friends made—is easy and fun, but it helps to have some guidelines.

How to Host a Food Swap

1. *Share the work*. I know I said it's fun and easy, but there's still enough in the planning and execution that you may want to find a friend to run the swap with you.

2. *Decisions, decisions*. Pick a place to hold the swap: in your living room, a backyard or a local park, maybe even a church hall. Decide if you'll let folks swap only food or whether you'll open the swap to items like soap or handmade scarves or whatever. (It's best to limit the swap to handmade items only.) You'll need space to handle at least a few long tables where swappers display their items, which leads to the next decision: how many swappers to allow? Too many can be madness, so most swap hosts limit themselves to twenty to thirty.

Many swap hosts also like to incorporate a bit of a potluck into the event. Foodies enjoy cooking for anyone, so have a separate space to set out those items.

3. *Get the word out*. Create an electronic invitation, a Facebook page or just an e-mail list to let friends know what's happening. If you're on Twitter, use a unique Twitter hashtag (e.g., #ATXfoodswap), so attendees can connect before and after your events. Be sure to include an RSVP so you don't oversell the event.

Some people will want to bring more than one item, so give them a limit on the number or an idea of how much space they'll have for display (generally about one and a half square feet). You may also recommend that they bring samples for people to try.

4. *Mise en Place*. You'll need to do a small amount of prep:

- Name tags. No one wants to be called the "Chocolate Cookie Lady," and in any case, you might have two of them. Name tags also make it easier for people to find the ones who wrote on their swap sheets.

- Give swappers a small sign or tag—like an index card—on which to write what they're offering, the ingredients and something about how it's used (i.e., marinade for pork, a relish for fish or sauce for pasta).

- Swappers will need a sign-up sheet for each offering, where bidders put their names and what they're offering to trade. Also, a sheet for each person to keep track of what he or she have bid on is handy.

5. *Send out instructions*. You'll want to let everyone know how the event works, either ahead of time or at the start of the swap.

Typically, a swap runs for two hours. The first hour is sort of like a silent auction, in which you scout out the offerings and write on a swapper's sheet what you like and what you have to trade. The second hour is more chaotic, when swaps actually take place. You assess what you want and what's been bid for your items and then work on completing the trades.

It's important to know that writing your name on something does not mean that you will get it. Actual swapping takes place via discussing exchanges. Bids you've received are a good starting place, but you might also want to focus on the items you're most interested in and seeing if you can get those people interested in a swap.

Want to know more or find a swap in your area? Visit the Food Swap Network at www.foodswapnetwork.com.

Sweet Hot Mustard

David Ansel, advisory council member

This mustard mellows slightly after a few days, but it still provides an invigorating burst of flavor when you serve it with pretzels, knishes, blue cheese on crackers or sausage wraps. Measure the Colman's—yes, Colman's, the kind in the yellow tin—by weight, not volume.

4 ounces Colman's dry mustard

1 cup white vinegar

2 eggs

1 cup sugar

1 teaspoon salt

Mix dry mustard and white vinegar together in a nonreactive bowl and let sit overnight. In a medium saucepan over medium heat, whisk together the mustard mix, eggs, sugar and salt until bubbly. Remove from heat and cool. Keeps for 4–6 months in the fridge. Makes one pint.

Mom's Green Chutney

Shefaly Ravula, Shef's Kitchen (shefskitchen.wordpress.com)

Chutneys in India are not what one thinks of as chutney in the United States, which is more like a marmalade. Indian chutneys (or chatnis) are savory, vibrant and exploding with flavor and have a sauce-like consistency. Sometimes chutneys are cooked, and sometimes they are raw. This cilantro chutney is called "green chutney" by most Indians and is a basic component in most chaat/snack dishes and Indian street foods, as well as a condiment in sandwiches or a dipping sauce for vegetables or chips.

As a kid, I watched my mother make this numerous times in her boisterous Osterizer blender. She made this traditional family recipe unique by adding peanuts to act as a thickener and also a better vehicle to balance the strong flavor of the cilantro and ginger. Most people that have had this chutney cannot

Mom's Green Chutney. *Shefaly Ravula.*

even taste the ginger. This chutney keeps well in the fridge, and you can even freeze it in ice cube trays.

¼ cup raw unsalted peanuts

1 bunch cilantro, coarsely chopped, discarding only the thicker parts of the stems

½–1 serrano chile pepper, coarsely chopped, including seeds

1½–2 tablespoons coarsely chopped peeled ginger

1 teaspoon kosher salt

½ teaspoon sugar

2 teaspoons fresh lime juice (about ½ of a juicy lime)

Put the peanuts into a blender or food processor. Pulse a few times to grind peanuts to a medium-fine powder. Be careful not to over-purée and make peanut

butter. Add the rest of the ingredients to the blender, as well as ½ cup water, and blend to a purée, stopping to stir from the bottom periodically. Within minutes, you will have a bright leprechaun green chutney with the consistency of thin pancake batter.

Hatch Chile Pepper and Cherry Salsa

Elizabeth Van Huffel, Local Savour (LocalSavour.com)

Hatch Chile Pepper and Cherry Salsa. *Elizabeth Van Huffel.*

Every August, Austinites seem to come down with a case of Hatch chile fever. Many local grocery stores and restaurant sell the peppers or hundreds of salsas, queso, sausages, enchiladas and other dishes made with them. Although I have spent some time (briefly) in New Mexico, where the chile peppers originate, I really didn't know much about these peppers until moving to Austin.

Roasted, grilled, stuffed, chopped or diced. You can do just about anything with these chiles, including freezing them for a taste of August in the dead of winter.

5–6 Hatch chile peppers, washed, seeded and chopped

1 small onion, peeled and chopped

zest of 1 lime

¼ cup chopped fresh cilantro

1–2 small jalapeños, seeded and chopped (optional)

1 teaspoon sea salt

2 cups cherries, pitted and finely chopped

In a medium bowl, add peppers, onion, lime zest, cilantro, jalapeños (if using) and salt. Stir well and set aside. Place the cherries in a strainer over a medium bowl to let the juices drain. Stir gently and let drain for about 5 minutes. If serving right away, combine pepper mix and cherries and serve. If serving later, cover both bowl and store in the refrigerator until ready to serve. (Keeping the cherries separated from peppers prevents the red color from taking over your salsa.) Makes 4–5 cups.

Local Food Bounty: Farmers' Markets and Urban Farms

Kristi Willis, Kristi's Farm to Table (kristisfarmtotable.com)

On Saturday mornings, the opening bell clangs as Republic Square transforms from a quiet park to a bustling shopping experience. Visitors at the Sustainable Food Center's Farmers' Market Downtown—Austin's largest—meander among the stalls, buying up fresh produce, cheeses, jams, meat and bread while enjoying prepared foods and drinks from local vendors.

You can repeat this scene at almost a dozen markets and farm stands in the Austin area on a Saturday morning and at least one every day of the week except Monday. (Even farmers need a day off.) In the ten years since the Sustainable Food Center started its market downtown, Austinites have shown overwhelming support for buying directly from area farms and artisans.

I was drawn to the downtown market shortly after it opened in 2003 because I remembered going to the Amarillo market on sunny summer mornings with my dad, with produce piled high on the tables and farmers greeting each customer warmly. I wanted to have that same sort of direct buying experience in Austin, as well as to learn more about what fruits and vegetables come from Central Texas's fields. Despite my fifteen years of living in Austin, I had no connection with local food.

Now I spend my Saturday mornings hopping between markets and farm stands all over town. For fresh gulf seafood, I head to Cedar Park. If I want flowers and vegetables, or I just miss my friends Paula and Glenn Foore, I wander over to Springdale Farm in East Austin. I stop by Barton Creek Farmers Market when I need tortilla chips, cheese from Full Quiver Farm or a bright smile—and some meat—from Richardson Farms. Farmers' markets now take place almost every day of the week in almost every corner of Central Texas.

Austin is fortunate that more than half a dozen of the area farms are actually located in the city, part of our urban fabric. You can visit the chickens while you buy from the farm stand at Boggy Creek, volunteer for a workday with the teenagers who manage the Urban Roots farm or be a farmer for a day in one of the classes at Green Gate. Our urban farms, which also include HausBar and Rain Lily in East Austin and Tecolote a little further east, serve as hosts for many local food events, and seldom does a week go by that you can't sip under the stars at one of the farms while supporting your favorite food-centric nonprofit.

Our farmers are so revered that they have graced the covers of local magazines and received their fair share of national press. It's not surprising that in this music-loving city, we have elevated our farmers to rock star status, celebrating them not only for the bounty they bring us but also for how they are changing our lives, one local vegetable at a time.

Hinkelhatz Criolla

Sommer Maxwell, The Seasonal Plate
(seasonalplate.blogspot.com)

We flew as a family to Buenos Aires, Argentina, to visit my mom, who had retired there temporarily. She had already picked out the best little restaurants tucked away on quiet streets in the heart of the city. On each crisp white tablecloth, you would find criolla with bread and an amazing glass of local Malbec. We couldn't get enough criolla and knew that we would have to eventually do our best to re-create it at home. The following summer, we were able to create our own version using hinkelhatz peppers from our garden, and when paired with a glass of local Texas wine, it helped us make it through the last hot days of summer.

Although it is traditionally served with bread, we found that the oil base of the criolla really adds flavor to venison hamsteak. It is also especially good on eggs for breakfast. The sunflower oil will give it a lighter flavor than using olive oil, and we swapped cilantro for the parsley. Spicy hinkelhatz peppers grow well in Austin's hot, dry summers, but you can substitute your favorite peppers or ones that are available in your area. (Be sure to wear gloves if you're using hot peppers like jalapeños or hinkelhatz.)

If you want a little sweet with your heat, try adding a cup of peeled and chopped peaches or loquats, which grow in many

Hinkelhatz Criolla. *Melissa Skorpil.*

residential neighborhoods in Austin.

1 cup seeded and finely chopped tomatoes, any variety
⅔ cup finely chopped red onion
⅓ cup seeded and finely chopped bell pepper
8 hinkelhatz peppers, seeded and finely chopped
4 cloves garlic, peeled and minced
⅓ cup sunflower oil (or safflower or grapeseed oil)
2 tablespoons apple cider vinegar
¼ cup finely chopped cilantro
1 teaspoon salt
pepper to taste

In a large bowl, combine ingredients and mix well. Adjust cilantro, salt and pepper to taste. Serve with tortilla chips or drizzle on top of eggs, venison hamsteak or fish. Serves 6.

Salsa Crema ingredients. *Kristin Schell.*

Salsa Crema

Kristin Schell, The Schell Café (theschellcafe.com)

One of the first dishes my friend and cooking partner, Chelita, shared with me is a delicious salsa crema. My kids, whom I call the Littles, love the creamy salsa so much that I'm sure they would eat it with nothing but a spoon.

Delicious on grilled chicken, spooned over shrimp tostadas or even straight out of the bowl as a dip with chips, we can't get enough salsa crema! Depending on your heat tolerance, feel free to cut back or increase the amount of jalapeños you add to your salsa.

3 tomatillos, peeled and quartered
2–3 garlic cloves, minced
2–3 jalapeño chiles, seeded and chopped
½ cup roughly chopped cilantro
½ cup sour cream
½ cup milk
2 avocados, peeled and sliced
salt and pepper to taste
lime juice, optional

Place tomatillos, garlic, jalapeños, cilantro, sour cream and milk in a blender and mix until smooth. Add avocados and pulse until smooth. Add salt and pepper to taste. You can add a squeeze of fresh lime to boost the flavors and prevent discoloration. Serves 8–10.

Habanero and Apricot Vinegar with Thyme

Alexandra Lopez, The Food Diva (thefooddiva.blogspot.com)

I love the combination of sweet heat when it comes to sauces and condiments, and an infused vinegar such as this one is a great way to add a little zing to fried foods like okra or hush puppies. I also use it in marinade or in from-scratch barbecue sauce. For this vinegar, you could use any fresh seasonal fruit and any chile and herb. Just heat the vinegar and add the ingredients (peel, seeds and all), along with a little salt, into a clean jar. Allow the ingredients time to flavor the vinegar for a few days, then enjoy. You don't even have to strain it out. I like all the little bits of fruit and herb in the jar.

Habanero and Apricot Vinegar with Thyme. *Melissa Skorpil.*

2 cups distilled white vinegar

½ teaspoon salt

2 fresh apricots, pitted and sliced into thick
 wedges

1 hot chile, such as habanero, sliced (seeds
 and all)

2 sprigs of thyme

Heat vinegar in a small saucepot. Add salt and stir to dissolve. Add apricots, chile slices and thyme to a clean quart glass jar (or two pint jars). Pour hot vinegar over ingredients, enough to cover. Let brine sit uncovered until cool. Store in the fridge until ready to use. The longer the vinegar infuses, the more flavor it will develop.

Homemade HP Sauce

*Lindsay Bailey and Lauren Macaulay,
The Hobbyists (thehobbyists.ca)*

This recipe originally came from Lauren's grandma, Olive Andersen, who lives on a small acreage on the Naramata Bench, an area of British Columbia known for its wine. Lauren remembers her grandma making this HP (House of Parliament) sauce every fall when local plums and apples were in season. A coveted gift that was slowly consumed, Lauren recalls her grandma saying about the HP sauce, "Like good wine or the rest of us, it improves with age."

It took a few years of canning experience together before Lauren got up the nerve to ask her grandma for the recipe. Over the course of a few batches with Lindsay, we have made a few Hobbyist additions, including adding fresh ginger and a good dose of malty beer (preferably a local craft brew). Our recipe has become a much fresher, zestier sauce than commercial HP sauce (which is popular in Canada), and it can be adjusted to your tastes. We love giving this jar as a gift to friends, but it also has a cherished spot in our fridge. It is a lifesaver for last-minute Friday evening entertaining: great with turkey meatballs, spring rolls, beer, chicken, hot dogs, French fries and even for dipping almonds.

Homemade HP Sauce. *Craig Kalnin.*

Place the fruit and onions into a large pot, adding the beer and then lightly boiling the mixture until the fruit is completely broken down. This will take about an hour. Remove the pot from heat. Place a sieve or food mill over a bowl and process the mixture through either, removing any chunks.

Put the strained mixture back into the pot. Add 32 ounces of the malt vinegar and all of the sugar and the spices. Place the pot back onto low heat and simmer until the mixture reaches the desired thickness, which can take an hour or more. As the mixture cooks down, slowly add the last 16 ounces of malt vinegar. Be patient with the cooking time because if you increase the heat too much, you risk scorching it and ruining the fragrant flavor of the fruit.

Once the mixture has cooked down enough, turn the heat off. Ladle the mixture into heated, sterilized canning jars, filling to within an inch of the top, place the lids and rings on the jars and process in a hot water bath for ten minutes. Makes 6 pint jars.

4 pounds apples, peeled, cored and cubed
 (about 10 cups)
4 pounds prune plums, pitted and halved
 (about 10 cups)
2 large onions, diced
1 bottle malty beer
48 ounces malt vinegar, divided
3½ cups sugar
4 teaspoons fresh ginger
2 teaspoons ground nutmeg
2 teaspoons ground allspice
1 teaspoon cayenne pepper
¼ cup salt

Preserving the Season

Carla Crownover and Lee Stokes Hilton

At the end of the season for your favorite fruits or vegetables, there's no better way to hang on to the taste and texture than to literally preserve some. Especially in the middle of winter, when everything is gray and brown, you can lift your spirits and add sparkle to your menu with pickles, jams, chutneys, confits and sauces that require no more effort than opening a jar.

You can find a recipe for preserving almost anything on the web, and most of them are pretty simple. For jams, jellies and chutneys, you'll need fruit, sugar, a bit of lemon juice or wine or flavored vinegar (all three of which slow down spoilage) and any other flavor you want to mix in—clove, cinnamon, ginger, almond extract, liqueurs...the list is endless.

For pickling, you can use the brine base for just about everything by combining 1 cup white vinegar, 1 cup cider vinegar, 2 cups water and 2 tablespoons kosher or pickling salt. From there, you can pick your spices: peppercorns, coriander, dill, Mexican oregano, red pepper flake, pickling spice and so on. And almost everything gets a clove of garlic or two.

Thanks to a renewed interest in canning, Mason jars are easier to find now than they used to be. They come topped with metal bands and rubber-rimmed lids; the bands are reusable, but the lids won't seal properly once they've been "processed," so they shouldn't be used for more than one round of preserving/pickling.

To seal the jars, you have to process them in a hot water bath, which kills any bacteria in the food and forces the air out to create a vacuum in the jar. This seals the jar so you can keep it on your pantry shelf until you're ready to open it. Once you've opened the jar, you should refrigerate it.

Start by running your jars (without the rubber-rimmed lids or the metal bands) through the dishwasher. The jars should be kept hot until you're ready to fill them, so just leave them in the dishwasher with the door closed. Put the bands in a small saucepan with water to cover and bring to a boil. Turn off the heat and add the lids. Cover the saucepan until you're ready to put the lids on the jars.

For preserving (jams, jellies and so on), spoon the hot, cooked mixture into the jars, leaving ¼–½ inch of space at the top. Wipe the rims of the jars with a clean, damp cloth, then carefully (they'll be hot) add a lid and a metal rim. Screw the metal band into place lightly; if you overtighten, the air won't be able to escape during the hot water bath. Using tongs, set the closed jars onto a rack in the bottom of a large pot of enough boiling water to cover the jars by 1 to 2 inches and boil them for approximately 10 minutes (each recipe varies, so follow the instructions carefully). Using tongs, transfer the jars to a work surface and leave them overnight or until cool.

For pickling, fill your jars with vegetables and add hot brine, leaving ¼ inch of the head space on the jars. Wipe the rims of the jars with a clean, damp cloth and then add a lid and a metal rim, but not too tight. Process in boiling water for 15 minutes. Let sealed jars cool and sit undisturbed for 24 hours.

You'll hear a *ping* as each ring seals. I count the *pings* to make sure all the jars seal. If one doesn't, stick it in the fridge or sterilize a new lid and ring and run the jar back through the boiling process. If a jar has properly sealed, you'll be able to remove the ring and lift the jar by the lid.

Desserts

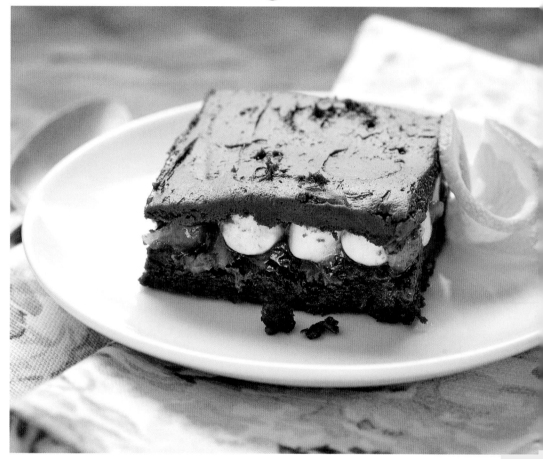

Savory Peach Gorgonzola Galette. *Amy Kritzer.*

Savory Peach Gorgonzola Galette

Margaret Christine Perkins, From Maggie's Farm (frommaggiesfarm.blogspot.com)

When milking time arrives, Stella and I have a little ritual we observe. After she's patiently done her time on the milking stand, and as a treat for her good behavior, I reach overhead and pull down a low hanging branch for Stella to snack on. She loves this. Not necessarily because the tree branch is better than every other tree branch she will have access to once down from the milking stand and out to eat freely, but simply because it's the branch she cannot get to on her own. She reaches for the farthest group of leaves on that branch, not the ones closest to her. Her goat peers eat much the same way—stretch, stretch, stretching to nab that one blade of grass that can't be reached, passing up the full patch among which they stand.

It took me a while, as these lessons along this path often do, to realize the "moral of the story" that plays itself out, daily, for me. Another lesson in patience and gratitude; always striving to get that which is out of our reach, we rob ourselves of the enjoyment that is right in front of us.

It is much the same way with seasonal eating. There is a rhythm to life and nature that we miss when we pass up the foods that are in season, and available in our region, to purchase food that is out of season and out of area. That fruit or vegetable in our own backyard doesn't seem nearly as exotic as the lychee from Asia or the banana from Ecuador. When we do throw over our local, seasonal fare for the more rarefied, we miss the perfect opportunity for fresh, delicious food. Foods grown artificially or transported thousands of miles are robbed of full flavor. The peach is a perfect example. When they are in season, you'll find them in pop-up fruit stands, at farmers' markets and in grocery stores everywhere, their scent drawing you in, begging for you to pick one up just for a waft of the sweetest smell. When you eat a peach in its proper season, it tastes like a peach is supposed to taste, not like one that was plucked from another hemisphere and then trucked in.

For the galette:

your favorite recipe for a single piecrust or, in a pinch, a ready-made piecrust (we won't tell)

5 medium peaches, washed, pitted, sliced (but with peels remaining)

2 ounces gorgonzola cheese, crumbled

1–2 tablespoons fresh, roughly chopped rosemary

1 tablespoon lemon juice

2 tablespoons cornstarch

¼ cup golden brown sugar

1 teaspoon finely ground black pepper

¼ cup unsalted butter

Preheat oven to 400°F. Roll crust out to ⅛-inch thick circle. Transfer to foil- or silicone-lined baking pan. Combine next six ingredients in a bowl and toss together. Pile filling evenly in center of crust, allowing a 2- to 3-inch margin. Fold margins of dough in evenly, pleating to ease in circle. Dot top with butter.

Bake for first 10 minutes at 400°F, then lower the temperature to 350°F and bake for an additional 30 minutes or until filling is bubbly and crust is golden. Remove from oven and allow to cool 20 minutes before slicing.

Creamy Lemon Blueberry Bars. *Jane Ko.*

Creamy Lemon Blueberry Bars

Anna Ginsberg, Cookie Madness (cookiemadness.net)

I was in the mood for something creamy and lemony, but rather than make a lemon cream pie, I baked a batch of these lemon bars. Originally from *Fine Cooking* and slightly modified over the years by me, the bars are perfect for picnics, potlucks or any event with lemon lovers in attendance. If you have a food processor, they're a snap to make. If you don't have a food processor, prepare the crust mixture in a large bowl and cut the butter in with a pastry cutter. This recipe was adapted from *Fine Cooking* magazine.

1¾ cups all-purpose flour (about 7.8 ounces)

½ cup packed light brown sugar

½ cup granulated sugar

1 teaspoon salt

½ teaspoon baking soda

12 tablespoons unsalted butter, cut into small pieces

1½ cups quick-cook oats

1 14-ounce can sweetened condensed milk

½ cup fresh lemon juice

2 teaspoons lemon zest

2 large egg yolks

2 cups blueberries, washed, drained, patted dry

½ cup toasted and finely chopped pecans

Preheat oven to 350°F. Line a 9x13-inch baking dish with nonstick foil or line with regular foil and spray with flour-added cooking spray.

Combine the flour, sugars, salt and baking soda in bowl of a food processor and pulse to mix. Add butter and pulse until mixture is coarse and crumbly. Add oats and pulse to mix. Press about ⅔ of crumb mixture into the pan and set remainder aside. Bake crust for 12 minutes. Meanwhile, prepare filling.

Whisk the condensed milk, lemon juice, lemon zest and egg yolks together in a medium bowl and let stand for 5 minutes.

Arrange blueberries evenly over the crust and pour lemon mixture over the top. Spread gently with a spatula to distribute evenly. Bake until the lemon mixture just begins to form a shiny skin, 7–8 minutes. Remove from oven and sprinkle reserved crumb mixture over the top, then sprinkle on pecans. Return to oven and bake for 25 minutes.

Let the bars cool in the pan on a rack, about 1 hour. When cool, transfer to refrigerator to chill for at least 2 hours. When ready to serve, grasp foil and lift from pan, then cut into 24 bars.

Postpartum Cookies

Lisa Goddard, advisory council member

Breast may be best, but it certainly isn't easy, especially when you have a full-time office job and only 12 weeks of maternity leave. I was determined to exclusively breast-feed my children for a minimum of a full year or as long as they wanted it, whichever came first. While I made it with my first son, Alexander, who cut me off cold turkey when he turned one year old, I fell short of my goal with my second son, Thelonious, by six months. Soon after my daughter, Carmen, was born, I set out to find a tasty alternative to herbal remedies to support not only breast milk production but all-over postpartum health. Oatmeal is often recommended by lactation consultants to boost milk production, and the flaxseeds and hemp seeds add fiber and protein. Blackstrap molasses is notoriously high in iron, and the applesauce cuts down the amount of sugar needed to sweeten the cookies. The chocolate? Well, that just makes me happy.

1½ teaspoons blackstrap molasses

1 cup sugar

½ cup unsalted butter, melted

1 cup unsweetened applesauce

2 large eggs, lightly beaten

2 teaspoons vanilla

1½ teaspoons baking soda

½ teaspoon salt

¼ cup ground flax seeds

¼ cup hemp seeds

1½ cups rolled oats

2 cups all-purpose flour

1 cup chocolate chips

Preheat oven to 375°F. Mix molasses and sugar well until there are no lumps of molasses left. It should look like light brown sugar. Add melted butter, applesauce, lightly beaten eggs and vanilla to the sugar mixture and blend well.

In a separate bowl, combine the remaining ingredients with a whisk. Then combine the wet ingredients with the dry. Using a spring-loaded ice cream scoop, create small balls of cookie dough and place them on a cooking sheet lined with parchment paper.

Bake until the edges start to brown, about 15 minutes. Makes about 12 cookies.

Supper Clubs

Shefaly Ravula and Addie Broyles

Supper clubs have been around for generations, but never in so many incarnations as now. For many years, a supper club meant friends gathering for dinner parties at one another's houses on a regular basis, but now, chefs have embraced the idea for their own pop-up dinner parties.

Austin chef Jesse Griffiths, who recently published his first cookbook, first gained fame through his Dai Due Supper Clubs, which quickly became the most popular in Austin and now sell out within minutes of being posted. Supper Underground, another popular longtime club that embraces the element of surprise, now uses a lottery system to determine which guests get seats. Supper Friends, Hosteria Verde, Bread & Circus and Royal Fig all put their unique spins on the supper club idea, some changing venues every month and others changing chefs or simply menu theme. Homegrown Revival is Chef Sonya Cote's break from everyday cooking at her restaurant, Hillside Farmacy.

If you decide to host your own supper club, consider these tips:

Make sure you only invite as many guests as you can seat comfortably in your house. If you need extra dishes, you can rent them, but it's a little harder to come up with extra space, unless you can seat some of the guests outside.

When you are planning the menu, incorporate dishes that you can prepare ahead of time. If you can't actually cook the dishes the day

before, figure out which ingredients you can prep the days before the party. If you know you are going to prepare extra food just to make sure you have enough, buy some extra food storage containers so you can send some of the leftovers home, if there are any.

Buffet-style and family-style service are easier than traditional restaurant-style service, but if you'd like to create that kind of environment, consider enlisting your friends to help prepare and serve food, as well as the not-so-fun part, cleanup.

Dark Chocolate Mandel Bread

Amy Kritzer, What Jew Wanna Eat (whatjewwannaeat.com)

My Bubbe always had some of her mandel bread around when the kindelah visited, though to be honest it was never as popular as her apple cake. Sort of like a Jewish biscotti, they are a little hard and are filled with orange marmalade, so they are never a kid's favorite treat. Well, I modernized mine up a bit with Greek yogurt in place of the sour cream and then dipped them in orange-infused dark chocolate. Yum! The yogurt softened the cookies up, and the chocolate is just perfect with the orange flavors.

1 stick (½ cup) butter

1 cup granulated sugar

½ cup Greek yogurt (or sour cream)

1 large egg

1 heaping teaspoon baking powder

½ teaspoon baking soda

2½ cups all-purpose flour, plus extra
 for rolling

1 12-ounce jar marmalade

1 cup walnuts, finely chopped (divided
 evenly over each of the four circles
 of dough)

1 tablespoon ground cinnamon

2 cups dark chocolate chips

zest of 1 orange

Dark Chocolate Mandel Bread. *Amy Kritzer.*

Using a mixer, cream together butter and sugar until light and fluffy. Add Greek yogurt and egg and mix well. Mix in baking powder, baking soda and flour. Divide dough into 4 balls and chill 1–2 hours.

Preheat oven to 375°F. Press each ball into a circle about ¼-inch thick. Spread with a thin layer of marmalade, then sprinkle with walnuts and cinnamon. Roll up dough and place seam down on a greased baking sheet. Repeat with other balls.

Bake for 30 minutes or until golden brown. Cool bread slightly and slice pieces to ½ an inch thick. Return slices to oven and bake until crispy, about 20 minutes, flipping over halfway through.

Melt chocolate in double boiler or microwave. Add in orange zest. Dip ends of mandel bread into chocolate. Let dry on parchment paper. Makes 24 cookies.

Carrot Cake Bouchons

Shelley Lucas, Franish Nonspeaker (franishnonspeaker.com)

My mother is an excellent cake maker, and I grew up in a home where there was always cake on hand. She has her own rendition on all the classics, but my personal favorite is her carrot cake. I've never had any other carrot cake that holds a candle to it. Mom's cake is light, fragrant, super moist and flat out delectable. It's sweet, but not terribly so, and she uses pecans, not walnuts, in her cake. Sadly, I did not inherit her cake making mojo, so I use my mom's carrot cake recipe to make bouchons, a French cake named after the cork it resembles. I substitute sunflower oil for the vegetable oil in my mom's recipe; either oil works just fine, so use whatever you have on hand.

2 cups all-purpose flour

1 teaspoon baking powder

½ teaspoon baking soda

½ teaspoon salt

2 teaspoons cinnamon

4 eggs

2 cups sugar

1 cup sunflower oil (or other neutral oil)

2 cups grated carrots (about 6 medium carrots)

Carrot Cake Bouchons. *Shelley Lucas.*

1 cup roughly chopped pecans, plus ¼ cup for topping, if desired

For the cream cheese icing:

½ cup butter

8 ounces cream cheese

16 ounces confectioners' sugar, sifted

2 teaspoons pure vanilla extract

Preheat oven to 350°F with a rack centered in middle of the oven. Butter and flour the wells of a popover, cupcake pan or individual timbales. If using timbales, place on a baking sheet.

Sift the flour, baking powder, baking soda, salt and cinnamon into a medium bowl and set aside. In a mixer on medium-high speed, beat the eggs and sugar until light. Add oil and continue to beat for another minute. Take the bowl off of the mixer stand and, by hand, use a spatula to fold the carrots in. Next, fold in sifted flour mixture and, last, the pecans.

Pour the batter into the prepared popover pan wells or timbales and bake 20–25 minutes or until done. The bouchons will be done when a toothpick inserted in the middle looks clean and dry when removed.

While the bouchons are baking, prepare the icing by beating the butter and cream cheese until smooth. Add the sifted confectioners' sugar and vanilla and continue to beat on high speed until fully combined and smooth. When the bouchons are done, remove the popover pan or timbales from the oven to cooling racks. Once fully cooled, remove from popover pan wells or timbales.

Pipe cream cheese icing on top of bouchons and top with a little chopped pecan or candied carrot peels, if desired. Makes about 12 bouchons. Adapted from a recipe by Sue White.

Berry Blast-Off Pops. *Michelle Fandrich.*

Berry Blast-Off Pops

Michelle Fandrich, The Kid Can Cook (thekidcancook.blogspot.com)

Summers in Texas are hot, hot, hot, so the Kid and I are constantly looking for ways to cool off. One of our favorites? Popsicles. Using fresh, organic fruit and natural sweeteners like agave nectar, these pops make for a sweet snack that you can feel good about.

1 cup fresh organic strawberries, washed and hulled

¼ cup fresh organic raspberries, washed

1 tablespoon organic agave nectar

juice of 1 lime

½ cup low-fat organic vanilla yogurt

1 cup fresh organic blueberries, washed

1 whole banana, peeled and sliced into chunks

In the pitcher of a blender, combine strawberries, raspberries, agave nectar and lime juice and process until smooth and well combined. Fill six popsicle molds one-third full with mixture. Place in freezer for about 20 minutes, until set, before adding 1 heaping tablespoon of vanilla yogurt to each mold. Return the popsicles to the freezer.

In a blender, combine blueberries and banana and blend until smooth. Remove pops from freezer and top off each mold with the blueberry mixture. Return to freezer until popsicles are completely frozen, 4–5 hours. Makes 6 popsicles.

Chocolate Sunshine Cake. *Melissa Skorpil.*

Chocolate Sunshine Cake

Christy Horton, epicuriosities (epicuriosities.com)

This recipe evolved from a southern classic, Mississippi Mud Cake, that my grandmother and mother both made when I was growing up. I have found the recipe in several community cookbooks dating back to the 1970s. I had a large batch of orange marmalade that I was looking to use in a recipe, and I love the flavors of orange and chocolate. You can substitute any jam you prefer. Raspberry, cherry or strawberry would all be delicious. I like a lot of icing on my cake, but you will still probably end up with some extra, about ¼ cup or so. It sets up like fudge in the refrigerator if your bowl-lickers can resist the urge to gobble it up right away.

For the cake:

½ cup unsalted butter

½ cup cocoa powder

1 cup granulated sugar

2 large eggs, lightly beaten

1 tablespoon vanilla extract

¾ cup flour

dash of salt

1 cup mini marshmallows

1 10-ounce jar (1 cup) orange marmalade

For the icing:

½ cup unsalted butter

½ cup (4 ounces) cream cheese

1 tablespoon pure vanilla extract

½ cup cocoa powder

3 cups confectioners' sugar

dash salt

1–2 tablespoons milk

Preheat oven to 350°F. Lightly grease an 8x8-inch pan. Melt butter in medium saucepan over medium-high heat. Remove from heat and whisk in cocoa. Pour mixture into a large bowl. Stir in sugar, then the eggs and vanilla. Lightly stir in the flour and salt, just until combined. Pour batter into prepared pan and bake 15–20 minutes, until a toothpick inserted in the center comes out clean. Remove cake from oven. While cake is still warm, sprinkle with marshmallows and gently spread marmalade over the top. Let cake cool.

Beat together butter and cream cheese for icing until light and fluffy. Add remaining icing ingredients except milk and beat until smooth. Use milk to thin to a spreadable consistency. Carefully spread over cooled cake. Cover and store in the refrigerator until icing sets, at least 2 hours. Serves 12.

New Mexican Hot Chocolate Pie

Kristina Wolter, Girl Gone Grits
(girlgonegrits.com)

In August 2011, I had the great pleasure to spearhead the philanthropy committee for the Austin Food Blogger Alliance. We held a "Pie Luck Social" in which AFBA members could come and share pie, as well as have the opportunity to enter their homemade pies in a contest judged by local chefs. The winning pie would then be reproduced at our local Alamo Drafthouse theater and sold on the menu for a special showing of *Waitress*; all proceeds

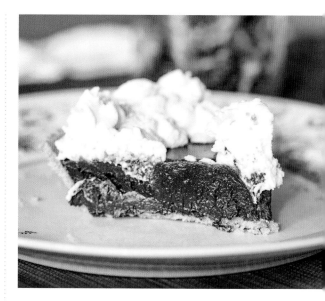

New Mexican Hot Chocolate Pie. *Jane Ko.*

benefited the local women's shelter. As a committee member, I had to sit back and not participate in the contest even though I am a prolific baker. My wonderful husband, Bob, stepped out of his comfort zone and created a pie that was true to his passion, tequila. His pie ultimately came in second place! I will never forget how strange it was for me to "switch" places with my husband this day; the pie's true flavors come from a trip we took to New Mexico earlier that year. The end result is a collaboration from both of us, as he took one of my chocolate truffle pie recipes and added his charm and spices to make it his own.

For the crust:*
1¼ cups graham cracker crumbs
3 tablespoons granulated sugar
1 teaspoon chili powder
⅓ cup butter, melted and cooled

*or use a premade graham cracker pie crust

For the filling:

2 cups (1 12-ounce package) semisweet chocolate chips

¼ cup powdered sugar

¼ teaspoon cinnamon

½ teaspoon chili powder

1 cup milk

¼ cup butter

For the topping:

1 cup heavy whipping cream, chilled

2 tablespoons sugar

2 tablespoons 1921 Tequila Crema

To prepare the crust, preheat oven to 350°F. Combine the graham cracker crumbs, sugar and chili powder in a bowl. Slowly pour melted butter into the bowl, tossing with a fork until the entire mixture is evenly coated. Press the mixture evenly into a 9-inch pie pan and bake for 8 minutes; remove and let cool. (If you use a premade crust, sprinkle chili powder evenly around the crust before adding the filling.)

For the filling, place chocolate chips, powdered sugar, cinnamon and chili powder in blender and set aside. Combine milk and butter in a saucepan over low heat, stirring regularly. When butter is melted and before milk boils, remove from heat and slowly pour into blender. Mix at a low speed to combine all ingredients. Pour into crust and refrigerate until filling solidifies.

For the tequila cream topping, in a large mixing bowl, whip the heavy cream at a medium speed, adding the sugar 1 tablespoon at a time. Once incorporated, increase speed until the cream begins to thicken, then add the Tequila Crema. Continue to beat until evenly incorporated and soft peaks form, but you should take care to stop before the cream turns into butter.

Decorate the top of the pie with the cream before serving or add to each slice after cutting.

Avon Lady Citrus Squares

Rebecca Saltsman, Salts Kitchen (saltskitchen.net)

When I was about eight years old, I started making lemon squares. The recipe is from my mother's college roommate's mother's Avon Lady. Yes, you read that correctly. It is *the* best lemon square recipe known to man. Over the years, I've made these for just about every occasion. It has been my go-to recipe when there is nothing else in the house or I just can't decide what to bring to that potluck; you can make it at parties in minutes flat with guests waiting for a midnight snack. My mother wrote this down on a piece of lined paper in about 1970. I used that browned and waxy piece of paper for years.

Here, I've altered it to reflect the local citrus in Central Texas this time of year: the wonderful grapefruit. I've also altered the crust for dietary restrictions and to include the local pecan.

This is a pucker-up kind of citrus bar—as in not those über-sweet ones you find at the store. It's also a very gooey recipe, not tons of

flour in the filling. I use arrowroot powder, but if you're not gluten-free, use regular flour for the filling if you prefer.

For the crust:

2 cups almonds

1½ cups pecans

5 tablespoons confectioners' sugar

¼ teaspoon baking soda

¼ teaspoon salt

½ cup butter (I use Earth Balance spread to substitute)

2 teaspoons natural vanilla extract

For the gooey filling:

4 eggs

2 cups (scant) sugar

½ cup grapefruit juice

2 tablespoons lemon juice

¼ cup arrowroot powder (or regular all-purpose flour)

To prepare the crust, preheat oven to 350°F. Grind the almonds and pecans in a food processor to a fine powder. Add remaining dry ingredients and blend. Add butter and vanilla and blend until completely mixed. Press the crust with your fingertips into a 9x13-inch glass baking dish and slightly up the sides. Bake the crust for about 10 minutes.

For the filling, in a large bowl, beat together all of the filling ingredients with a whisk and pour into the par-baked crust. Bake for another 20 minutes. It should still jiggle, but only a little. Let cool completely. Sprinkle with additional confectioners' sugar if desired. Makes 12–15 squares.

Strawberry Rhubarb Pie

Shelley Lucas, Franish Nonspeaker (franishnonspeaker.com), adapted from a recipe on epicurious.com

I love its tart, tangy flavor and eagerly await rhubarb season every year. Hence I'm always on the lookout for rhubarb recipes to try, and this is an adaptation of one I found on epicurious.com. After making the recipe as originally written, I decided that it needed a little tweaking. While researching recipes, I hit pay dirt on David Lebovitz's blog (davidlebovitz.com). His suggestions on making a rhubarb-strawberry compote using raw sugar and adding orange peel sounded terrific. My husband, a chef, suggested adding cardamom to complement the orange flavor. After incorporating these additions, I was very pleased with the results. For the pie crust, I used the flakey tart dough recipe from the book *Tartine*, by Elisabeth M. Prueitt and Chad Robertson.

For the dough (makes two 9-inch pie shells):

1 teaspoon salt

⅔ cup water, very cold

3 cups plus 2 tablespoons all-purpose flour

1 cup plus 5 tablespoons unsalted butter, very cold

For the filling:

1 orange, zest and juice

1 cinnamon stick

Strawberry Rhubarb Pie. Aimee Wenske.

5–6 cardamom seeds

3½ cups trimmed rhubarb, cut into ½-inch-
thick slices (1½ pounds untrimmed)

1 16-ounce container strawberries, hulled,
halved (about 3½ cups)

1 cup raw turbinado sugar

½ cup cornstarch

¼ teaspoon salt

For the glaze:

1 large egg yolk beaten

1 teaspoon milk

To make the pie dough, in a small bowl, stir the salt into the cold water until dissolved. Place the bowl in the refrigerator to keep cold until ready to use. Add the flour to a large mixing bowl. Dice the butter and scatter over the flour. Use a pastry blender to cut the butter into the flour until large crumbs form. There should still be pea-sized pieces of butter visible in the mixture.

Gradually stir the salty water into the flour mixture with a fork until the dough begins to come together in a shaggy mass. Using your hands, work quickly to bring the dough together into a rough ball. You should still see chunks of butter so be careful not to overwork the dough. Lightly flour a work surface and turn the dough out on the surface. Divide the dough into two equal pieces and shape each piece into a 1-inch-thick disc. Wrap each disk in plastic and chill in the refrigerator for at least 2 hours.

When ready, butter a 9-inch pie pan and set aside. Roll one disc of dough out on a lightly floured surface to a 13-inch round of about ⅛-inch thickness. Lift and rotate the dough as you roll to prevent it from sticking, working

quickly so it remains cold. Wrap the dough over the rolling pin to transfer it to the pie pan, roll out over the pan and then lift and press gently into the sides and bottom of the pan. Trim the dough with a sharp knife, allowing a ¾-inch overhang. Prick the bottom of the dough lightly with a knife and place back into the refrigerator to keep cool while making the filling.

Preheat oven to 400°F; adjust oven racks so pie can be placed in lower third of oven. In a small pot or pan, over medium-low heat, reduce orange juice slightly with the cinnamon stick, orange zest and cardamom seeds to infuse flavors, about 10 minutes. Strain and reserve juice.

Combine remaining filling ingredients and reserved juice in large bowl. Toss gently to blend.

Roll out second dough disc on a lightly floured surface to a 13-inch round. Cut dough into fourteen ½-inch-wide strips. Spoon filling into crust. Arrange half of the dough strips, spaced evenly, over the filling. To form a lattice, place the rest of the dough strips in the opposite direction over the filling. Cut the ends of the lattice strips even with overhang of the bottom crust. Fold the bottom dough overhang over the strip ends and press to seal. Use your thumb to crimp the pie edges for a decorative look.

Mix the egg glaze in a small bowl and brush over the piecrust. Place the pie pan on a baking sheet and transfer to the oven. Bake 20 minutes at 400°F in the lower third of the oven, then reduce oven temperature to 350°. Continue to bake until the crust is golden and the filling has thickened—it may take up to 1.5 hours to fully bake but begin checking early at the 1-hour mark. When done, place the pie on a rack to cool. Serves 8.

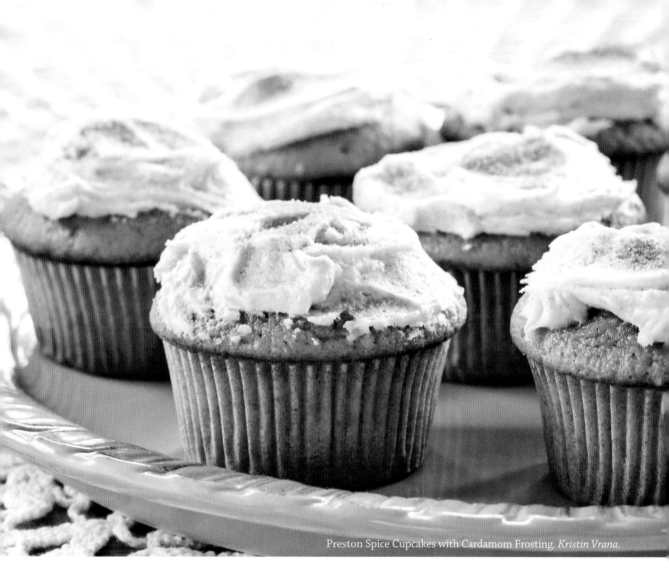

Preston Spice Cupcakes with Cardamom Frosting. *Kristin Vrana.*

Preston Spice Cupcakes with Cardamom Frosting

Tiffany Young, Antonio Delgado and Lindsay O'Neal, OhSpooning (ohspooning.com)

The OhSpooners Tiffany Young and Antonio Delgado, joined by illustrator Lindsay O'Neal, created this recipe to go along with their *Jump Little Cake, Jump!* children's book. The book is about Preston Spice O'Nilla, a pumpkin spice cupcake who is adopted by the O'Nilla family. We enjoy taking cupcakes to parties, where they are always a big hit. Learn more about the book at jumplittlecake.com.

¾ cup unsalted butter (1½ sticks), softened

2½ cups sugar

3 eggs

1 (14-ounce) can solid pumpkin

½ tablespoon vanilla extract

2⅓ cups cake flour

¼ cup ground almonds

1 teaspoon baking powder

½ teaspoon baking soda

1 teaspoon ground cinnamon

¾ teaspoon salt

½ teaspoon cardamom

¼ teaspoon ground nutmeg

¼ cup milk

¼ cup raisins

For frosting:

1 cup unsalted butter, softened

3 cups confectioners' sugar

1 teaspoon vanilla extract

1 teaspoon ground cardamom

1–2 tablespoons milk, optional

sliced almonds, for garnish (optional)

Preheat oven to 350°F; prepare two cupcake pans with liners.

Using a mixer, cream butter and sugar together in a large bowl. Beat in eggs, one at a time. Mix in pumpkin and vanilla. In a separate mixing bowl, combine flour, ground almonds, baking powder, baking soda and spices. Slowly add in flour mixture to pumpkin mixture until well combined. Add milk and combine well. Fold in raisins with a spatula. Pour batter into cupcake pans about ¾ full. Bake for 20–25

minutes or until an inserted toothpick comes out clean.

To make the frosting, cream butter in a mixer. Add confectioners' sugar, vanilla and cardamom to butter until well blended and creamy. Add a tablespoon of milk and beat if frosting consistency is too thick; add more if needed.

When cupcakes are completely cool throughout, frost with a spatula or by piping the frosting onto the cupcake. Garnish with sliced almonds and sprinkle with cinnamon. Makes 2 dozen.

Ginger Cookies

Michelle Nezamabadi, Beyond Picket Fences (beyondpicketfences.com)

These spicy ginger cookies are my go-to holiday recipe and have always been a hit. I love the crispy edge, chewy center and the kick of spice. The recipe has evolved over the years, and this is my take on a family favorite. If you prefer a more subtle cookie, feel free to cut the spices in half, but I prefer the intense flavors of ginger, cinnamon and nutmeg. The cookies are delicious when paired with vanilla ice cream, fresh whipped cream, hot tea or a hoppy beer.

1 cup turbinado sugar, divided

½ cup light brown sugar, firmly packed

½ cup unsalted butter at room temperature

½ cup margarine at room temperature

1 large egg

⅓ cup molasses

½ teaspoon vanilla extract

2¼ cups all-purpose flour

Ginger Cookies. *Melissa Skorpil.*

2 tablespoons ground ginger

1 tablespoon ground cinnamon

½ teaspoon freshly grated nutmeg

2 teaspoons baking soda

1 teaspoon salt

With an electric mixer, cream ½ cup of the turbinado sugar, brown sugar, butter and margarine until light and fluffy. Add the egg and continue beating to blend well. Add the molasses and vanilla.

Sift the dry ingredients together three times, then stir into the butter mixture a half cup at a time. Refrigerate for at least 30 minutes.

Preheat the oven to 325°F. Line a cookie sheet with parchment paper and grease lightly or use a silicone baking mat. Place the remaining turbinado sugar in a shallow dish. Roll tablespoonfuls of the cold dough into balls and then lightly coat in sugar.

Place the balls 2 inches apart on the prepared sheet. Bake until golden around the edges but soft in the middle, 12–15 minutes. Let stand for 5 minutes before transferring to a rack to cool. Makes about 4 dozen cookies.

Dreamsicle Tart

Monica Riese, It's the Yeast I Can Do (theyeasticando.tumblr.com)

In my memories, Dreamsicles exist only at Cracker Barrels and in elementary school cafeterias, but Matt Lewis and Renato Poliafito really know how to class up a childhood favorite. This recipe, adapted slightly from their version in the cookbook *Baked Explorations*, yields a light and refreshing dessert that won over so many at my office that someone requested it a few weeks later as a housewarming gift. It's an involved recipe, but it looks more complicated than it is, and at the end of it all, your inner kid will thank you.

For the filling:

8 tablespoons unsalted butter, cubed

¼ cup lemon juice

1¼ teaspoons unflavored gelatin

¾ cup orange juice

1¼ cups orange (or orange cream) soda

3 tablespoons orange zest

2 tablespoons lemon zest

3 large eggs

2 large egg yolks

¾ cup sugar

For the crust:

8 tablespoons unsalted
 butter
¼ cup sugar
2 tablespoons orange zest
¼ teaspoon salt
1 large egg
1½ cups all-purpose flour

For the assembly:

2 ounces white chocolate

For the topping:

1 cup heavy cream
2 tablespoons sugar
2 tablespoons orange soda

Special equipment:

9-inch pie or tart pan
candy thermometer
medium-mesh strainer

To make the filling: Drop the butter into the bottom of a large bowl and set it aside. Put the lemon juice in a small bowl and carefully sprinkle the gelatin on top; set aside.

Over medium-high heat and in a medium saucepan, boil the orange juice and orange soda together until the mixture reduces by half. Since the final yield will be approximately 1 cup, keep a heatproof measuring cup by the stove to pour into if you're not sure. Drop the temperature to low.

In a medium bowl, whisk together the remaining filling ingredients and add them to the saucepan. Turn the stove up to medium-low heat and stir constantly until the mixture reaches 180°F. Be sure to scrape out the edges of the pan or parts will burn. Remove the pan from the heat and quickly whisk in the lemon juice/gelatin mixture.

Place a medium strainer over the bowl with the butter and pour in the saucepan's contents. Whisk furiously for 5–10 minutes (or however long your arm can take it; the more you whisk, the fluffier it'll be). Then press a layer of plastic wrap to the top of the curd to prevent skimming and place the bowl in the refrigerator for at least 4 hours or overnight.

To make the crust: Beat everything but the egg and flour in a stand mixer with the paddle attachment. Incorporate the egg, then add the flour and beat just until a ball forms. If in doubt, finish by hand. Wrap the dough in plastic wrap and put it in the refrigerator for half an hour. Let the dough warm back up a little bit, then roll it into a ¼-inch-thick circle wide enough to cover the bottom and sides of the pie pan. Gently lift the dough over the pan and press it into place. Trim or shape excess, then freeze for another half an hour.

Preheat the oven to 375°F. Parbake the crust for 25 minutes—the first 15 minutes lined with foil and filled with pie weights or dried beans and 10 minutes more to brown. Cool.

To assemble: Melt the white chocolate in the microwave or over a double boiler and brush it into the bottom of the cooled crust. Refrigerate for 5 minutes to set.

Meanwhile, remove the curd from the refrigerator and beat in a stand mixer with a whisk attachment for 5 minutes. Pour into the cooled crust and level, then put it back in the fridge for an hour to set.

Whip the heavy cream in a chilled bowl for a minute, then add the sugar and orange soda and beat until soft peaks form. Top the tart with the whipped cream immediately before serving. Tart will keep, covered and refrigerated, for up to two days, but good luck with that!

Gaga's Coffeecake. *Addie Broyles.*

Gaga's Coffeecake

Addie Broyles, The Feminist Kitchen (thefeministkitchen.com)

In 1891, my great-great-grandmother boarded a ship in Sweden bound for both America and a husband who'd left when she was pregnant, ten years before, for a wagon factory job in Springfield, Missouri. In tow were two children and a suitcase that carried just a few necessities, including a bread knife and a rolling pin from a country that Carolina Sophia would never visit again.

Almost 120 years later, the sturdy black-handled knife with razor-like teeth and the long, smooth rolling pin are still in use in my grandmother's kitchen, less than forty miles from where her grandmother first unpacked them after the long journey. My grandmother still uses both utensils today, as well as a recipe for her mother's coffeecake, which has been in the family as long as we've been in the United States.

2½ cups all-purpose flour

1½ teaspoons baking powder

1 teaspoon salt

½ teaspoon ground nutmeg

1 teaspoon ground cinnamon

¾ cup sugar

¼ cup softened butter

2 eggs

1 cup milk

For topping:

¼ cup butter

¾ cup brown sugar

3 tablespoons all-purpose flour

½ teaspoon ground cinnamon

pinch of salt

Preheat oven to 350°F. Mix together flour, baking powder, salt, nutmeg, cinnamon and sugar. Work in the softened butter, eggs and milk; stir until smooth. In another bowl, cream together the topping ingredients.

Pour half of the batter into a greased 8x8-inch glass or metal pan. (A bread loaf pan will also work.) Sprinkle half of the topping mixture on the batter and then pour the rest of the batter on top. Add the last of the topping mixture and then bake for about 35 minutes. Serves 8.

Far Breton

Rachel Matthews, And Then Make Soup (andthenmakesoup.wordpress.com)

I ate this one evening in Brittany, France, and fell in love. Imagine that Yorkshire pudding married Crêpe Suzette and they had a baby… on second thought, never mind; that would probably just cause an international incident of some sort.

Far Breton is an eggy, rich, dense pudding-like breakfast, snack and/or dessert. Does that help explain it? It would be a custard or flan but for the flour. It would be a pancake but for the lack of rising agent and the proportion of liquid to dry ingredients. It is made with a very thin batter and bakes up sort of like a sweet failed popover. Hmmm…it really tastes much better than that sounds. Honest!

Here's the nice thing. This is incredibly easy to make, and while it is *ooohhh*-worthy right out of the oven, it needs to sit and set before it is dished up, so there is none of that worrisome soufflé business of rousing your guests if they're late to the table for breakfast or rushing dinner guests to get to dessert. Timing is *not* of the essence with this dish. And it transports well; I've actually taken the finished product to potluck brunches.

The only trick to this is that I cut the prunes in half, both to make them smaller bites and to be really sure that there are no pits. I've had amazingly bad luck with olive pits, cherry stones and the like, so I'm cautious. And if the

prunes seem a bit over dry, you can macerate them in a bit of rum or brandy for an hour or so before getting started with the actual prep. Mmmm.

½ tablespoon butter

about 15 pitted prunes, cut in half

2 cups milk, at least 2 percent

¼ cup sugar

a pinch of salt

⅔ cup all-purpose flour

1 packet vanilla sugar (or 1 teaspoon vanilla extract)

3 eggs

1 tablespoon rum or brandy (optional)

Preheat the oven to 350°F. Butter a glass or ceramic ovenproof baking dish and scatter the cut prunes over the bottom.

Warm the milk to lukewarm temperature. In a mixing bowl, whisk together the dry ingredients. Add two of the eggs, one at a time, and whisk in. Add one-third of the warm milk and continue to mix. Add the remaining egg and the vanilla extract if you are not using vanilla sugar.

Whisk briefly, then add the rest of the milk. The ideal is a thin batter with no lumps. Pour this over the prunes in the baking dish and bake at 350°F for 45–50 minutes. Do not open the oven door to peek beforehand; it's one of *those* recipes, and it *will* fall.

When it is lightly brown and puffy, remove from oven. Show it off if your guests haven't already crowded around to see, but let it rest for at least 15 minutes before cutting it into serving portions.

Note: Vanilla sugar is available in the bakery aisle in many grocery stores, usually in packages of three or four packets each. If you enjoy the flavor and you bake enough to make it worth your while, you can buy a vanilla pod or two to submerge in your sugar canister. It takes a while for the flavor to really soak into the sugar, and it is not as intense as store-bought vanilla sugar, but it works fine. Serves 6–8.

Texas Sheet Cake

Stacey Rider, The Four Points Foodie (fourpointsfoodie.com)

My grandfather, Dale Thompson Sr., was in the navy and served during World War II. After the war, he was a businessman who owned his own company, Thompson Plumbing. My grandparents bought their dream home in 1955 in Lawton, Oklahoma, and my darling grandmother, Virginia, still lives in the same house.

Grandpa was a well-known baker, and his nickname was "Pie Baker." He'd get up at 3:30 a.m. when we'd visit and make all sorts of delicious recipes, from oven-baked quail to homemade biscuits, pies and this wonderful sheet cake, made famous in their neighbor state to the south. All the cousins would devour it in a day.

It's been three years since I last visited, but the house looked and smelled the same as I remember when I was younger. I've had this tried-and-true recipe since 1982. (Yes, it has chili powder in it. You can leave it out if you want.) I hope you enjoy baking it as much as I do, in honor of my grandpa.

For the cake:
1 cup butter
¼ cup cocoa powder
1 cup water
2 teaspoons ground cinnamon
1 teaspoon chili powder
1 teaspoon baking soda
1 teaspoon salt
2 cups sugar
2½ cups all-purpose flour
2 eggs, well beaten
1 cup sour cream
1 teaspoon vanilla extract

For the frosting:
½ cup butter
¼ cup cocoa powder
⅓ cup half and half
1 tablespoon vanilla extract
1-pound box confectioners' sugar
1 cup chopped Texas pecans

For the cake:
Preheat oven to 375°F. In a small saucepan over medium heat, combine butter, cocoa powder and water and bring to a boil. In a separate bowl, mix together the cinnamon, chili powder, baking soda, salt, sugar and flour. Add the butter mixture, stirring well, then add the eggs, sour cream and vanilla. Mix well and pour into a greased and floured cake sheet pan. Bake for 20 minutes.

For the frosting:
Combine butter, cocoa, half and half and vanilla in a saucepan, then heat until butter is melted. Add confectioners' sugar and chopped pecans. Mix well and spread over cooled cake. Cut into individual servings and place on a large platter. Serves 24.

Texas Sheet Cake. *Jane Ko.*

Vegan Chocolate Peanut Butter Postal Cookies. *Kristin Vrana.*

Vegan Chocolate Peanut Butter Postal Cookies

Kristin Vrana, Food Fash (foodfash.com)

When a friend e-mailed me the recipe for these cookies, it made my day. Dairy-free and perfect for wrapping up and sending in a care package, these cookies are right up my alley. I've mailed them to friends all over the country, which is where they earned their name.

1½ cups white chocolate peanut butter (such as Peanut Butter & Company, or use
 regular natural peanut butter)
¼ cup maple syrup
½ teaspoon vanilla extract
½ cup almond flour
½ cup nondairy chocolate chips (such as Enjoy Life)

Preheat oven to 350°F. In a large mixing bowl, blend peanut butter, maple syrup and vanilla. Add flour and beat until thoroughly mixed. Then fold in chocolate chips.

 Roll 2-inch diameter balls with your hands and place on a parchment paper–lined cookie sheet. Flatten balls with a fork and bake for 12 minutes. Remove cookies from oven and let cool for 20–30 minutes before handling. The cookies are very mushy and fragile when they are warm, but they harden when cooled. Makes 12 cookies.

Biographies

Natanya Anderson is the director of social media at Whole Foods Market and the president of the Austin Food Blogger Alliance. She has been working with new media for over a decade with a focus on both strategy and execution, helping organizations change the way they engage and communicate with customers. She blogs about cooking and entertaining at Fete and Feast (feteandfeast.com) and being an epicurean in Austin at the Austin Food Lovers' Companion (austinfoodlovers.com).

David Ansel is the founder of the Soup Peddler (souppeddler.com), a food delivery service in Austin. *The Soup Peddler's Slow and Difficult Soups*, his cookbook and fictionalized memoir, was published by Ten Speed Press in 2005. Ansel is a member of the AFBA Advisory Council.

Sahar Arafat-Ray grew up in the Dallas/Fort Worth metroplex with her German-Texan mom and Middle Eastern father before moving to Austin in the early 1990s. She worked her way up from unpaid volunteer to the manager of the acclaimed Central Market Cooking School in central Austin before leaving to start TartQueen's Kitchen (tartqueenskitchen.com), for which she teaches private cooking lessons. She lives in Austin with her husband, Steve, and four geriatric cats.

Canadians **Lindsay Bailey** and **Lauren and Michael Macaulay** started The Hobbyists (thehobbyists.ca) after a food-and-wine tour of British Columbia's famed Okanagan Valley. There they decided that a deep love of food and wine was not a problem—it was a hobby. Now their blog has grown to cover other hobbies, including beer, music, art, design and travel. In 2012, Bailey, an art and entertainment lawyer, moved from Vancouver to Austin, and the friends have continued the blog despite the geographical distance.

Jodi Bart began blogging in 2008 and is a founding board member of the Austin Food Blogger Alliance. In 2010 and 2011, Tasty Touring (tastytouring.com) was named Best Local Food Blog in the *Austin Chronicle*'s "Best of Austin Reader's Poll." She believes that when food is made with love, you can taste it. Her goal is to taste and share the best of what Austin has to offer.

Meredith Bethune is a native Rhode Islander who works at the University of Texas by day and is an amateur charcutier by night. She also likes to cook, garden and bike in skirts. Her blog is Biscuits of Today (biscuitsoftoday.com).

Michael and Tracy Blair have enjoyed cooking together since their college days. Michael was raised in a Greek family who owned restaurants, and he gained an early appreciation for great food. Tracy was born in Australia and exposed to unique and flavorful cuisines during her travels across the globe with her parents. The bloggers behind The Bee Cave Kitchen (beecavekitchen.blogspot.com) enjoy wrapping up their busy days together over a craft beer or a glass of wine while joyfully preparing a scrumptious dinner for two.

Stephanie Bogdanich, a graduate of Evergreen State College in Olympia, Washington, currently works as a media technology specialist in Austin. In 2007, she started a personal blog, Lazy Smurf's Guide to Life (lazysmurf.wordpress.com). She now also works on promoting vegan options at local restaurants, raising money for farm sanctuaries and other nonprofit organizations and teaching people about food.

William Burdette is a PhD candidate in English and program coordinator of the Digital Writing & Research Lab at the University of Texas–Austin. He is also passionate about food. He has worked in restaurants and commercial kitchens, volunteered for food-related nonprofits and written food reviews. Currently, he produces a food podcast called *No Satiation* (nosatiation.com).

Eli Castro writes the blog Grubbus (grubbus.com). He has been a coffee enthusiast since his unsuspecting parents first let him try a few sips at a dinner party when he was ten. Eli is the author of the Austin Food Blogger Alliance Coffee Guide for 2012 and has been known to route his travel schedule to pass through cities with particularly amazing espresso bars.

Jennie Chen is a research scientist with a penchant for cooking, puppies and clean driving. By day, she is an adjunct professor, behavioral endocrinology nerd, statistics geek, startup/tech enthusiast and social strategy consultant. By night, she is a hobby collector. She holds a doctor of philosophy in social psychology and blogs at Miso Hungry (misohungrynow.blogspot.com.)

Suzanna Cole is the South Austin Foodie (southaustinfoodie.blogspot.com). She lives and works in South Austin but will wander all around in search of a good meal, so she can document it constructively on her blog.

Carla Crownover is a wannabe farmgirl, avid gardener, food preserver who blogs at Austin Urban Gardens (austinurbangardens.wordpress.com). In 2010, Crownover stopped shopping for food at grocery stores and now sources entirely from local markets and producers, many of whom have become her friends in the years since. "In getting to know my food, I found my people," she says.

Rachel Daneman is a Dallas native who recently graduated from the University of Texas–Austin with a degree in public relations. She started her blog Dinner with Daneman (rachel.daneman.com) in December 2010 as a way to show people that they can still make gourmet food at home.

On her blog ZestyBeanDog (zestybeandog.wordpress.com), **Jen Daugherty** likes to experiment with new ingredients and create recipes for the out-of-the box dishes that her mind dreams up.

Brittanie Duncan is a self-taught chef who follows the Paleolithic diet. Her daily challenge since "going Paleo" is finding a healthy way to feed herself and her family without being a short-order cook. She used to make three separate dinners for her family's three different diets, but that was expensive, time-consuming and frustrating. Three Diets One Dinner (threedietsonedinner.com) is her solution to this dilemma.

Michelle Fandrich of The Kid Can Cook (thekidcancook.blogspot.com) chronicles the kitchen adventures of one precocious preschooler ("the Kid") and his food-loving mom. From healthy takes on comfort food favorites to learning about the cuisines and food cultures of countries around the world, this blog encourages all families to get in the kitchen and cook together.

A native of Paris, Texas, **Susan Stella Floyd** is a self-taught cook who loves to learn about food, create delicious meals for friends, improve her food photography and, of course, eat. Her blog, Stella Cooks (stellacooks.com), started as a showcase for her personal recipe collection and has expanded into an exploration of the history and culture of food, especially Texas food, as well as a place to spotlight regional Central Texas producers and products.

Anna Ginsberg loves to talk baking with anyone who will listen. The winner of the 2006 Pillsbury Bake-Off and author of *The Daily Cookie* (Andrews McMeel, 2012) bakes every day and posts recipes on her baking blog, Cookie Madness (cookiemadness.net).

Lisa Goddard, food activist and new mom of three, is a member of the AFBA Advisory Council. She works for the Capital Area Food Bank and is on the board of directors for the Sustainable Food Center.

When life handed **Tara Miko Grayless** lemons, she cried, got angry and then made lemonade. After suffering from a diet-related illness, Grayless found that hemp seeds were the catalyst to get her health back on track, and in the journey, she saw a need to create dishes that were simple and healthy with big taste. She hit the restart button and launched a hemp seed company called Happy Hemp, which has a corresponding recipe blog (happy-hemp.com).

Tiffany Harelik is the fourth-generation Austinite behind Trailer Food Diaries (trailerfooddiaries.blogspot.com), a blog about food trucks and trailers that has turned into a cookbook series of the same name. Harelik's great-grandfather moved from Russia to Texas in the early 1900s and started a mobile food cart selling bananas; this ultimately progressed into owning five general stores in Central Texas. Also a mom, Tiffany and her daughter spend a lot of time outside in the garden, hiking and swimming.

Lee Stokes Hilton is a native Texan who spent what seemed like a lifetime in corporate communications on Wall Street before she discovered how much more fun it was to write personal essays. Now they are pretty much all she writes. Her essays have been published in various national magazines and in the *New York Times*. In 2008, she and her husband moved to Austin, where her love of cooking and farmers' markets inspires her blog, Spoon & Ink (spoonandink.blogspot.com).

Christy Horton is a native Austinite and a trained pastry chef. She started her blog, Epicuriosities (epicuriosities.com), as a way to share her love of the Austin food scene.

Kathryn Hutchison started blogging as a way to stay in touch with friends and family when she moved to Austin in 2003, but by 2009, she was writing almost exclusively about cooking adventurously in the kitchen of her first apartment. She still cooks in a tiny apartment kitchen, but through The Austin Gastronomist (austingastronomist.com), Hutchison documents her own culinary adventures, as well as local farms, artisan foods, culinary events and the people who create Austin's food culture.

Katie Inglis is the creator of Liberty and Lunch (libertyandlunch.com), a blog that explores the intersection of her two favorite parts of life: food and adventure. A Colorado native, Inglis moved to Austin in 2010 to pursue a career in design. When she's not working on the computer, she's busy building a wood-strip canoe with her partner, Ryan,

writing about the wilderness, cooking out of her vegetable garden, rock climbing or planning her next trek into the mountains.

Hilah Johnson started an online cooking show called *Hilah Cooking* (hilahcooking. com) in January 2010. She says that she has the cutest dog in the world and that doing experiments with food is her idea of a good time.

Melissa Joulwan of The Clothes Make the Girl (theclothesmakethegirl.com) likes to train hard and eat Paleo. She CrossFits, runs, practices yoga/meditation and loves Prague, Jane Eyre and lifting heavy things. In 2011, she published her second book, *Well Fed: Paleo Recipes for People Who Love to Eat*.

Joshua Kimbell of the Avocado Apex (theavocadoapex.blogspot.com) is a Southern California transplant who made his way to Austin for a culinary arts degree. His love for food took him to Central Market, where he currently works helping people with food and recipes.

Rachelle King writes Blinded by the Bite (blindedbythebite.wordpress.com), a website to discuss all things food, in particular how to live a gluten-free lifestyle with an emphasis on how to eat sustainably and locally. As a professional PR/social media consultant, her clients include several Austin companies, including Kohana Coffee, Delysia Chocolates and Edible Austin.

Jane Ko created A Taste of Koko (atasteofkoko.com) in March 2010 when she was a University of Texas student and a photographer with a passion for food who was majoring in nutrition. Even though she finished her degree, you don't find many "healthy" recipes on her blog. She calls herself a nutrition student who has gone rogue.

Mike Krell loves food and drink—period. For the last few years, he has focused on the ever-growing mobile food cart and trailer scene in Austin at austinfoodcarts.com.

Amy Kritzer of What Jew Wanna Eat (whatjewwannaeat.com) is a food writer and recipe developer originally from Connecticut. She moved to Austin in 2009 to escape cold weather, only to discover her love of queso and country music. In her spare time, Kritzer enjoys cooking, theme parties and cowboys.

A recovering Yankee and ex-expat from a food-crazy family of fishermen and restaurateurs, **Mary Helen Leonard** fell in love with Austin several years ago and is now proud to call this little city her home. She's a professionally trained cook with a background in French,

Japanese and Chinese cuisines, which blend together for Leonard's self-proclaimed "homespun fusion" cooking style. She blogs about her food obsessions and adventures in competitive cooking at Mary Makes Dinner (marymakesdinner.typepad.com).

In the past fifteen years, Le Cordon Bleu graduate **Alex Lopez** has studied cuisine in Thailand, worked as a personal chef and caterer in Chicago, taught cooking classes and worked as a food stylist and recipe developer in San Francisco. After a stint back in Chicago as a chef on an organic farm, Lopez moved to Austin, where she writes the blog Food Diva Alex (alexfooddiva.com).

Franish Nonspeaker (franishnonspeaker.com) began as a blog to chronicle **Shelley Lucas**'s journey to Paris to attend Le Cordon Bleu's Patisserie Program and has evolved into a home baker's ramblings on recipes and life.

One fated Saturday afternoon in 2012, six Austin women, including cookbook designer **Shaun Martin**, went to a local brewery tour and came out with a buzz and a blog idea. Bitch Beer (bitchbeer.org), a female-centric beer blog, was born. Since that day, the writers have been dedicated to tracking Austin's craft beer movement and having a few drinks along the way.

Gemma Matherne is a Brit who moved to Austin in 2008 to study patisserie and baking at a local culinary school and to be closer to her "mad-scientist" American boyfriend. With his help and the recent passage of the Texas Cottage Law, which allows home bakers to sell products baked in their home, Matherne created a bakery and a blog called Curious Confections (curiousconfections.com).

Rachel Matthews lives in Austin, eats most anything, has a passport and is not afraid to use it. She writes from her home, while traveling and in cyberspace, thus proving that she can be in more than one place at any given time. She blogs at And Then Make Soup (andthenmakesoup.wordpress.com).

Sommer Maxwell is a home cook for her husband, son and occasionally family and friends. She stays inspired in the kitchen by wandering the local farmers' markets and their family garden, which is tended and harvested each morning by their four-year-old. She blogs at The Seasonal Plate (seasonalplate.blogspot.com).

Through her blog Way Out West Austin (wayoutwestaustin.com), **Laura McCarley** helps West Austinites who are looking for food and fun. Her tagline is: "We're here to give you some ideas, and turn you on to something new. We're not just out there, we're way out."

In 2007, when **Jessica Meyer** was diagnosed with celiac disease, she was inspired to help others living the gluten-free lifestyle. She created ATX Gluten-Free (atxglutenfree.com), where she blogs original recipes and gluten-free news for Austin and beyond. She also founded Locate Special Diet, a website and mobile application that helps people find local businesses that cater to a gluten-free, vegetarian or organic lifestyle.

Rob Moshein was introduced to the world of wine while studying at Cambridge University in England. He built his wine palate, passion and collection while living in Southern California during the 1980s and started working in the wine industry full time as a wine buyer in Austin in the mid-1990s. He blogs, muses and rants about wine at austinwineguy.com.

Megan Myers grew up in Wisconsin and moved to Austin after graduating from college. She blogs about cooking from scratch, using local ingredients and teaching her son about good food on her blog Stetted (stetted.com).

Born into an Italian American family, **Cecilia Nasti** had little choice but to love food. An organic vegetable gardener and cook on her mother's side, Nasti promotes locally produced food and cooking from the garden, and she shares that love at the table and on Field and Feast (fieldandfeast.com), her blog and radio segment that airs on the weekends on KUT, the local NPR affiliate.

Michelle Nezamabadi of Beyond Picket Fences (beyondpicketfences.com) is a native Texan with Persian roots. She is inspired by food that honestly represents the people who make it and is always looking for delicious ways to merge the traditional, modern and local takes on food. Keeping family and cultural traditions alive is very important and helped create the southern/Tex/Persian cuisine that is this Austinite's comfort food.

Dawn Orsak is a sixth-generation Czech Texan who writes and speaks about the intersection of food with culture, history and family, especially her own. She blogs at Svacina Project (svacinaproject.blogspot.com).

Natalie Paramore is a twentysomething foodie turned blogger living, eating and cooking in Austin. She loves experimenting with new ingredients and trying out new flavor combinations at local restaurants. When she's not cooking or trying out a new recipe on her blog, Food Fetish (natalieparamore.com), she loves to hang out with her dog, go to concerts and stay active.

Kate Payne is the blogger and author behind the book *The Hip Girl's Guide to Homemaking* (HarperCollins, April 2011). On her blog (hipgirlshome.com), she posts small-batch canning recipes, gluten-free baking projects, DIY cleaning ideas and other creative home improvisations.

Chris Perez developed a fascination with the arts as a child, creating comic books with friends and experimenting with oil paints. In high school, he turned his focus to math and science, which has led to a career in engineering at a major tech company in Austin. But his blog, MetropoChris (metropochris.com), has given him the chance to bring that creative side front and center again. He is also a writer and photographer for Apartment Therapy and The Kitchn, which are flourishing lifestyle websites.

Through her blog, From Maggie's Farm (frommaggiesfarm.com), **Margaret Christine Perkins** shares the poignance, pitfalls, pratfalls, grit and grace of living close to the land on her Hill Country farm. A "late to the party" farmer, Perkins uses words and photos to brings together ethnic cuisines, cultural traditions and her beloved creole traditions into a simmering symphonic soup that she joyfully shares with readers.

Michelann Quimby, a stay-at-home mom, part-time college professor and full-time know-it-all, writes the blog CSA for Three (csaforthree.com). An enthusiastic amateur cook from a family of professional cooks, Quimby says that she loves her community-supported agriculture box because it helps her feed herself and her family healthy, fresh, vegetable-heavy meals made with produce from local farms.

Shefaly Ravula created Shef's Kitchen (shefskitchen.wordpress.com) to share traditional Indian recipes, Indian-inspired dishes and non-Indian dishes, many of which have been passed down or inspired by her north Indian family, her south Indian in-laws or the many public and private cooking classes she teaches in the Austin area. Ravula's blog also includes anecdotes about family cooking, parenting and childhood memories, all intertwined with food and recipes.

Lisa Rawlinson of Full and Content (fullandcontent.blogspot.com) uses the story of food to write about seeking balance in life, having a rich existence while enjoying the simple things and trying to do the right thing along the way.

As Austin's taco ambassador for Taco Journalism (tacojournalism.com), **Mando Rayo** brings flavor and fun to the capital city by building the taco community through reviews, insights and tours. Rayo is a member of the AFBA Advisory Council.

Stacey Rider, a wife, realtor and mom of five, writes the Four Points Foodie blog (fourpointsfoodie.com). Food is her passion, and "Bringing families home and to the table" is her motto.

When she's not fiddling with semicolons or bowling, **Monica Riese** is busy contemplating ways to give her friends and family high blood pressure and diabetes (according to them). She blogs about her efforts at It's the Yeast I Can Do (theyeasticando.tumblr.com).

Lindsay Robison moved to Austin in 2004 and has been enjoying the food scene ever since. By day, she works in food public relations, and by night, she enjoys testing out new recipes with her husband, Luke, for her blog, Apron Adventures (apronadventures.com).

On **Rebecca Saltsman**'s blog, Salts Kitchen (saltskitchen.net), she writes about not only what she cooks and eats but also what new food she's discovered and the things that inspire her to make food she's never made before. Most of all, she loves feeding other people things that they have never tried before. She likes disproving myths about food and what it means to eat well and healthy, even if you are on a budget or have food allergies.

Jam Sanitchat grew up in Thailand and moved to Austin as a graduate student in 2001. In 2008, she and her husband, Bruce, opened Thai Fresh, a restaurant in South Austin. You can often find her at her booth at the downtown farmers' market or teaching cooking classes in the restaurant. She is on the advisory council of the AFBA and blogs at thai-fresh.com.

Heather Santos was drawn to Austin by her career in the automation industry, but the city's energy and abundance of barbecue captivated her taste buds, and Austin became home. On her blog, Midnite Chef (midnitechef.wordpress.com), Santos weaves together traditional dishes from her childhood in Alberta, Canada, with contemporary Texan fare, and the importance of food and mealtime have increased as her two children continue to grow as fast as their appetites can carry them.

Kristin Schell chronicles life as a wife and mother of four with daily musings about what's cooking at The Schell Café (theschellcafe.com).

Ryan Schierling and Julie Munroe write about everything from highbrow food to humble home cooking, as well as their culinary explorations of Austin and beyond, at Foie Gras Hot Dog (foiegrashotdog.com). Their motto is "The kitchen is church, and we go to church every day."

Combining the seafood and produce of her native New Jersey with the bright flavors of Austin, **Kristin Sheppard**'s meals are a unique spin on "home." She writes about food and pop culture at Mad Betty (madbetty.com).

Melissa Skorpil is a photographer in Austin who specializes in food photography and writes a food blog on her website (skorpilphotography.com).

Through his blog, Fork and Spoon (forkandspoon.typepad.com), **Derrick Stomberg** is cooking his way through several cookbooks, cataloguing the recipes that cross his path and creating new recipes, with a focus on fine dining.

Elizabeth Van Huffel is a food geek. The blogger behind Local Savour (localsavour.com) has spent more than twenty years working in food, both in public relations and in the kitchens of some of the finest chefs in North America. She now runs a small catering company and continues to learn about food and wine.

Kristin Vrana started her blog Food Fash (foodfash.com) in 2009 to fill the creative void that rushing to grow up had left behind. As a veteran healthy eater, Kristin focuses mostly on her love for fresh eats, but she dabbles in the worlds of culinary splurges, fashion and music as well.

Kristi Willis shares her passion for real food by exploring farmers' markets, food artisans and restaurants that work with local farms. She writes about these adventures for *Edible Austin* magazine and on her blogs, Kristi's Farm to Table (kristisfarmtotable.com) and Ditch the Box (ditchthebox.com).

Kristina Wolter was born and raised in Northern California, and more than a decade ago, she packed her KitchenAid and moved from sunny and predictable weather to smoking-hot, unpredictable Austin. GRITS is an acronym for "Girls Raised in the South," and though it took her a while, she got here and started Girl Gone Grits (girlgonegrits.blogspot.com). The food (especially barbecue), people and lively music keep her feet tapping and her heart grounded.

Jack "IronJack" Yang blogs on Eating in a Box (eatinginabox.com) about exploring every corner of the world in ethnic themes or crazy ingredients all in a four-course lunch box.

Tiffany Young and Antonio Delgado, with illustrator **Lindsay O'Neal**, started OhSpooning! (ohspooning.com) because of their shared love of food. They also co-write children's books and children's music for the young-at-heart.

Index

About the Editor

As the food writer for the *Austin American-Statesman*, Addie Broyles writes about everything from farmers and up-and-coming chefs to cookbooks and family recipes in a weekly column and blog called "Relish Austin." In 2010, she helped found the Austin Food Blogger Alliance, which now has more than 150 members and is the only nonprofit of its kind in the country. When she's not chasing after her two young sons, the Ozarks native and University of Missouri graduate writes about women and food at thefeministkitchen.com. Her interest in women's and gender studies propelled her interest in community cookbooks, which have long given a voice to women whose work has been undervalued in American society. In recent years, Broyles has been voted the top food writer in Austin by readers of the *Austin Chronicle*, and in 2012, she won the National Headliner Award for her features writing.